INKED

INKED

CAREY HART
AND CHRIS PALMER

ARTISAN

photographs by **BILL THOMAS**

Published by Artisan
A Division of Workman Publishing Company, Inc.
225 Varick Street
New York, NY 10014-4381
www.artisanbooks.com

Library of Congress Cataloging-in-Publication Data

Hart, Carey.
Inked / by Carey Hart and Chris Palmer; photographs by Bill Thomas.
p. cm.
ISBN 978-1-57965-335-4—ISBN 978-1-57965-341-5
1. Tattooing. 2. Tattooing—Pictorial works. I. Palmer, Chris. II. Title.

GT2345.H37 2008
391.6'5—dc22 2007040262

Designed by Andy Taray

Printed in China
First printing, September 2008

10 9 8 7 6 5 4 3 2

To all of the tattoo artists out there who are constantly pushing the true art form known as tattooing. Just because there isn't a TV camera documenting your life doesn't mean that you aren't the best. Keep pushing the boundaries and spread the good name one tattooed body at a time.

My skin tells a story. Not the kind of story with a beginning, a middle, and an end but more like the journey of who I am. Tattoos are my life. They've become part of my identity. But it wasn't always that way.

I didn't grow up immersed in tattoo culture, but I was always aware of it. When I was a kid, tattooing was still taboo, a back alley pursuit reserved for tough-guy types or outlaw bikers. My dad worked construction, and a couple of his buddies had the occasional faded chest or forearm piece. What little I saw of tattoos had a profound effect on me.

When I was in the second grade I'd come home from school with drawings and little designs all over my arms and hands, which would make my dad yell and scream. He was always against the idea of me getting inked, but in the back of my mind I knew that's exactly what I was going to do.

As I got older and more into the punk rock scene, tattoos were all around me. One of my biggest tattoo influences was Mike Ness, the lead singer of Social Distortion. When I was fourteen I started sneaking into Social D shows whenever they played Vegas. Mike's tattoos are still so vivid in my mind. The LOVE and PAIN on his knuckles and the skeleton drinking a martini on his right shoulder definitely planted a seed for me.

I thought eighteen years was long enough to wait for my first tattoo, so when my birthday rolled around I had it all planned out. I didn't have the money to get tattooed in a real shop, but my friend's father had experience giving tattoos, and I trusted him. Right there on my buddy's kitchen table I got a skull with flames and the number 111, which was my motocross number, on my chest. It wasn't the greatest tattoo in the world, but I was proud of it. I knew tattoos would be a big part of my life and I was excited to get started. My dad was a little pissed when he saw it, but he understood that I was old enough and it was my life.

After that it just kind of snowballed. Within a year and a half I had two sleeves and began working on my back piece. My dad was still skeptical and with each new tattoo he would look at me and say, "What the hell are you doing to yourself?" I would explain to him that this was how I'd decided to express myself creatively. He didn't understand, but still accepted me as his son.

One of the tattoos that has the most significance to me is the words HART LUCK across my knuckles. Hart Luck is the misfortune of all the men in my family. I come from a family of single men, and we're prone to occasional misfortune. My father was single and my uncles were too. They're all self-sufficient and taught me how to take care of myself. Sometimes our luck is just all-bad. But without setbacks I'd never have had the chance to pick myself up.

For as long as I can remember my life has revolved around motorcycles. I could ride a motorcycle before I could ride a bike. Before I could even walk my family would take motorcycle camping trips to the dunes of Southern California. When I was in diapers my grandfather would prop me up on the gas tank of his Honda Elsinore 125 and ride me around the sand. My dad had a 1976 RM 250 that was made out of spare parts. Soon, we moved to Las Vegas, and when I was four my dad got me my first bike, a Suzuki RM 50.

The only thing I wanted to do from that point on was ride my bike. When I was in kindergarten I would ride my motorcycle to school, with my dad trailing behind me on his 250. I'd chain it to the bike rack with all the other kids' bicycles. At the end of the school

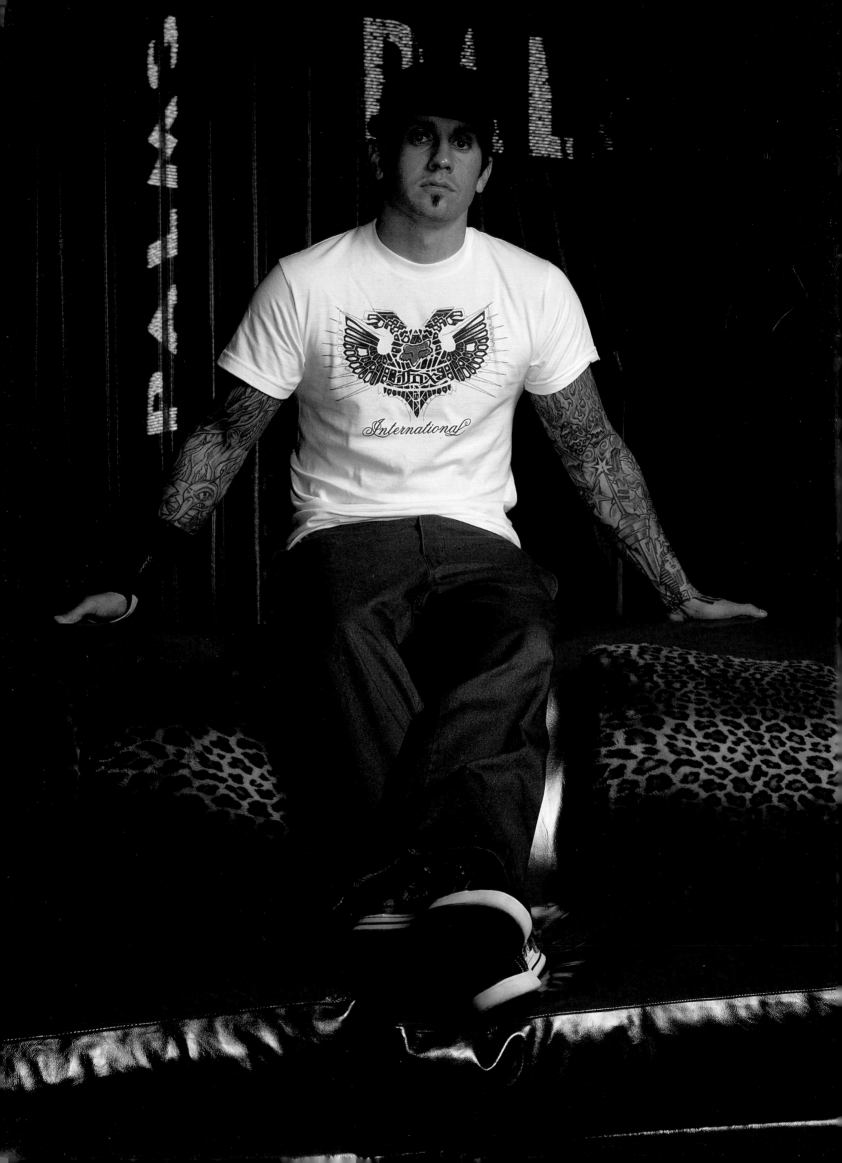

day, when other kids' parents picked them up in cars, there was my dad waiting on his Suzuki next to the bike rack. We'd ride home side by side across the Las Vegas desert.

At five, I started entering local races and quickly became one of the fastest amateur riders on the West Coast. I played soccer and Little League baseball, but I had found my calling on two wheels. Racing, however, was draining our money. We had to scrape to get by. Sometimes my dad would make us soup for dinner that was more water than soup. There were times we couldn't afford hot water. At big races I couldn't ride in the practice sessions because we had only enough gas for the actual race.

Still, I was riding well enough to be recruited by a top factory race team, which could fully sponsor a racer's professional career and provide the most cutting-edge equipment. At fifteen, I decided this was how I would make my living.

Then, without warning, Hart Luck struck. As I was putting in a test lap on a new track my dad built, a bulldozer pulled out in front of me. I was coming off a seventy-foot double and slammed right into it, breaking both my arms and legs. I was confined to a hospital bed for weeks and then to a wheelchair for nearly a year. Only after an eighteen-month rehab was I able to resume my racing career. While my peers were signing factory contracts, I was learning to ride again.

When I graduated from high school I decided it was time to be a man and pursue my dream. So I packed up my stuff, loaded the bike in my truck, and moved in with another aspiring racer buddy in Southern California.

I began my career on the pro circuit as a privateer, paying for expenses out of my own pocket. My dad still had to put everything he had into my career. It took him five years to pay off the debt he racked up from my first year as a pro.

At the time I was trying to make it on the professional motocross circuit the sport was in the midst of a seismic change. The American Motorcyclist Association, which promotes the tour, saw what NASCAR was doing and wanted to head in the direction of corporate sponsorship too. Almost overnight motocross became this clean-cut world that looked down on guys with tattoos, Mohawks, piercings, and just about every other fashion statement. The factory-sponsored motocross teams didn't want guys like me. At the time my sleeves went down only to my elbows, but even that was too much for them. I was being pushed out by the values of the buttoned-down corporate world.

It was becoming harder and harder to succeed without factory sponsorship. At twenty that was tough to understand. I was already buying my own bikes and driving back and forth to the races in my van. I was running out of money and willpower. Something had to give, and by 1996 I was ready to give up.

I was all out of options when fate tossed me a life preserver. In the mid-1990s several small motocross companies began producing motocross jumping videos. They would hire a bunch of pro riders and film them jumping sand dunes or huge man-made jumps, then sell the videos at motorcycle shops and through industry magazines. I always had the reputation of being a good jumper, so it was an easy way for me to make extra cash. Since the camera crews would film whatever we did, we called it free riding.

Oddly enough some of the riders who stood out as the best jumpers were the guys who could only dream of making the podium on race days. Guys like Brian Deegan, Mike

"TATTOOS ARE MY LIFE. IF YOUR SKIN TELLS A STORY TOO, CHANCES ARE YOU KNOW WHAT I'M TALKING ABOUT."

Metzger, Mad Mike Jones, and I began developing midair stunts. Free riding started with no-handers, then no-footers, then variations of both, all while sailing ninety feet through the air. The bigger the jumps, the more popular the tapes.

By 1998 there were at least a dozen racers committed to free riding, and the stunts were becoming more complex and dangerous. With the exception of Jeremy McGrath, the top motocross racers began to bow out of free riding as the envelope was being pushed. They had factory contracts and were forbidden by their race teams to take unnecessary risks. But the rest of us had to eat. We began to steal tricks here and there from BMX (Bicycle Motocross) freestyle and do things no one ever thought possible on a motorcycle.

And just like that, out of a creative urge, neglect from the racing community, and the need to survive, the sport of freestyle motocross was born. From there it skyrocketed. Every time we went free riding we pushed one another to develop bigger and better tricks. Soon we were selling thousands of videos, and fans began to recognize us more from the tapes than from actually racing.

All we needed was a consistent venue in which to ply our trade. So a bunch of riders got together, rented out the Las Vegas Speedway, and hauled in a ton of dirt and temporary bleachers. My dad brought in a few bulldozers from his construction job to build the jumps, and we put on the first-ever freestyle contest.

In front of seven thousand curious, revved-up fans, freestyle competition was born. My fellow outcast racers and I had created a new line of work—and a subculture—that fully embodied our lifestyle. The one thing most free riders had in common was a love for big air, punk rock, and tattoos. Tattoos weren't a curse anymore—they were more like a prerequisite for the job.

At the time, most of us were living in or around Temecula, California. When we weren't on tour or practicing new tricks you could usually find us at a local tattoo shop called Soul Expression. Nearly everyone I rode with had full sleeves and a back or chest piece in some stage of completion, so you can imagine how much time we spent there. The atmosphere was friendly and the vibe laid-back, so even when we weren't getting work done we just hung out there.

In the space of a few years, freestyle, racing's hell-raising stepchild, had surpassed racing in popularity and marketability. It exploded into the marquee action sport world at the 1999 X Games, and ESPN's ratings hit record levels. Freestyle was also the featured event at the newly formed Gravity Games. We had become better known than most top-level racers, and the money was rolling in like never before. Unlike the corporate-bound racers, we were free to develop personas. We were the new rock stars. Not bad for a bunch of guys who didn't fit in.

Just as I was establishing myself as one of freestyle's top riders Hart Luck struck again. In the summer of 2003, during a session on Tony Hawk's Boom Boom Huck Jam Tour, I ditched my bike in midair to avoid a skateboarder who was supposed to jump over me. I slammed into a wall, breaking both my arms and my legs. On top of that I nearly died from internal blood clotting and trauma. I spent thirty-one days in a Seattle hospital. My dad flew

1,500 miles from Vegas to sleep in a chair five nights a week until I got out. My days of riding competitively were over. It was a crushing blow I didn't want to accept, but I had to move on.

When I sat down to think about the next chapter of my life I asked myself, "What if I had a place to go when I wasn't riding?" I thought about the time I had spent with friends bonding, telling stories, and getting inked at Soul Expression. That was an important time in my life, and I wanted to re-create that feeling. I decided to open my own tattoo shop. The motivation for the shop wasn't money. I just wanted a cool environment where I could hang out with my friends. I imagined a place with style and character that would bust the stereotype of a tattoo shop always being in a sketchy part of town populated with scary artists with bad attitudes.

I knew Las Vegas inside and out and quickly formulated a business plan to present to George Maloof, the owner of the Palms Hotel and Casino, along with his brothers. George understood youth culture and was impressed with our presentation. So with a handshake we went forward with our plans to open the first-ever tattoo shop in a Las Vegas casino.

From there things went into high gear. My team and I went through an exhaustive process to find fifteen of the best tattoo artists in the business capable of creating the kind of art that would build a loyal client base. To me their personalities were just as important as their artistic abilities because I wanted first timers to walk in and feel a level of comfort they wouldn't find at any other shop.

On February 25, 2004, the doors to Hart & Huntington opened for business, and it's a day I'll never forget. At first I thought I'd show up and just hang out with my boys—that was my plan after all—but before I knew it I was doing everything from running the register to sweeping the floor. In the early days of the shop I was there seven days a week. I had to be hands-on with everything. Launching a business is no picnic. Every day there are fires that need to be put out. Anything can happen and usually does. You've got to know what to do when the computers go down or when employees call in sick or when an unruly customer shows up. It's as challenging as anything I've ever done on a motorcycle.

After filming part of the A&E reality series *Inked*, which revolved around daily life at the shop, I bought my partner's (John Huntington) share of the business and have been expanding ever since—to Orlando, Honolulu, and Cabo San Lucas in Baja. I felt a book was the next logical step. This book is an extension of Hart & Huntington—the attitude, the mood, the lifestyle. The words and pictures within these pages are about the lives of tattoo collectors and the art itself. People with tattoos often share a special kinship. We can all relate to the stares and the whispers. We've all got answers for curious strangers. There's no pain a needle can inflict that we haven't endured. Besides, the torment of a needle can't compare to the satisfaction of seeing your creative vision come to fruition.

Tattoos are my life. If your skin tells a story too, chances are you know what I'm talking about. Most people assume tattoos put you in a box. Actually, they've set me free. And you know the best part about the whole thing? My dad finally understands.

—Carey Hart
Las Vegas

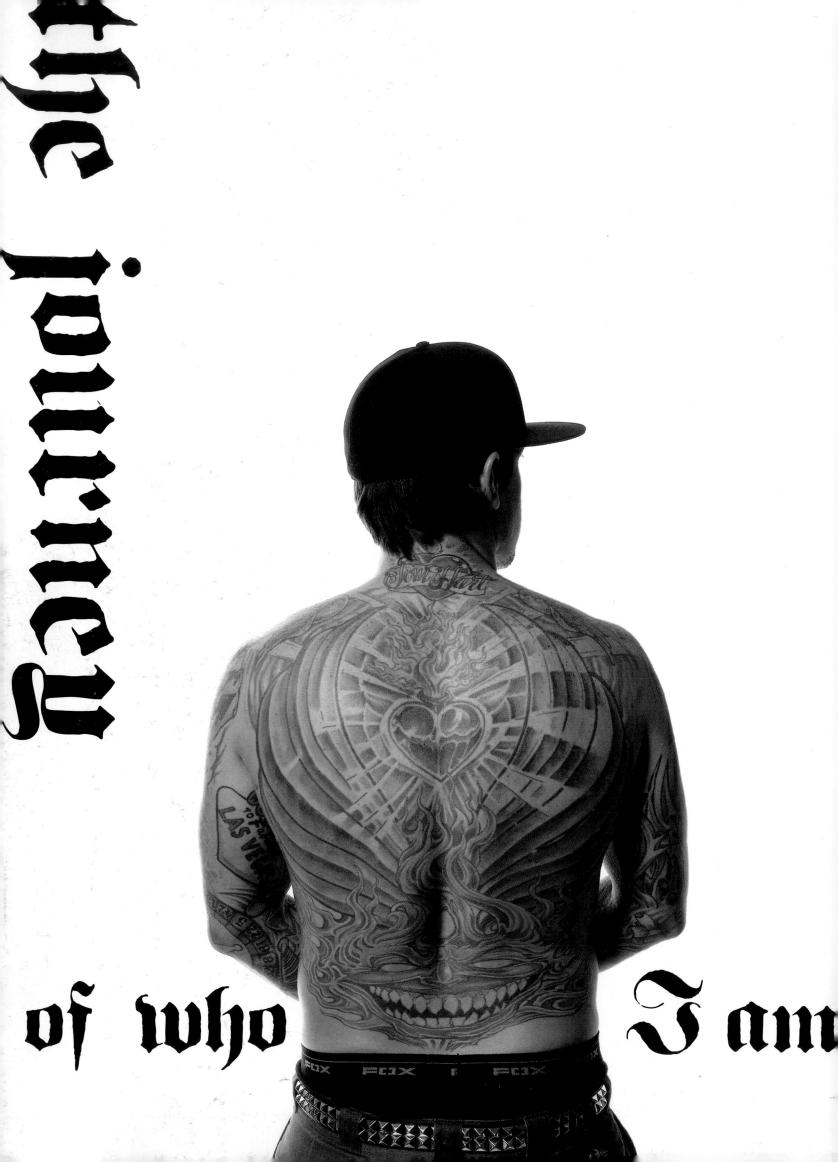

the journey

of who I am

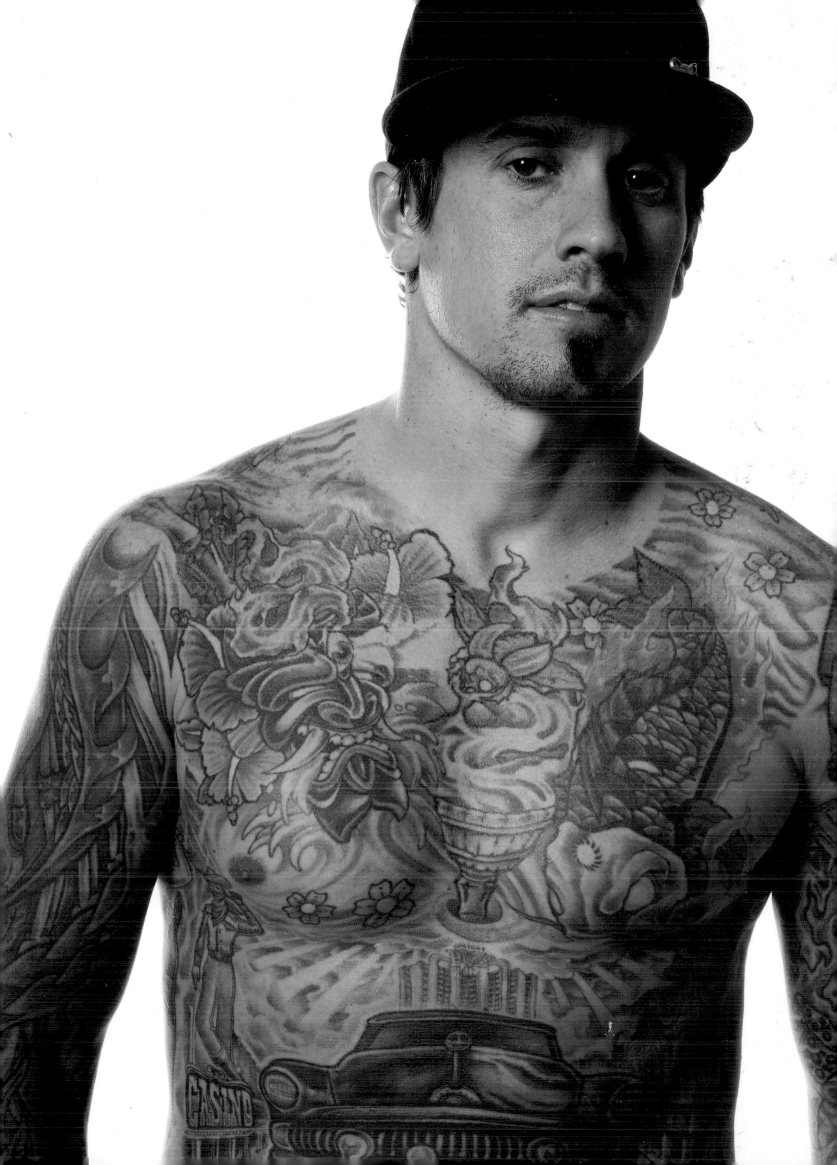

A BRIEF HISTORY OF TATTOOS

BY CHRIS PALMER

ncient forms of tattooing can be traced back thousands of years on nearly every continent. The word tattoo comes from the Tahitian tatu, which means "to strike something." Tattooed mummies dating back five thousand years have been found in the pyramids of Egypt. Samoans used intricate symbols to honor tribes and community, many of which are the basis for common tribal tattoos seen today. In Japan tattoos were used to mark criminals. Offenders were given a line on the forehead to symbolize their crimes. By the third offense the lines formed the Japanese character meaning "dog."

Early tattoo equipment was handmade, and sharpened sticks, stones, reeds, or animal bones were used as rudimentary needles. These needles used to deliver a precise strike to the skin to insert pigment. The process was laborious because each puncture to the skin was made separately, then filled with ink.

These primitive forms of tattooing were brought back to Britain by explorers from the East, and family crests became the most popular tattoos. After the Norman Invasion of 1066 the practice was banned for four centuries—the Normans saw tattooing as barbaric and despised it—until the British explorer Captain James Cook returned from an exploration with a tattooed Polynesian who captured the public's imagination. Soon after, the upper crust began to get small, easily hidden tattoos. Sailors in the eighteenth-century British Navy also began returning home with permanent images on their arms. These tattoos were done by locals they encountered in places like Japan and Polynesia. Eventually tattoo artists began popping up in seaports.

Some of the first references to American tattooing are contained within ship logs of early nineteenth-century American Navy vessels. Sailors using crude metal needles would tattoo their shipmates with anchors or animals they saw abroad. Back home tattooing failed to catch on because it was too expensive, and even applying a simple design was time-consuming. Tattooing floundered until tattoo artist and amateur inventor Samuel O'Reilly gave the medium a shot in the arm.

In 1891 O'Reilly invented the modern tattoo machine, based on Thomas Edison's autograph printer, which was used for engraving. The handheld machine used rotors to move the needle up and down to drive the pigment into the skin. (Today electromagnetic coils have replaced the rotors.) Tattoos could now be applied faster and with more distinct designs and detail. It was also a much cheaper process because less labor was involved. This new technology enabled tattoo artists to proliferate. O'Reilly set up shop in New York City on the Bowery in Chatham Square, a neighborhood populated with saloons and flophouses. Working-class folks with a day's wages in their pocket frequented the district, and business thrived until the Great Depression, when tattooing once again stumbled.

In the early half of the 1900s underground tattoo artists began to gain cultlike followings as word of their artistic prowess spread. Legendary freehand artists like Charlie Western, August Bernard Coleman, Phil Sparrow, and Lou Alberts were redesigning flash (simple, predesigned tattoo art) and drawing unique pieces that appealed to sailors and circus sideshow performers alike. They also inspired and mentored young artists who would go on to become major influences in the tattoo world. One such artist was Bert Grimm. He made an impressive thirty dollars a week in 1924 giving full-body tattoos to people who wanted to join the circus—*Come See the Amazing Tattooed Lady.* After World

War I, though, carnivals and circuses began phasing out freak shows in favor of acrobats and animal acts, so it was no longer possible to profit financially from having a bodysuit.

Grimm had much success in St. Louis, where he tattooed riverboat workers in the back of a shooting gallery, and next set up shop on the Pike in Long Beach. There he tattooed sailors sixteen hours a day, helping to give rise to the notion that tattoos were a sailor's specialty.

The stereotype wasn't far off. Sailors and military men represented a good portion of the business and helped make tattoo shops in port towns around the world successful during the 1930s and 1940s. Even the iconic cartoon character Popeye the Sailor had anchors tattooed on his bulbous forearms. Wherever there were military bases, tattoo parlors—and other businesses that catered to the needs of sailors, such as bars, saloons, pool halls, gentlemen's clubs, and other clandestine dens of iniquity—weren't far off. Their proximity to stockyards and dilapidated warehouses only added to the grimy mystique of tattoos: welcome to the wrong side of town. Far from picket fences, pillbox hats, and the beautification projects of Eleanor Roosevelt, the Other Side of the Tracks was born into urban lore. And there tattooing thrived. For locals that meant sometimes risking your life to go to an undesirable part of town to have MOM tattooed on your forearm. Step into a tattoo shop and you'd better know what you wanted. The tattoo artists there were just as gruff as the grizzled old sea dogs who sought permanent reminders on their weathered appendages.

Near the end of World War II thriving port towns began to dry up, sending these grungy urban oases into a state of neglect far from Norman Rockwell's sentimentalized America. When it seemed no end to the war was in sight, President Truman gave the order to drop two atomic bombs. One week later Japan surrendered and World War II was over. Then, before the last bit of ticker tape fell on Broadway and the first baby boomer was conceived, a new outlaw breed emerged, stamping tattoos with a stigma that would last for five decades—biker gangs.

Just as Rosie the Riveter was rolling her sleeves back down, hundreds of returning servicemen were rolling theirs up to stash cigarettes. Storing them in jeans pockets while cruising on a bike meant a worthless pile of crushed Marlboros or Camels. Former soldiers who had difficulty readjusting to civilian life found camaraderie and their own brand of freedom in motorcycle gangs. Many sported arms emblazoned with tattoos that chronicled their experience in the service or announced allegiance to their new swarms of two-wheeled terrors.

In 1947 the American Motorcyclist Association organized a biker rally in the sleepy town of Hollister, California, which liked to bill itself as the Earthquake Capital of the World. Event organizers drastically underestimated the turnout. Over the course of the three-day event, four thousand bikers descended on the town. Most were well behaved. But a couple of rowdy crews, the Boozefighters and the Pissed Off Bastards, caused mayhem that overwhelmed local authorities. Police arrested dozens of bikers, mostly for disturbing the peace and public drunkenness. Headlines across the country warned of the unsavoriness of bands of lawless biker gangs. The de facto message to Americans: bikers and all their accoutrements—leather jackets, brash behavior, and tattoos—were bad news and to be avoided at all costs.

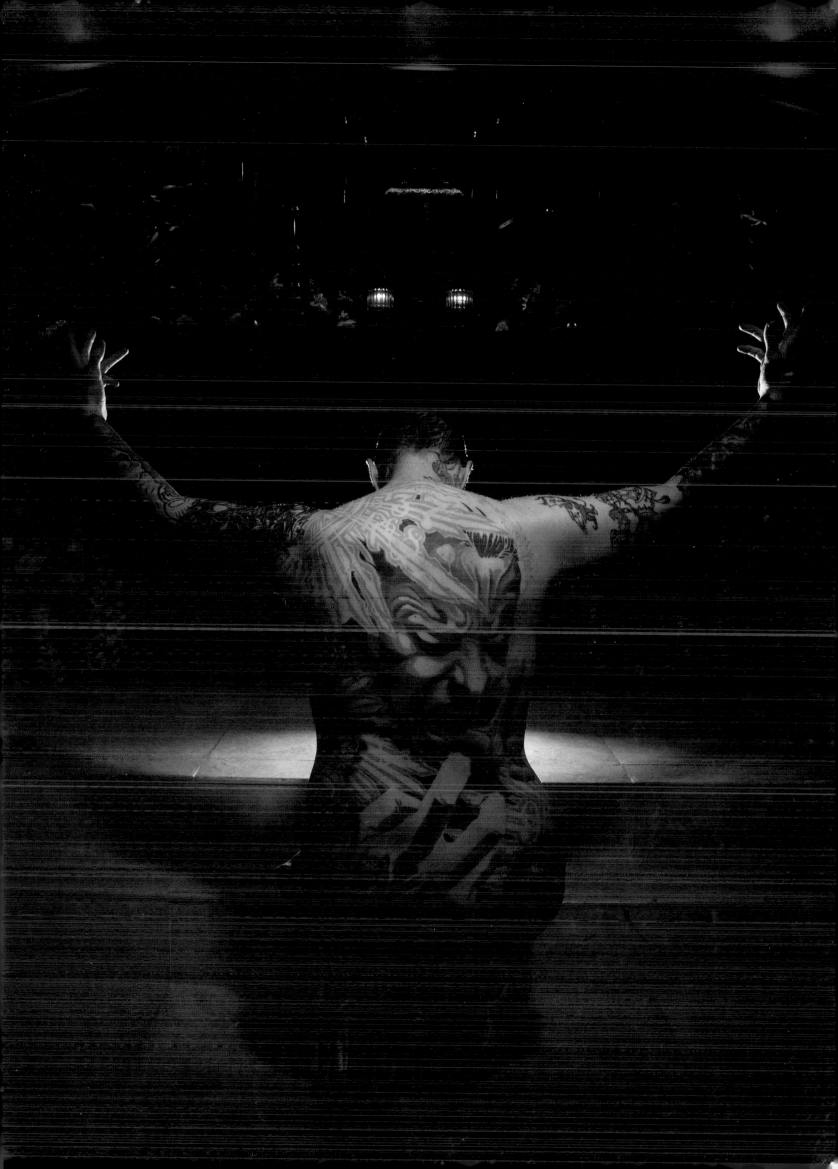

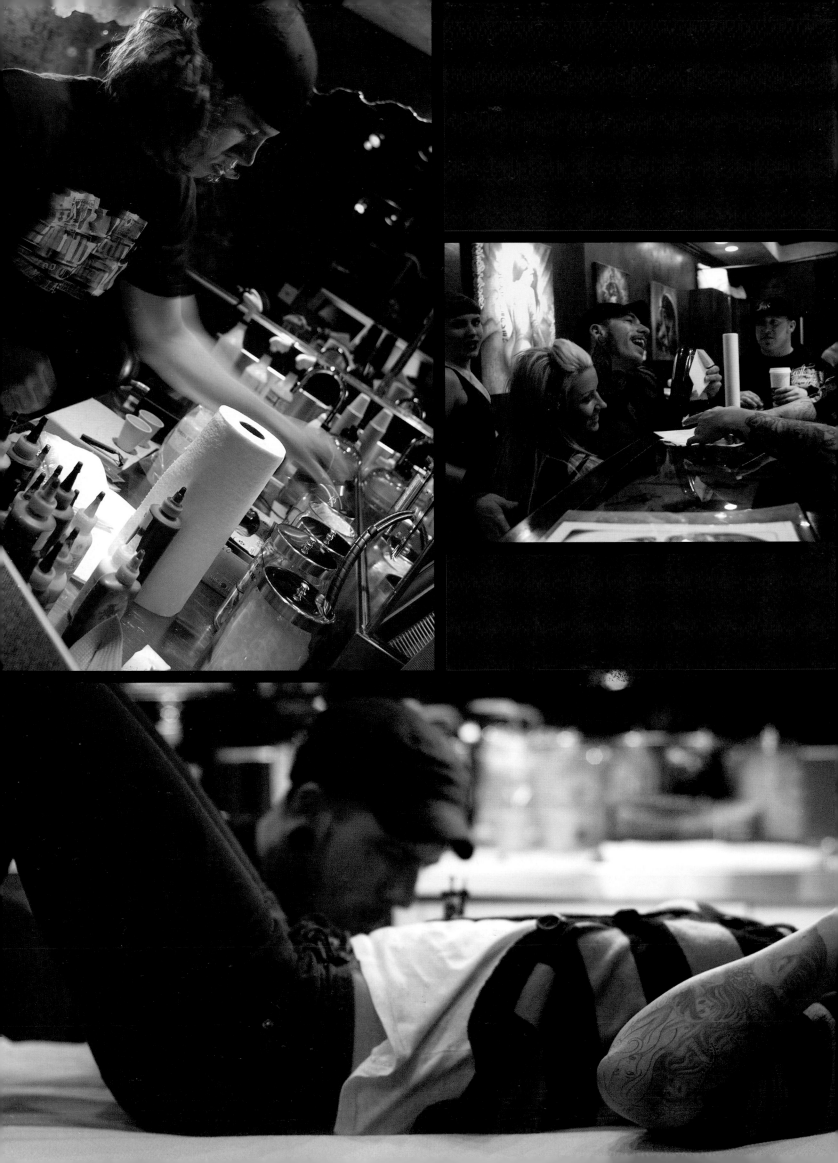

The Hollister incident was etched deeper into the American psyche by the 1954 movie *The Wild One*, starring Marlon Brando, which further reinforced the notoriety of two-wheeled outlaws. Journalist Hunter S. Thompson's 1966 book, *Hell's Angels: The Strange and Terrible Saga of the Outlaw Motorcycle Gangs*, brought the reader inside a forbidden underworld that culminated with Thompson being badly beaten. Three years later the Hells Angels again stoked the flames of controversy by stabbing a concertgoer who brandished a gun as the Rolling Stones played a free concert at the Altamont Speedway in California where the Angels were hired as security. For two decades, as bikers bucked convention and shuffled in and out of prison, their arms, chests, and backs became pigmented road maps of antisocial conventions. For better or worse, in a fire-breathing mix of myth and infamy, bikers had exploded into pop culture consciousness. And so had tattoos.

For an extensive period tattooing was outlawed in New York City, the birthplace of modern Western tattooing. The New York City Department of Health blamed tattoo parlors for a string of hepatitis cases and declared a health crisis in 1961. This didn't sit well with a popular tattoo artist named Spider Webb. He protested by tattooing porn star Annie Sprinkle on the steps of the Metropolitan Museum of Art and was subsequently arrested. Tattooing was relegated to the basements, alleys, and back rooms of Canal Street. And to the very brave or foolish, depending on your perspective. The hepatitis plague officials had warned about never materialized, and although some health risks remained, the controversy faded but the law was never repealed. Underground parlors operated at their own risk, and some even advertised in the back of the *Village Voice*. Tattooing was not made legal again in New York City until 1997.

As baby boomers came of age they began to shake the *Father Knows Best* ideals they had been raised on. After all, *Father Knows Best* would never have approved of spending your allowance at a seedy tattoo parlor, let alone desecrating your body. Amid the tumult of the 1960s—political unrest, social upheaval, antiwar demonstrations—the freedom of creative expression began to chip away at the ignominy of tattoos. Nowhere was creative expression more defined than in the music of the era. In 1969 the trajectory of the public acceptance of tattoos took a turn for the better thanks to the fabled needle of tattoo artist Lyle Tuttle and a wispy blues rock singer named Janis Joplin. In a seminal moment in tattoo history, Tuttle tattooed a small flower on Joplin's left wrist.

Soon every girl wanted a flower on her own wrist. And so tattoo shops had a new type of customer, which led to a spike in the popularity of tattoos. "Women's liberation!" Tuttle exclaimed to *Prick* magazine in 2006 when asked what made tattooing fashionable back then. "That put tattooing back on the map. It increased the marketplace by 50 percent of the population. For three years after Janis I tattooed almost nothing but women. They made tattooing a soft and kinder art form."

Tuttle's renown and skillful hand landed him on *The Tonight Show* with Johnny Carson, and he was the subject of an article in the *Wall Street Journal* as well as numerous documentaries. In 1970 Annie Leibovitz photographed him for the cover of *Rolling Stone*. Other rock-and-roll acts like the Rolling Stones, Aerosmith, and The Allman Brothers Band began getting tattooed and were again inevitably copied by their fans until tattoos became synonymous with the music. As tattooing became more socially acceptable better artists began to work in the medium, increasing the aesthetic quality of tattoos and further widening their appeal.

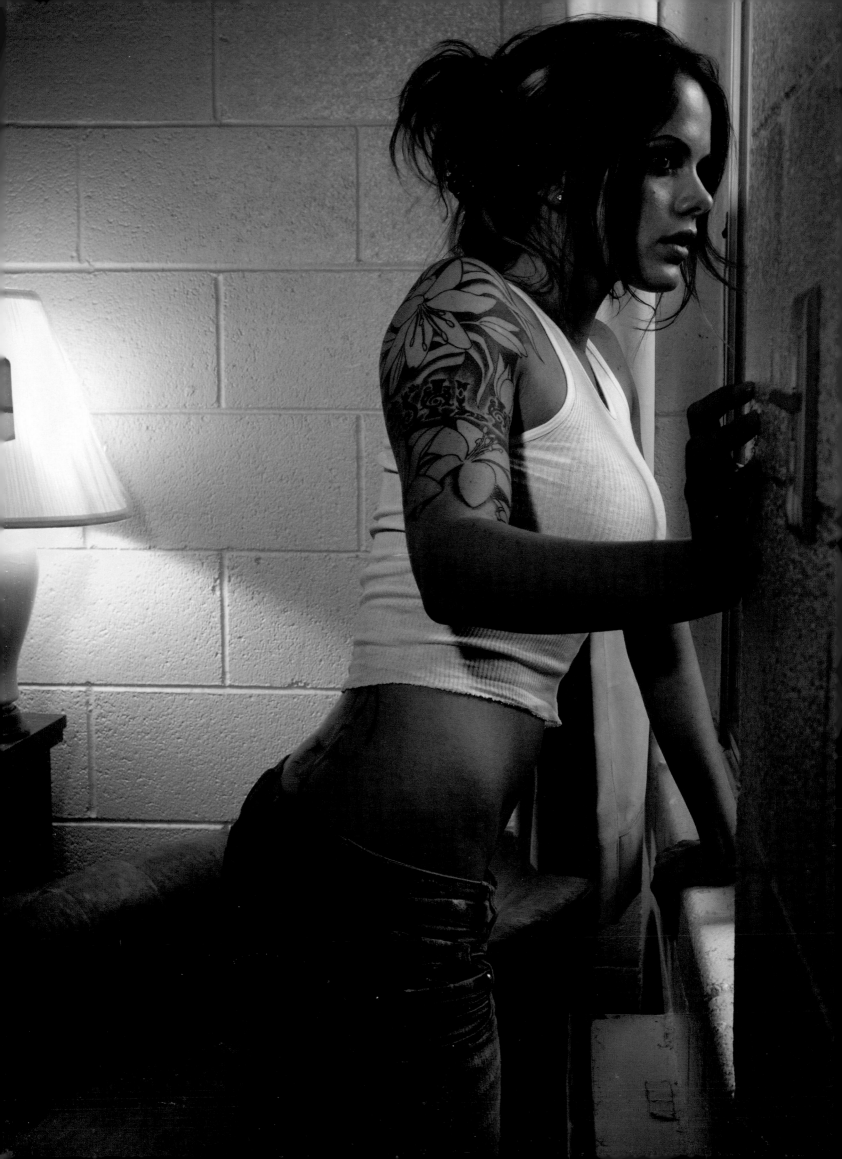

In the last ten years tattooing has seen a resurgence in popularity and social acceptance. Much like Janis Joplin's wrist tattoo decades ago, today's celebrities have had a hand in pushing tattoos into the mainstream. Pamela Anderson's dainty barbwire tattoo on her upper left arm showed that women could get inked without compromising their femininity. Not only has Anderson continued to trade on her sex appeal but she is also credited with giving tattoos an unmistakable sexual cachet. Dennis Rodman was the first athlete to successfully incorporate tattoos into his persona during his colorful run as a rebounding machine with the Chicago Bulls. Mainstream favorite Michael Jordan's acceptance of Rodman's skills was a subtle but powerful message that showed a growing tolerance of tattoos.

With over a dozen tattoos, most having spiritual or reflective connotations, Angelina Jolie has proven that she can get tattooed and still be a mother, activist, and leading lady of Hollywood. Christina Aguilera has collected a half dozen, including the much buzzed about XTINA on the back of her neck. Red Hot Chili Peppers frontman Anthony Kiedis's extensive tribal tattoos have inspired many imitators. Heavily adorned hip-hoppers include Lil' Wayne, 50 Cent, and LL Cool J. On MTV's *Meet the Barkers*, scenes of Blink-182's tattooed drummer Travis Barker ruminating on the importance of family while holding his infant son in his fully inked arms melted more stereotypes.

Today, tattoo shops are everywhere, and entire magazines are devoted to the topic. But as the popularity of tattoos has grown, so have advances in tattoo removal. This has lessened the impact of getting a tattoo and shortened the decision-making process for those who reason they can opt to remove it should love fade, personalities change, or job offers be extended. Even Jolie has had a half dozen removed over time. Television shows such as A&E's *Inked*, which chronicled the daily goings-on at Hart & Huntington Tattoo in the Palms Hotel in Las Vegas, and TLC's *Miami Ink* have gone to great lengths to dispel misconceptions about tattoos and the people who get them. Tattoo artist Kat Von D has become a cult celebrity thanks to her own show *LA Ink*.

The accessibility and glamour of Carey Hart's tattoo shops have turned the once taboo act of getting a tattoo into a matter-of-fact part of a weekend in Vegas with friends. "I believe tattoos should be available for anyone who wants to get one," says Hart. "Whatever helps the art of tattooing is a positive thing. Getting a tattoo is something you'll never forget, and that experience should be a memorable one." Today tattoos have gained a foothold in respectability thanks to ever-changing social values, a tolerance for individual freedom of expression, and, ironically, a tattooed motorcycle rider.

Tattooing has always struggled—and some feel will always struggle—for acceptance and acknowledgment beyond the rebellious and absurd in Western culture. Society's first impressions of tattoos as being a favorite of rabble-rousing bikers will always dog the art form. There will always be stares. Always questions. Some parents will never approve. Employers will turn up their noses. Collectors' closets will always have long-sleeved shirts just in case. But tattooing will go on. There will always be youthful bare skin that will long to tell a story, memorialize a friend, commemorate a birth, proclaim a motto, or chronicle a rite of passage. Or perhaps simply just be fine art.

As Joplin once put it, "To me, it's just decoration."

A TATTOO TIMELINE

3200 bc	Third Century ad	1066	1769	1846
Otzi, the world's oldest mummy, gets lines tattooed on his lower spine, right knee, and ankle joints	First evidence of tattooing in Japan. Used for decoration, warding off evil, and marking criminals (who had symbols of their crimes tattooed on their faces)	Tattoos banned in England	British Captain James Cook sails to Tahiti and discovers Polynesian tattoos	Martin Hildebrandt opens New York's first tattoo shop on Oak Street in Manhattan

1944	1947	1954	1961	1966
Norman Rockwell's painting *The Tattooist (Only Skin Deep)* appears on the cover of the *Saturday Evening Post*	Motorcycle rally sponsored by the American Motorcyclist Association leads to notorious Hollister riot in Hollister, CA. Event is sensationalized by media and cements the image of the outlaw (tattooed) biker	Premiere of *The Wild One*, a film version of the Hollister rally starring Marlon Brando	Following a hepatitis-B scare, the New York Department of Health bans tattooing. Tattoo artist Spider Webb protests by tattooing porn star Annie Sprinkle on the steps of the Metropolitan Museum of Art	Hunter S. Thompson publishes *Hell's Angels: The Strange and Terrible Saga of the Outlaw Motorcycle Gang*

1992	1997	1999	1999	2004
The nonprofit Alliance of Professional Tattooists is founded	New York legalizes tattoos and holds its first tattoo convention	Mattel introduces Butterfly Art Barbie, a doll with washable body art	The American Museum of Natural History presents an exhibition titled "Body Art: Marks of Identity"	Carey Hart opens Hart & Huntington Tattoo Company in the Palms Casino Resort in Las Vegas—the first tattoo parlor in a casino

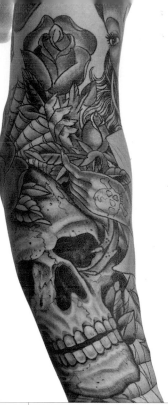 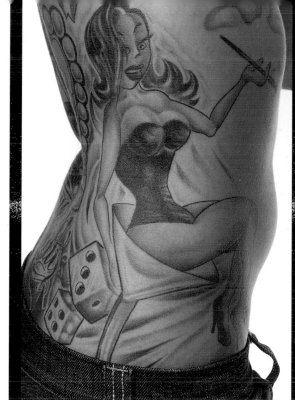 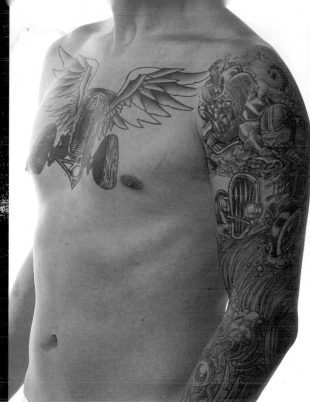

1891

Samuel O'Reilly invents the modern tattoo machine in New York City

1924

Tattoo artist Bert Grimm makes a name for himself giving full-body tattoos to people who want to join the circus

1929

A tattooed Popeye first appears in *Thimble Theatre* comic strip

1930s

Circuses feature tattooed sideshow performers like Betty Broadbent

1944

Tattoo artist Charlie Wagner is fined by the city of New York for not sterilizing needles

1969

Lyle Tuttle tattoos a small flower on Janis Joplin's wrist

1970

Tattoo artist Lyle Tuttle appears on the cover of *Rolling Stone* magazine

1974

Don Ed Hardy opens Realistic Tattoo in San Francisco—the first custom only, appointment-only tattoo shop in the United States

1976

Founding of the National Tattoo Association

1979

The first national tattoo convention is held in Denver

2005

TLC premieres *Miami Ink* and A&E premieres *Inked*—both reality shows that follow the day-to-day happenings at tattoo studios

2005

Paul Booth is invited to join the National Arts Club—the first tattoo artist to receive this honor

2007

The *New York Times* reports that 45 million Americans have tattoos

THE
PROFILES

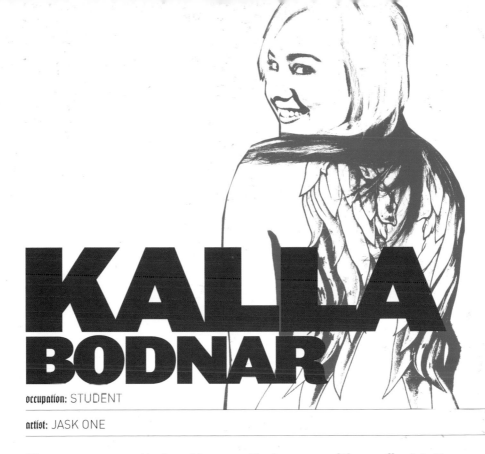

KALLA BODNAR

occupation: STUDENT

artist: JASK ONE

There was a really hard lesson that came with my first tattoo.

My parents forbade me from getting a tattoo, even though they both knew I'd always wanted one. When I turned nineteen I couldn't wait any longer and got a pair of angel wings that stretched from my shoulders to the small of my back. My grandmother used to buy me little angel figurines when I was younger, and she always said I was my own guardian angel. It was something that meant a lot to me, so this was my way of honoring that. After seven months of work totaling over thirty-five hours of excruciating pain—and costing two thousand dollars!—my wings were finally complete. I was so excited because they were even more beautiful than I had imagined. Now all I had to do was hide them.

I knew my parents were serious about their rule against tattoos. They reminded my dad of one thing: gangs. And being a Las Vegas homicide detective, he was very familiar with them. Every day he sees violence, death, and crime. And tattoos. Usually with some gang affiliation or another. One day my father saw the bottom of one of my wings sticking out of my shirt. "You have a week to get out," he told me. He said that I'd regret it on my wedding day because I couldn't wear the dress I'd want. That was two weeks before my twentieth birthday. And it wasn't like I didn't get along with my parents. I was good in school and excelled in sports. My parents always came to my swim meets, where I did well enough to earn a swimming scholarship to the University of Nevada, Las Vegas. We bonded on Sundays by watching football and would even take trips to Dallas to see my father's beloved Cowboys. But a week after he saw the tattoo I packed up my stuff and kissed my mom good-bye.

"THE FURTHER ALONG MY WINGS GOT, *THE STRONGER I BECAME. I* FELT IF I COULD DEAL WITH THE PAIN TATTOOING CAUSED, I COULD DEAL WITH ANYTHING."

It was rough but I eventually landed on my feet and found my own apartment. In the long run my tattoo was well worth it. It gave me strength and freedom. The further along my wings got, the stronger I became. I felt if I could deal with the pain tattooing caused, I could deal with anything.

Right now I'm really into stunting on my motorcycle. I can wheelie my bike at ninety miles per hour, do burnouts, or ride the front wheel with just the right amount of brake control. If you're around motorcycles long enough you'll eventually experience pain and suffering, both physical and mental. I've experienced both. I've crashed my bike pretty hard, and in 2006 my boyfriend was killed in an accident. Getting a memorial tattoo for him on the back of my neck was part of the healing process.

Life can throw a lot at you, but I'm ready for it. I've got a lot of goals for this life. Right now I'm studying sports medicine at Boise State and plan to be a physical therapist for a professional sports team. But that's just the beginning; someday I plan on owning my own team.

No matter what I do I'll have my wings. They'll always be an artistic, beautiful, and elegant symbol of my strength.

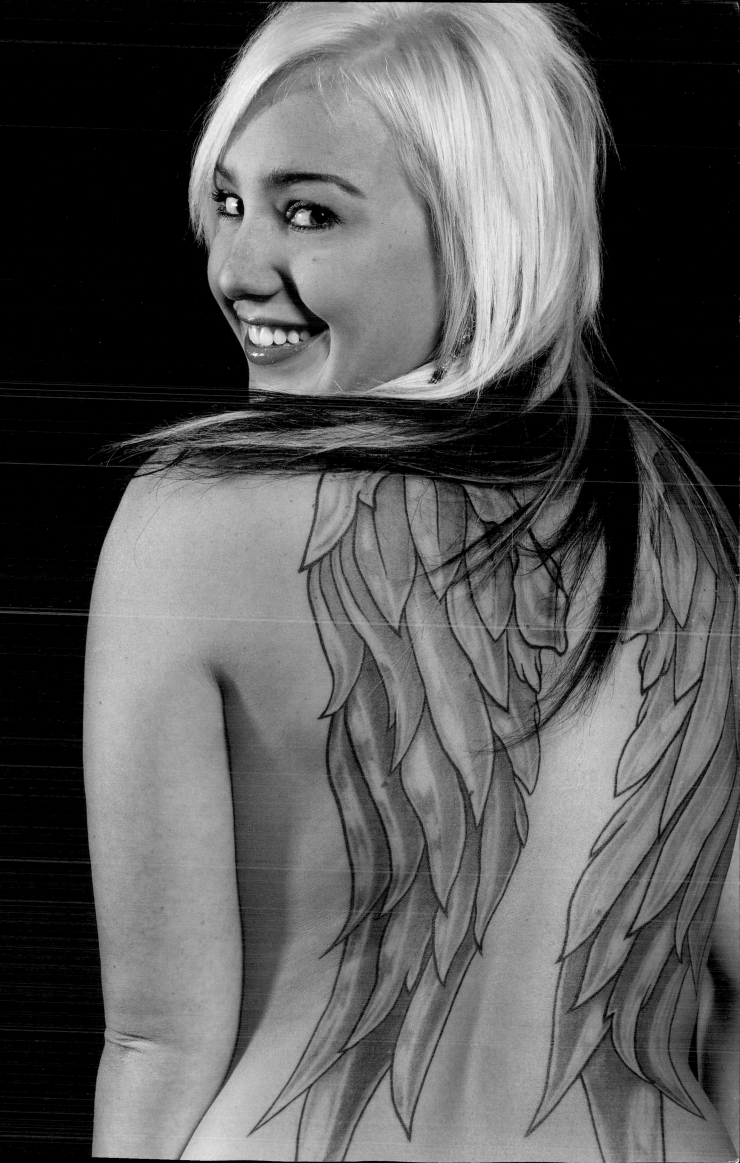

JOSH PETTY

occupation: TATTOO ARTIST, HART & HUNTINGTON TATTOO

artists: ERIC PAYNE; DON BROUSE

Like many tattoo artists I was always drawing as a kid. But unlike many people I was drawing floor plans. My dad was an architect, and I loved to help him with his work. Drawing was fun and that planted the seed for me. I wanted to be able to draw for a living too. Eventually I gravitated to a more cartoonish new-school style with an exaggerated twist on the traditional methods.

After school I packed up and went to Salt Lake City, where I knew a couple of guys and got set up in a shop and began tattooing. I then returned to my native Boise, Idaho, but wasn't really digging the tattoo scene up there. The way they did things was like being in the past. I needed to be on the cutting edge. So I came to Vegas. It was here that I really began to define myself as an artist. I've seen the industry explode over the last ten years. Shops are everywhere. That means that customers have more choices, which is why there is an emphasis on good, clean, quality work.

As for my own work, I stick to traditional Japanese themes—the koi fish with a blade going through it is one of my favorites. Japanese themes have always interested me, but I like to work in blacks and grays and with realism as well. I may be in Vegas but there's a part of me that still recognizes where I'm from. On my left leg I have a Sacred Potato, the ultimate symbol of Idaho.

FIRST TATTOO: Sepultura logo
MOST TIME SPENT ON ONE TATTOO: 8½ hours
FAVORITE STYLE: Black and gray, new school, traditional, biomechanical

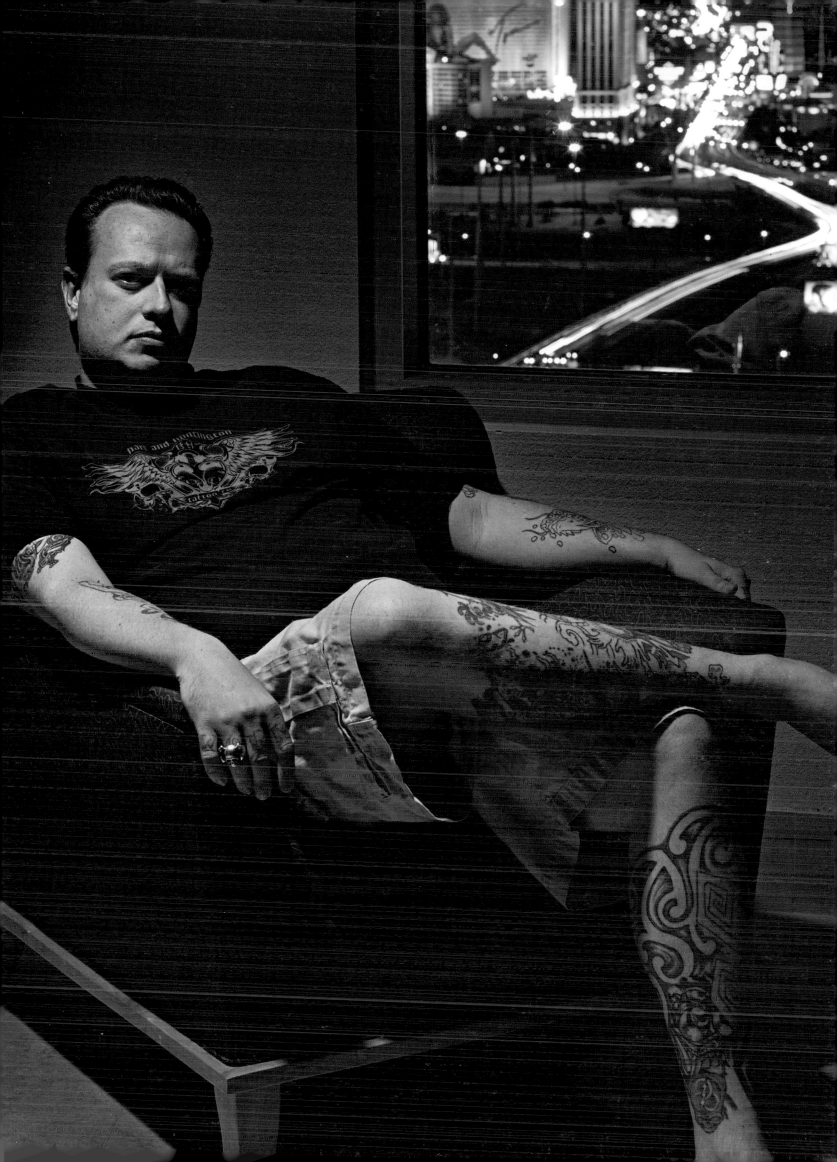

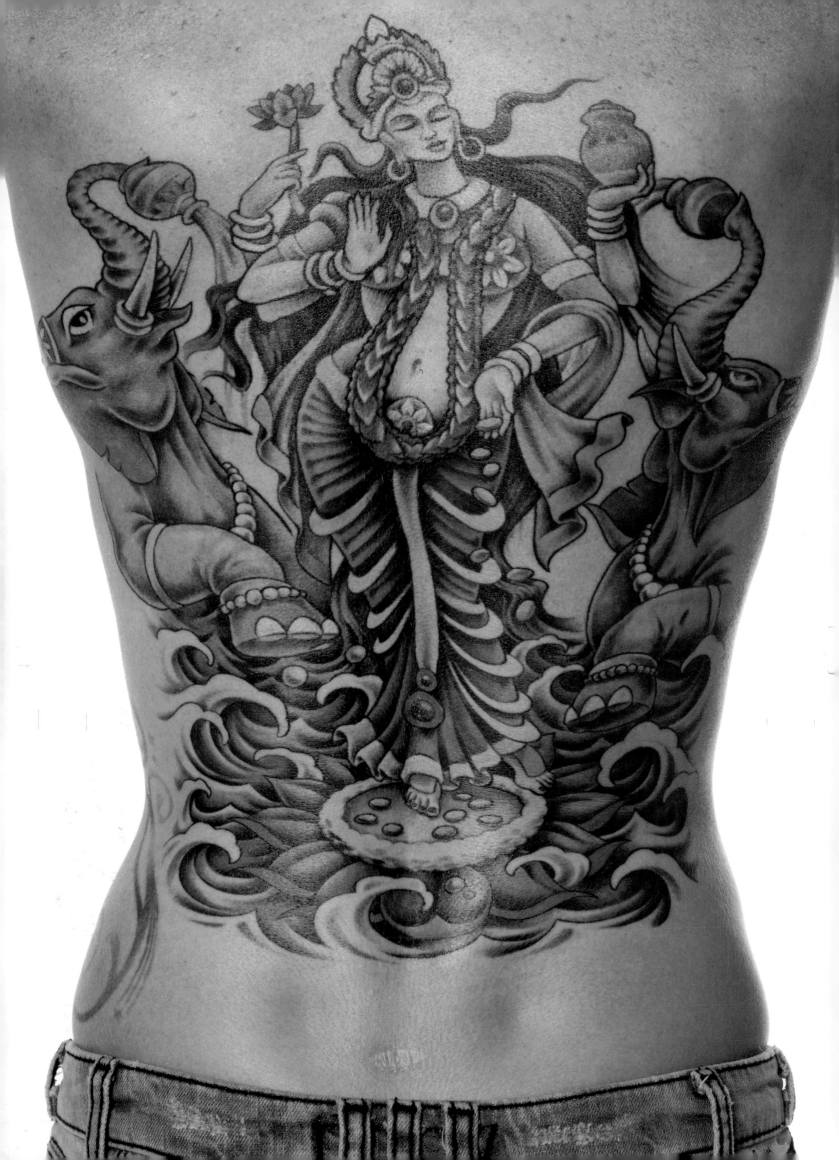

LESLIE CULLER

occupation: GRAPHIC DESIGNER

artist: MATT VICTOR, HART & HUNTINGTON TATTOO

When I first came to Las Vegas I was overwhelmed by the pursuit of beauty and materialism. So many people here are slaves to it and lose their way obsessing over how to achieve it. I wasn't immune, but I made the choice that I didn't want to go down that path. For my twenty-sixth birthday I got the Hindu goddess Lakshmi—the goddess of beauty and wealth—on my back to free myself of wanting those things. I still love shoes, but I don't need material things to achieve happiness.

I consider my tattoos art. I played sports in high school, but I was always more into the art scene in Austin, where I grew up. As far back as I can remember I was drawing or doodling on something. After high school I attended the College of Interior and Fashion Design. My teachers considered me a bit of a square peg because I always went with what they considered unsafe choices. When we designed kitchens I'd go with yellow subway tile while the other students picked generic neutral colors. Needless to say I didn't fit in there, and when I got my tattoos I wanted them to burst with color.

My first tattoo was two green dots on my wrist that I got when I was eighteen without my parents' permission. I didn't bother asking because my dad was always strict about stuff like that. Since it was small I thought I could hide it, but I was wrong. At Thanksgiving dinner I was clearing the table and he saw it under my sleeve. He didn't say anything, but the look on his face said it all—he was not happy. But in time he got used to it because he understood that I was still his little girl. So much so that when I moved to Las Vegas after high school, my parents moved with me.

My parents understand that the image of tattoos has changed since their day. They know my tattoos are an act of expression as opposed to rebellion. Small tattoos are a completely accepted part of society. Tattoo sleeves still draw long stares, but people generally know that tattoos aren't just for bikers anymore.

When I'm old I won't regret a single tattoo. I'll be much more concerned with whether or not I can still walk.

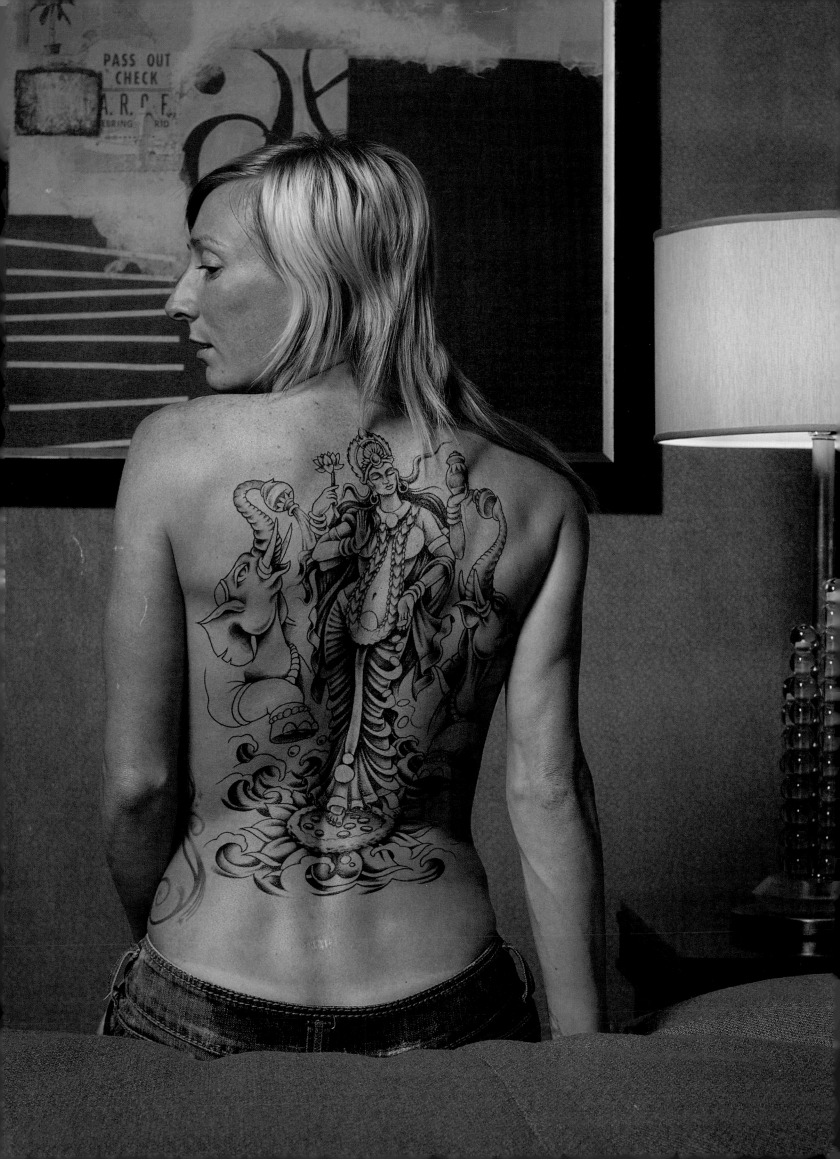

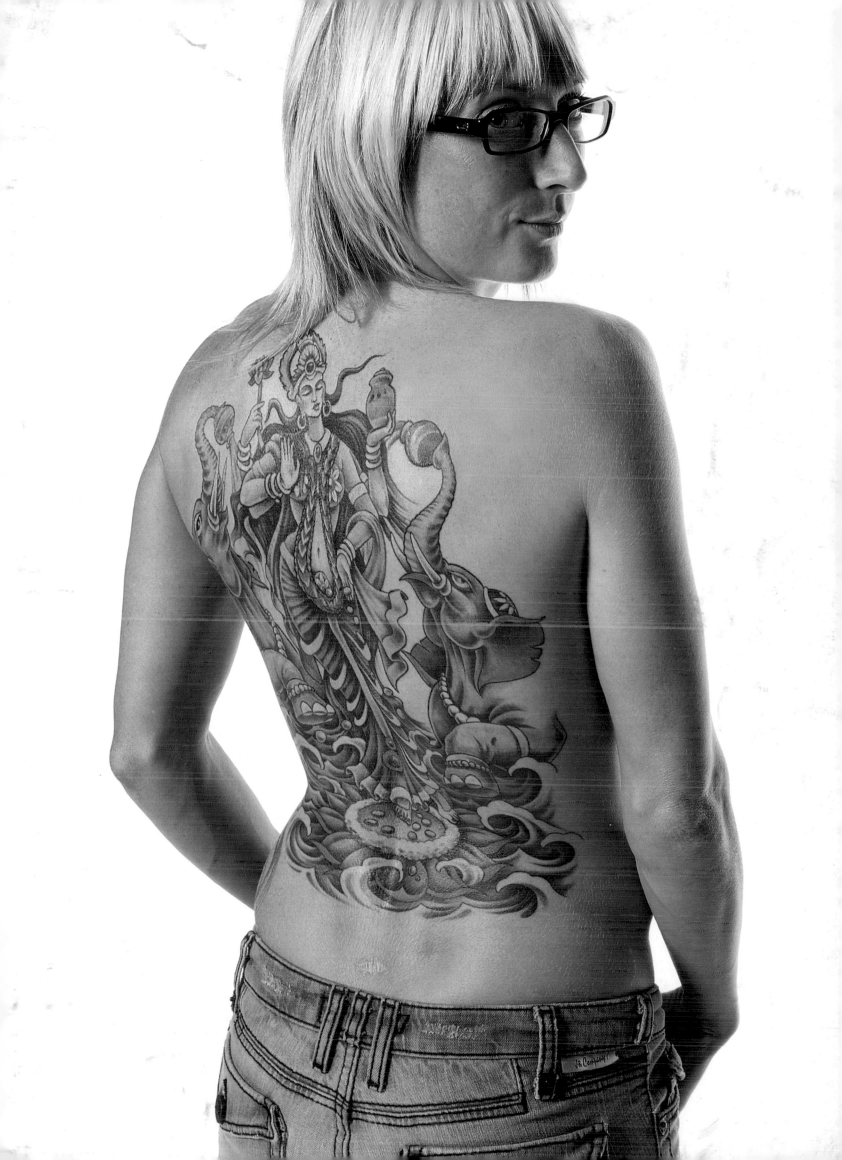

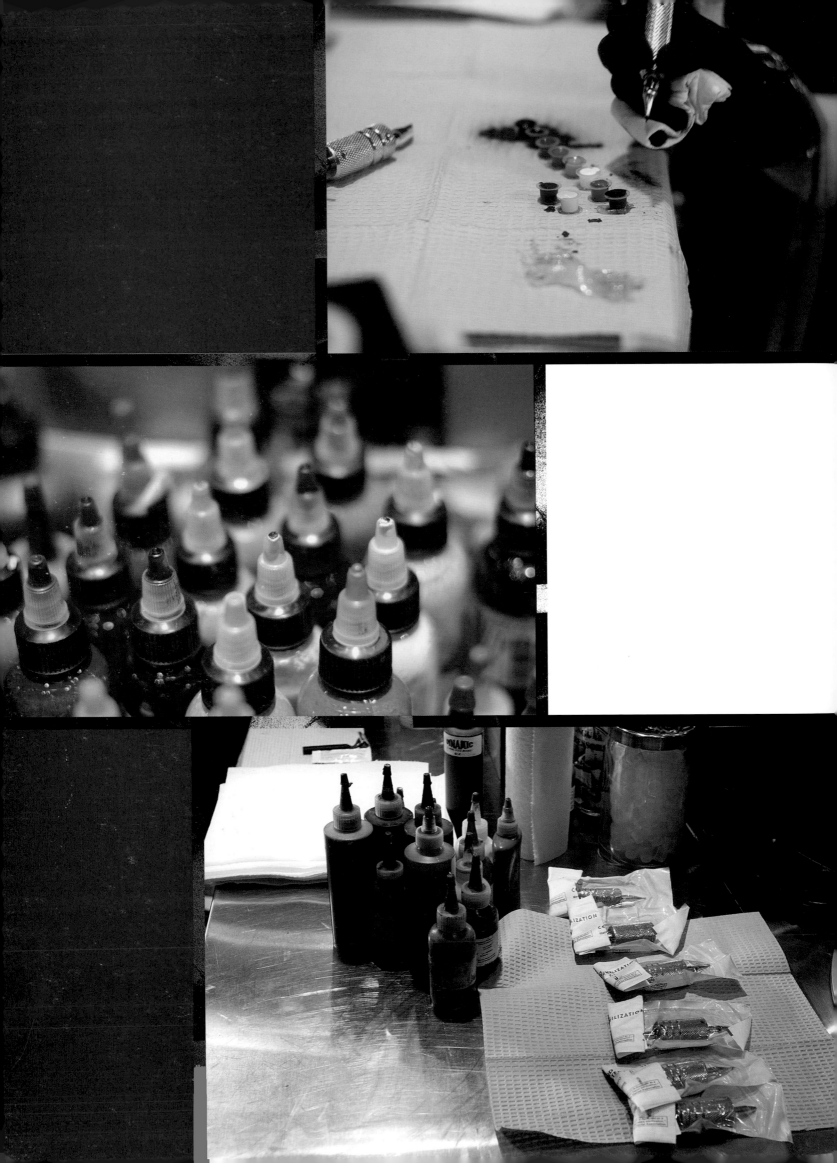

LIQUID LIFE EVERYTHING YOU NEED TO KNOW ABOUT INK

Ink is the lifeblood of the tattoo industry. The colorful liquid in those little plastic bottles will remain in a person's skin forever. Tattoo ink consists of pigment (powder) and a liquid carrier, usually ethyl alcohol, water, or glycerin. The liquid carrier can be a single substance or a mixture. Carriers inhibit the growth of pathogens, distribute the pigments evenly, and help in applying the ink to the skin. Needles are dipped into ink much like a paintbrush into paint.

As with everything in the tattoo world, ink preferences vary from one artist to another. But one thing all artists agree on is that there is no replacement for vibrant colors. A great deal of thought goes into choosing the right ink. Artists know which companies make the purest whites, most dynamic yellows, deepest blues, and striking reds.

The hallmark of quality ink is that its color in the skin looks as vivid as it does in the bottle. Poorer inks have a tendency to dull after they're in the skin. Common ingredients in color pigments include iron oxide, ocher, chromium oxide, azure blue, cadmium yellow, manganese violet, and titanium dioxide. Carbon black (India ink) is one of the most commonly used ingredients and is made from the soot of animal bones.

"When it comes to finding inks you're comfortable with it's all trial and error," says Jesse Smith of Hart & Huntington, Orlando. "You just have to kind of play with it and find out what works best for you."

Red inks can pose a problem for some people because they're the only inks that aren't hypoallergenic. Though allergic reactions are rare, red inks have been known to cause swelling and irritation in some people. Yellow pigments are one of the more difficult to work with since a high concentration of the pigment can cause burning or scarring. To offset this effect manufacturers sometimes use lower concentrations, which can cause the color to dull.

Any veteran artist knows the value of mixing inks. Sometimes you need a specific shade of blue that may require you to lighten it with a few drops of white. Or maybe a customer is looking for a fuchsia you don't have in your toolbox. "I'll see a younger kid looking at an ink catalog flipping out over a shade of orange," says Las Vegas Hart & Huntington inker Uncle Johnny. "I tell him all you need are your three primary colors and black, and white and you can mix any color you want. The first thing any artist should do is get a color wheel. When you're just starting to work with ink it's your best friend."

A color wheel allows you to see the result of any two primary colors combined.

Some artists prefer to work with ink with a higher level of viscosity. "I like inks that don't run so much," says artist Josh Bailey. "I prefer a nice thick opaque paste." One way of getting the consistency you desire is to mix the pigment and carrier yourself as opposed to buying predispersed inks. This gives the artist complete control over the ink's ingredients.

MERDOK

occupation: TATTOO ARTIST, HART & HUNTINGTON TATTOO

artists: ABLE R; JACK RUDY; JEFF HARP; SMALL PAUL; TRAE HANSEN; THEE WOODY; TENNESSEE DAVE

born and raised: CALIFORNIA

first tattoo: A ROSE

prior career: GARDENER

favorite style: SINGLE NEEDLE

tip for first timers: BREATHE AND DON'T WORRY

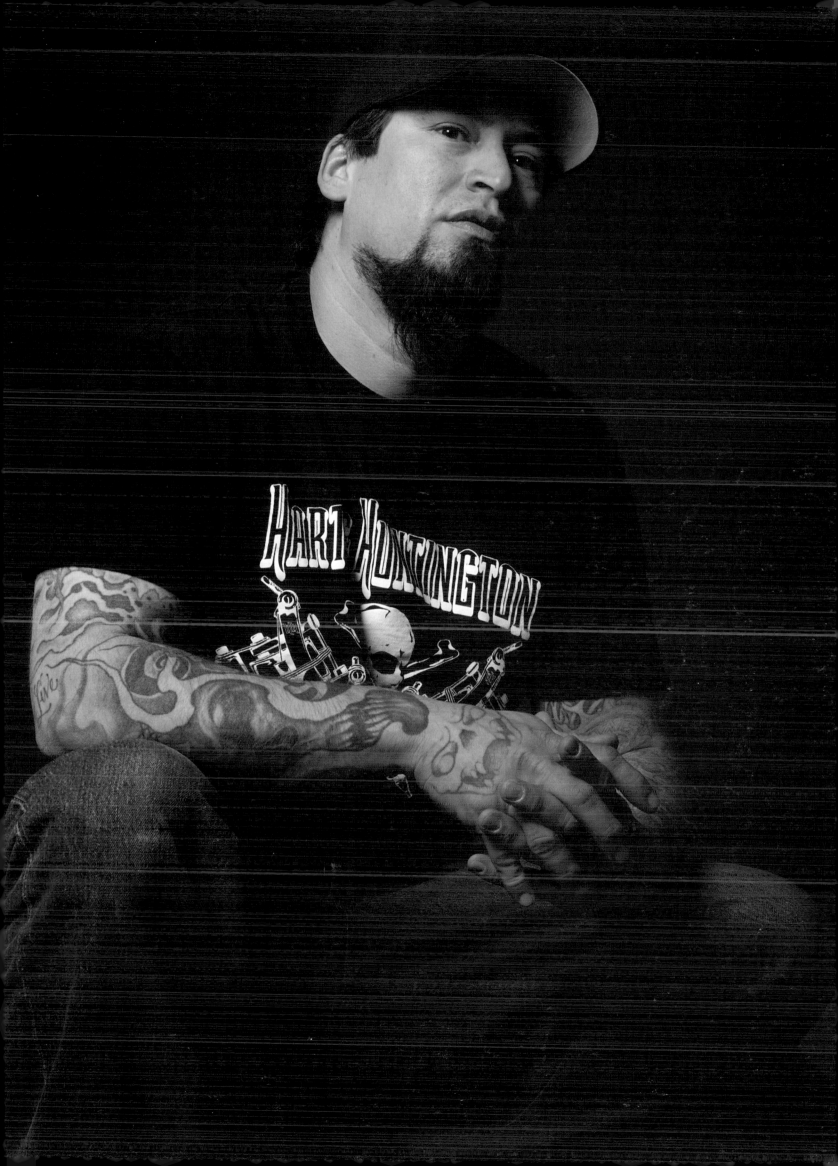

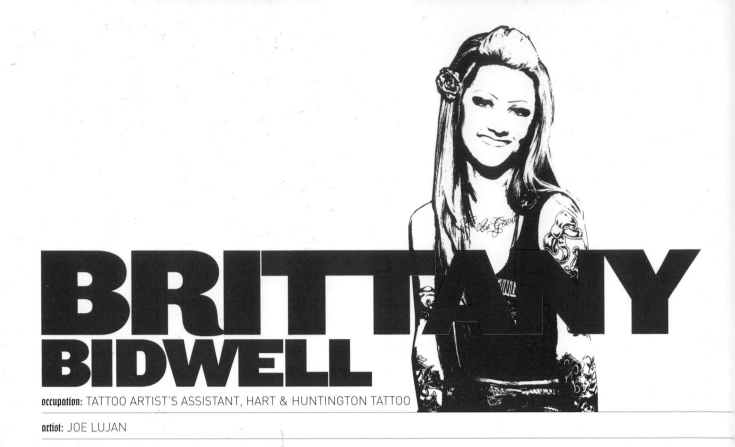

BRITTANY
BIDWELL

occupation: TATTOO ARTIST'S ASSISTANT, HART & HUNTINGTON TATTOO

artist: JOE LUJAN

If I had one wish for myself it would be to be tougher. I think my tattoos give the impression that I am tough, even though I'm not. I don't like getting into confrontations with people, so I thought having all of these tattoos would make people just turn the other way when they see me. But actually it's had the opposite effect. Whether I'm at a restaurant or in a grocery store people come up and ask about my tattoos every single day. At first it was weird when old ladies would stare at me and ask questions, but you just get used to it. Everyone always tells me that my tattoos don't match my personality, and because of that they have a hard time figuring out who I am.

People are usually shocked by some of my more graphic tattoos, but they don't really have a sinister meaning. On the inside of my right arm I have a dead baby and above that there is a raven pecking at a dead woman with a decapitated head. On my back I have a pair of angel wings that are haggard and torn. I don't like when everything is pretty. In real life things are worn-out and tattered, and that's what I wanted to portray.

Across my stomach in Old English lettering are the words DIRTY PIRATE HOOKER. It's from a line Will Ferrell said in *Anchorman,* which is one of my favorite movies. My mom isn't too happy with my tattoos, but surprisingly she thought that one was funny. I thought about the tattoo for only a day before getting it but I don't regret it. One of the first tattoos I got was the words NO SHAME across my fingers because that's the way I felt about my tattoos. I'm never going to be ashamed or worry about people judging me because this is how I express myself.

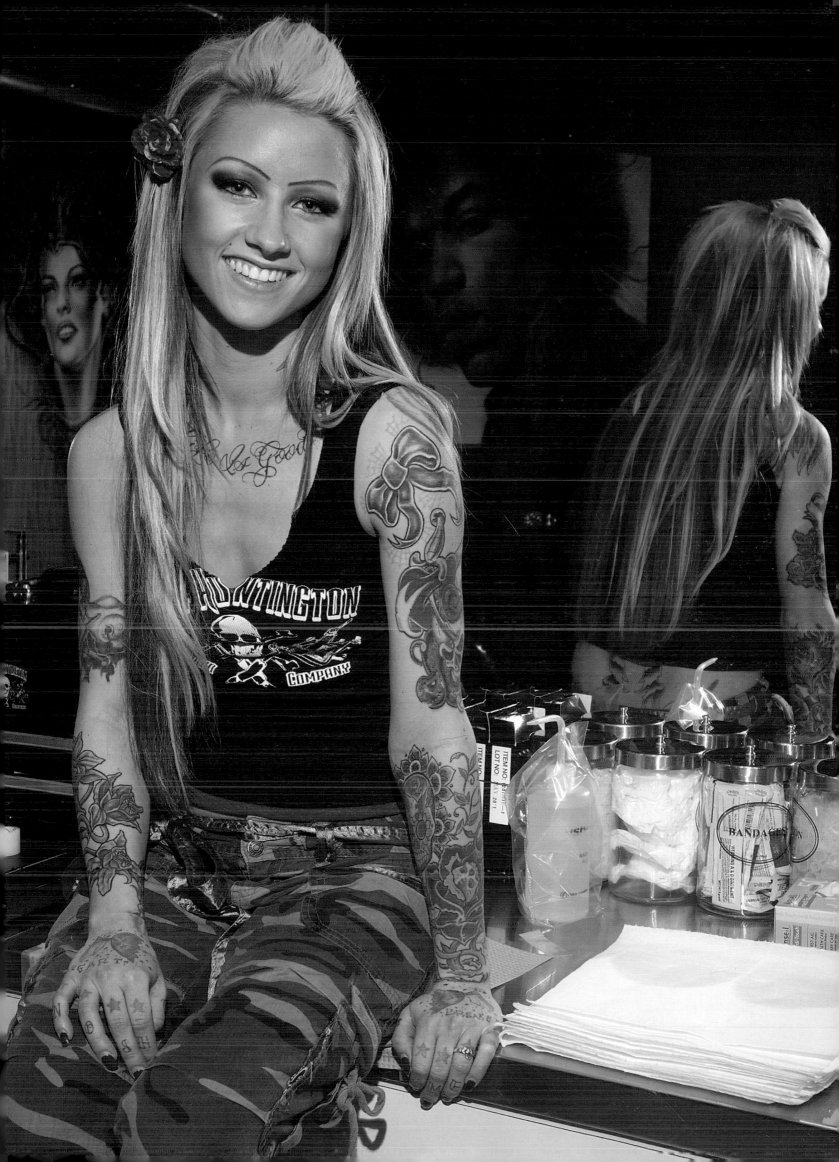

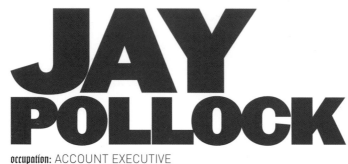

JAY POLLOCK

occupation: ACCOUNT EXECUTIVE

artist: JESSE SMITH, HART & HUNTINGTON TATTOO

My first experience with tattoos came in a small tattoo shop on the island of Maui when I was twenty-three years old. I had just gotten married, and my wife and I were on our honeymoon and decided to commemorate our love by getting matching tattoos. We chose the Japanese kanji symbol for heaven. I got mine on my left bicep and she got hers on her upper thigh. It was just a stupid little symbol but it meant something to both of us.

But a year or so later we ended up going through a painful divorce. I needed to pick up the pieces of my life. I decided to take a trip to Las Vegas to clear my head and, of course, got drunk. So there I was at the Hard Rock Hotel pounding drinks when the bartender says to me, "Why don't you just move out here?" Two weeks later I returned to stay. The bartenders at the Hard Rock hooked me up with a job until I could find something more solid.

Shortly after moving to Vegas I met Jesse Smith, an artist at Hart & Huntington. I told him I was looking for a tattoo that would symbolize the beginning of a new chapter in my life. I was out of LA and my ex-wife was behind me. My focus was on the future. One day I was in the gym when the song "Moving Forward" by Hoobastank came on over the radio. It became my theme, Move Forward with No Regrets. That inspired me to create my new tattoo.

The centerpiece of my design is a huge cross. It doesn't represent religion, but faith. Because I have to keep the faith. Beneath it I have a musical clef because of my passion for music. If it hadn't been for music I don't know if I could've gotten through my divorce. At my darkest hour, I would listen to the song "Terrible Lie" by Nine Inch Nails over and over. I was angry at God and angry at the world but I was able to get through it with music.

Today things are going well for me. I met someone new and am working as an account executive. I'm moving up in the corporate world and finding out who I really am. My eyes are always toward the future.

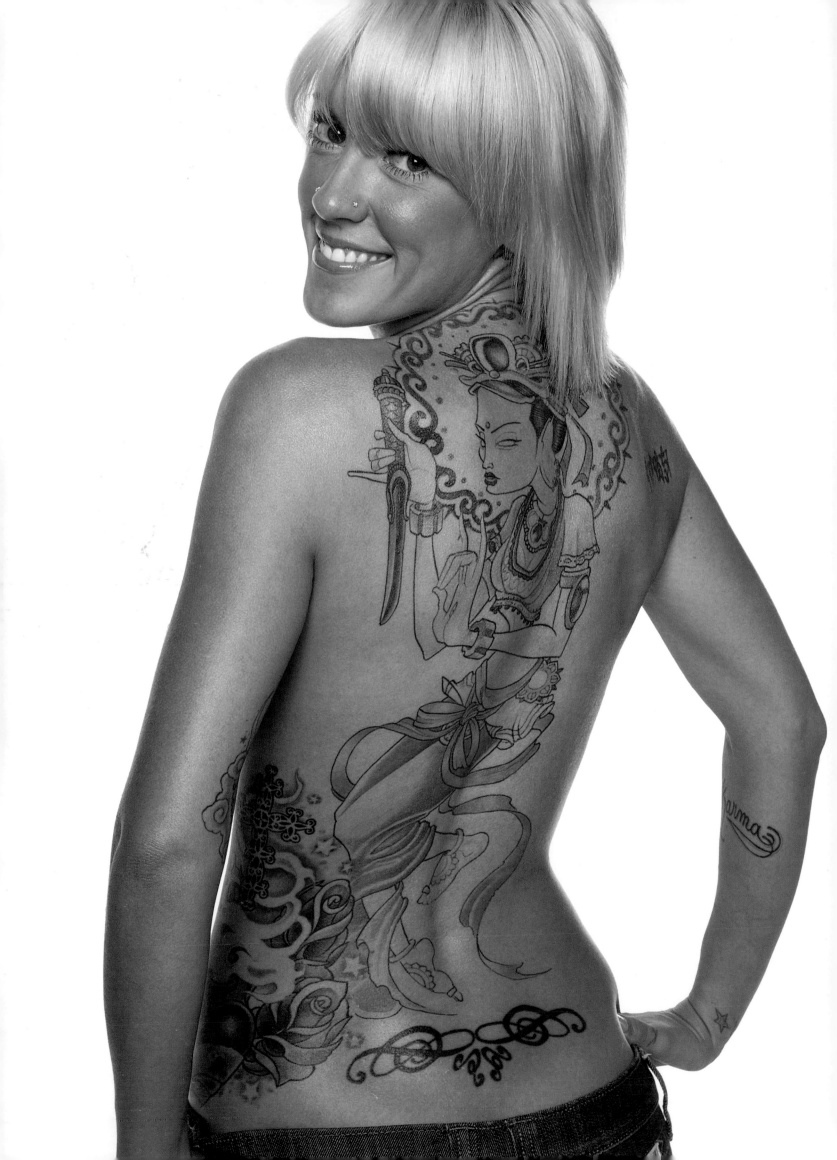

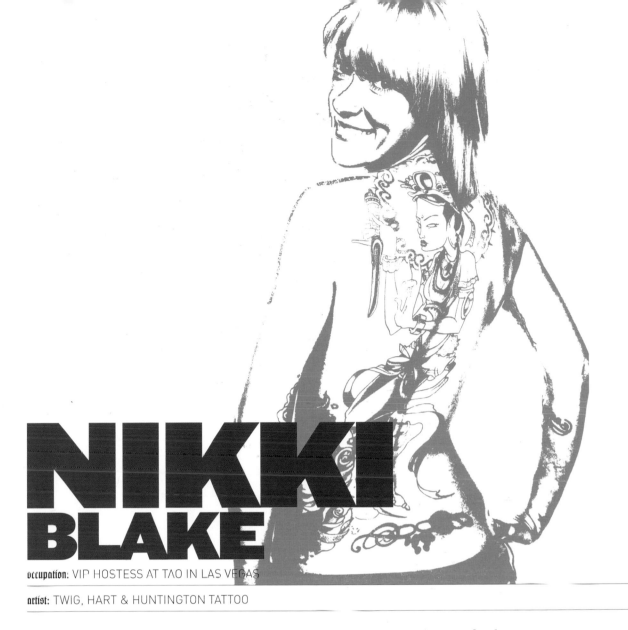

NIKKI BLAKE

occupation: VIP HOSTESS AT TAO IN LAS VEGAS

artist: TWIG, HART & HUNTINGTON TATTOO

The thing I love most about tattoos is how sexy they make me feel.

It's definitely about the sex for me. When I began working on the geisha on my back I started wearing backless shirts to show it off, because I don't get tattoos to hide them.

I'm a real girly girl so I never want my tattoos to take away from my femininity or my sexiness. My mother and I are really close, and she always said that my back was the sexiest part of my body, so before I got my first tattoo—a clef on the small of my back because of my love for the piano—she asked me why I wanted to do that to my body. But when she saw how artistic the design was she came around.

Tattoos fit my personality because I love being a wild and crazy girl. I love to be daring, and I've broken so many bones I can't even remember them all. In 2006 I went skydiving, which was a complete adrenaline rush. But on the way home I got into a motorcycle accident when a truck pulled out in front of me. I flipped over the handlebars and flew over the truck, breaking my ankle when I landed.

I definitely get my adventurous spirit from my mother, who's been riding a Harley for years. When she turned forty-two we got matching tattoos, the cancer sign on the back of our necks. It's something we've bonded over. I've always been a firm believer that your family, for better or worse, plays a huge part in what path you choose in life.

"I'M A REAL GIRLY GIRL SO I NEVER WANT TATTOOS TO TAKE AWAY FROM MY FEMININITY OR MY SEXINESS."

Growing up I was the normal all-American girl. I did well in school, played the piano, and ran track. I was really fast in the 4 x 200 relay and the 400-meter relay. My family moved to Las Vegas from Niagara Falls when I was five, and I've been here ever since.

When I was eleven years old I was fascinated by a book of designs I found in the school library. I would stare at the intricate beauty of the shapes for hours. But the thing I most remember about the book is the picture of the author. She had this badass tattoo sleeve on her right arm, and I thought she was so cool. I knew I had to have that.

I was really into piercing in my teenage years, so that kind of occupied me because you can't get tattoos until you're eighteen. But my mom was so cool she let me get my nose pierced at thirteen.

My little sister is eleven years old—the same age I was when I discovered tattoos—and she's a big part of my life. She's a little version of me. When she was nine I put lipstick on her and had her kiss a napkin. I then had her lips tattooed on the inside of my left bicep. It's definitely my favorite tattoo.

Tattoos will always be a huge part of my life. They're who I am, and they come with the package.

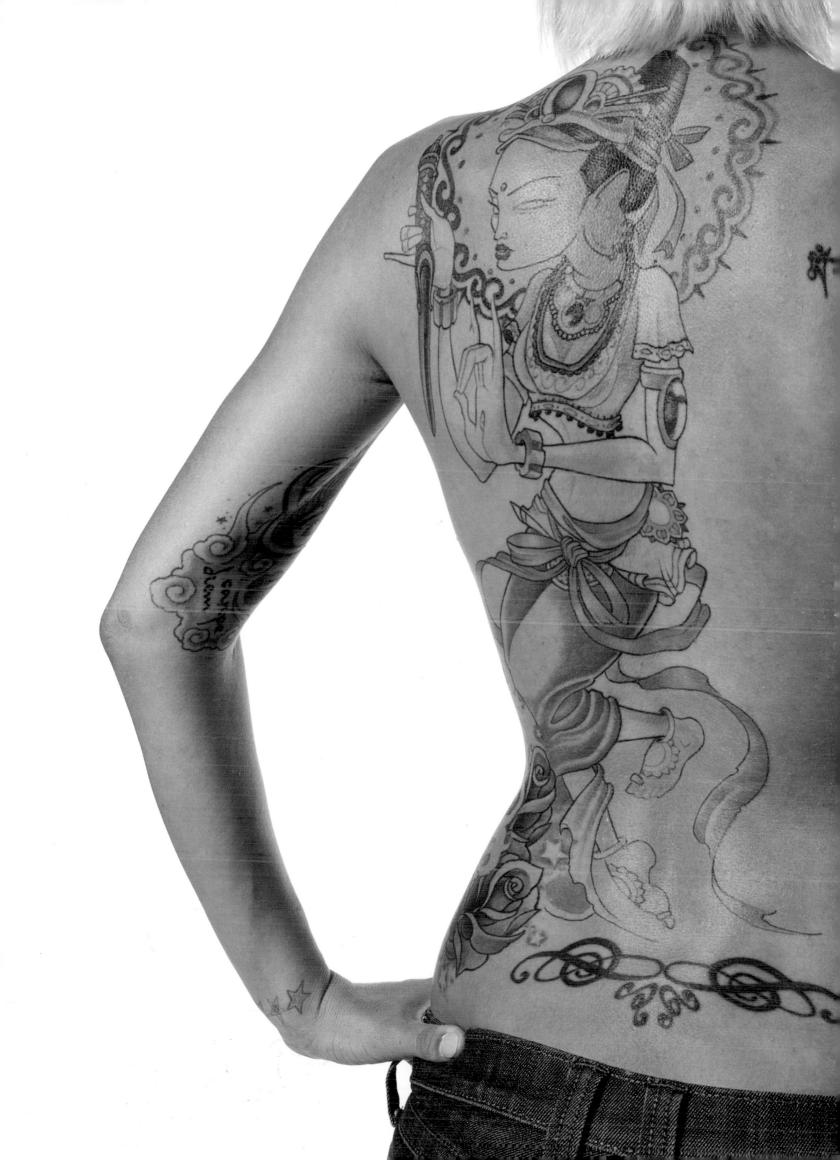

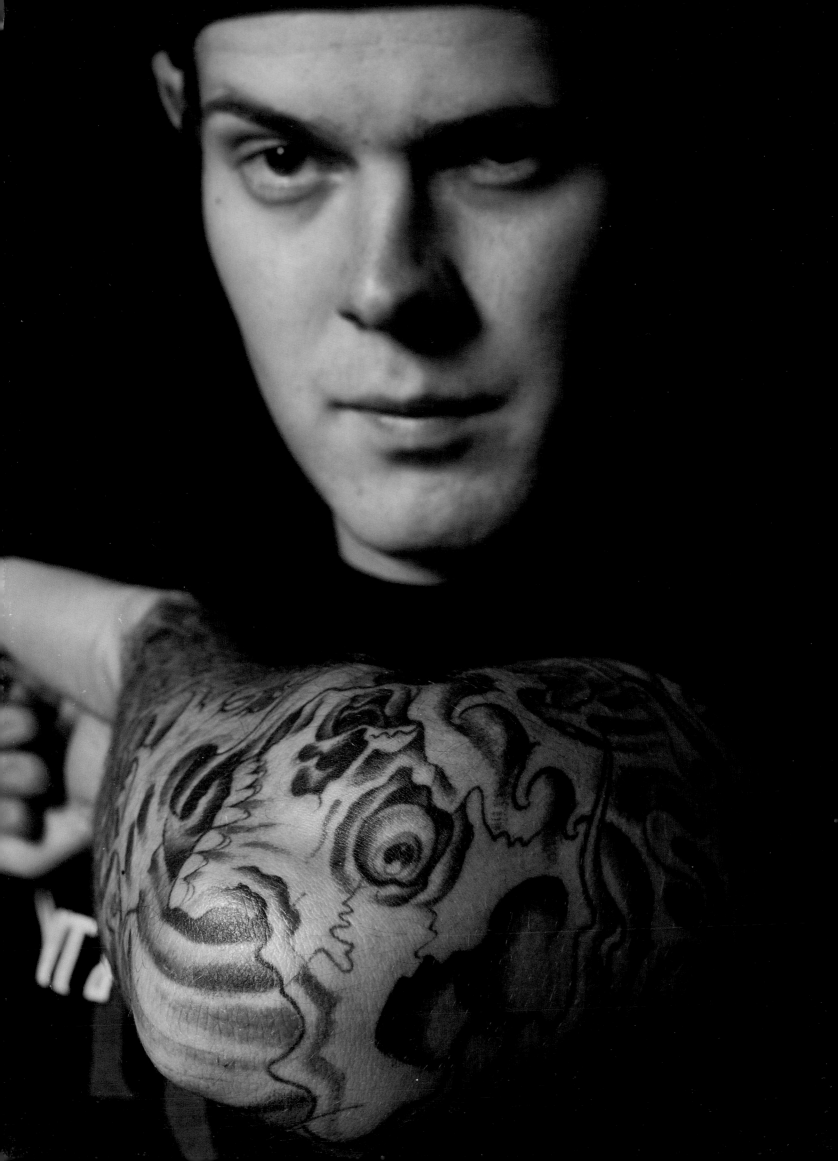

AARON JOHNSON

occupation: SHOP ASSISTANT, HART & HUNTINGTON TATTOO

artists: MERDOK, HART & HUNTINGTON TATTOO; JIME LITWALK,
HART & HUNTINGTON TATTOO; UNCLE JOHNNY,
HART & HUNTINGTON TATTOO; KENT KELLEY

born and raised: CHEYENNE, WY / LAS VEGAS, NV

first tattoo: BIKE CHAIN

passions: BIKES, DIRT BIKES, GUNS, AIRBRUSHING

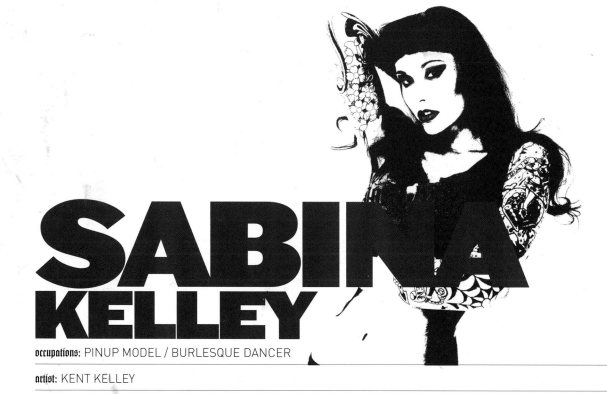

SABINA KELLEY

occupations: PINUP MODEL / BURLESQUE DANCER

artist: KENT KELLEY

People would never guess it, but I am a mom. My kids are five and three and are fascinated with my tattoos. They draw all over themselves with Magic Markers and say they want to get tattoos when they're old enough.

On my left arm I have a pinup girl, a skull in a rose, cherries, a black widow, a Kewpie doll with an ax in its head, a bombshell with my daughter's name on it, and a pirate ship and anchor with my son's name. My right arm is all traditional Japanese themes: a geisha, a black panther, cherry blossoms, and a lotus. Several years ago I went to Japan to be tattooed by the legendary artist Horitomo. I'm very picky about my tattoos and usually take a long time deciding what to get. Placement is really important to me because I like a certain kind of symmetry.

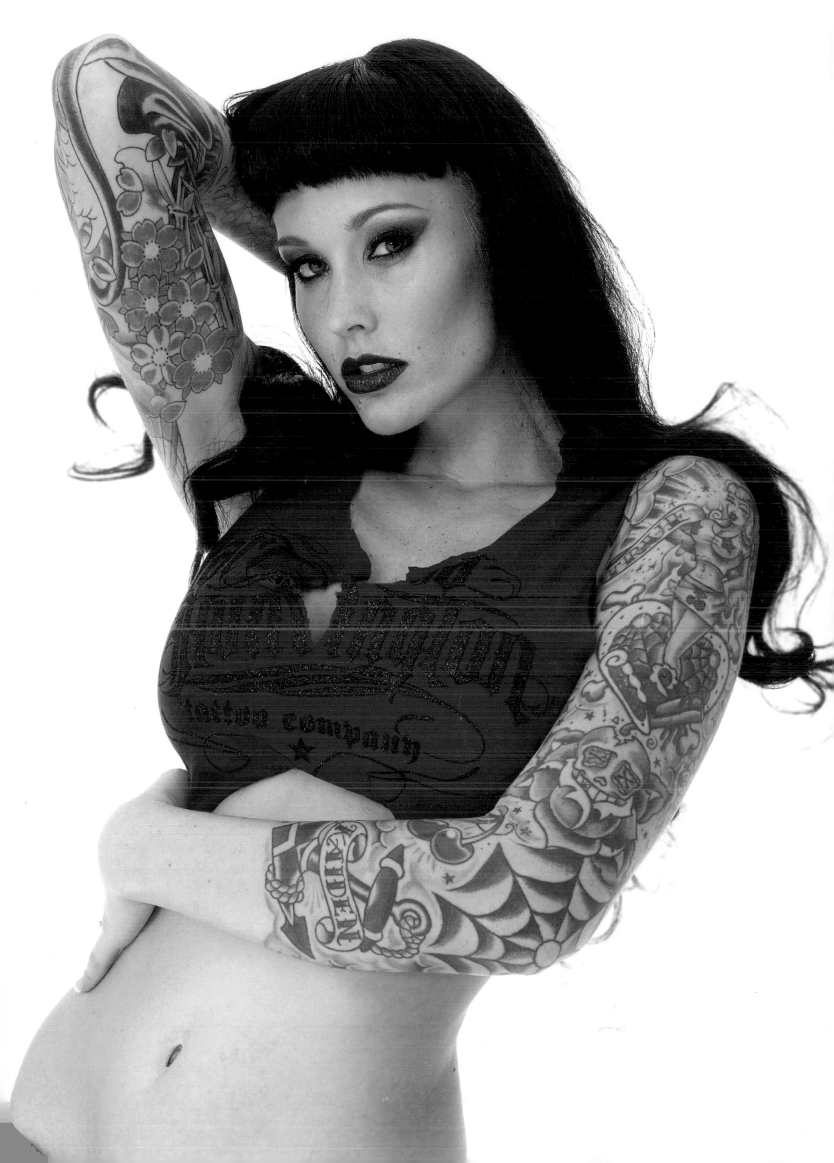

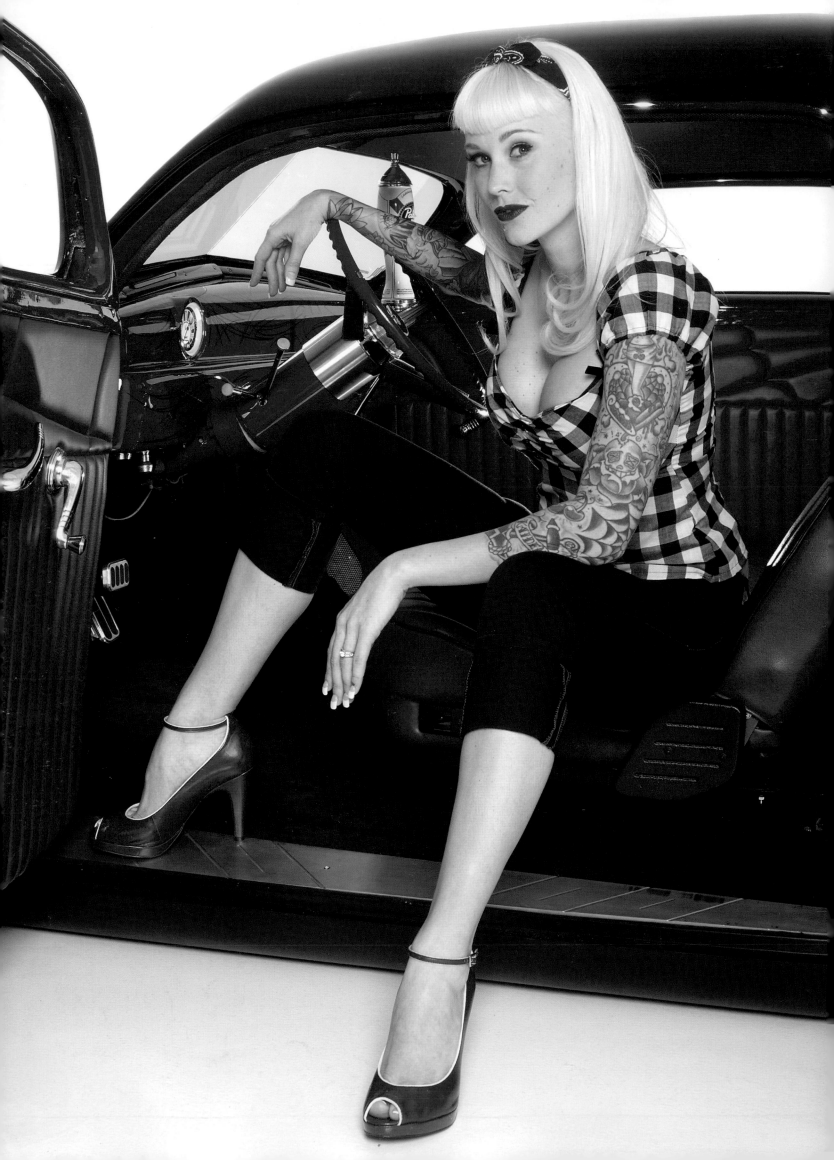

showgirl
no tattoos

I definitely get a lot of stares from the other parents when I pick up my kids from school. Most of them have never seen tattoos up close, so they want to examine them and touch them to see how they feel. They have their own impression of tattoos, but they've been really cool about it. The only negative comment I've gotten is, "You're so pretty . . . why would you do that to yourself?"

I hate to think tattoos are becoming a mainstream trend. That's embarrassing. Anyone who would get a tattoo because of a trend is just lame. They should always mean something. All of my tattoos have meanings and stories behind them, but I'm not telling what they are.

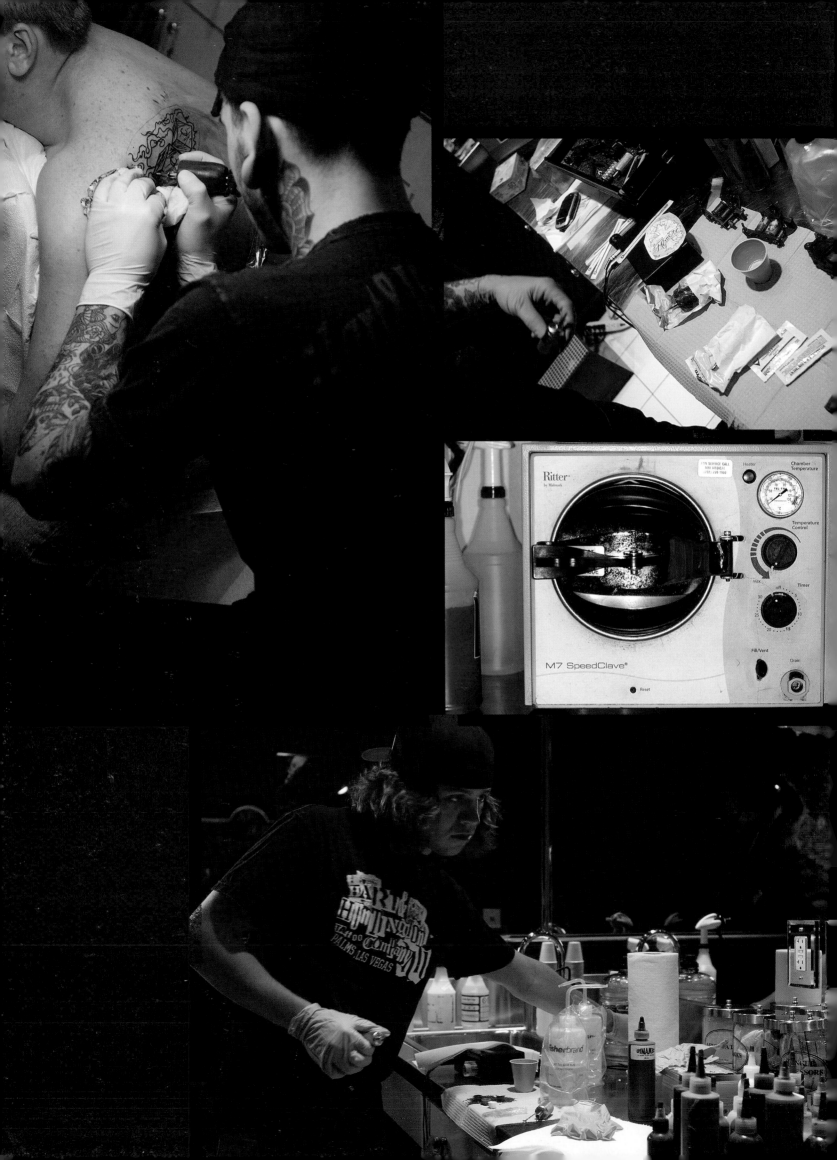

KEEPING IT CLEAN WITH UNCLE JOHNNY

When I got my first tattoo more than twenty years ago it was in a cramped booth just a few feet from another artist. In between the chairs was a bucket of warm water and a sponge that both artists used to wipe their clients down. The water wasn't changed until the end of the day, at which point it was a murky brown, swimming with blood, sweat, and dust. The artist would use the same needle the entire day. If you weren't the first one in the chair when the shop opened, chances were you would've had your tattoo done with a contaminated needle.

You can be sure those days are long gone. With all that we now know about diseases, the tattoo industry's biggest priority is sterilization and sanitation. I've talked to friends who work in hospital emergency rooms who say they aren't half as clean as a tattoo shop. As a tattoo artist I take every precaution to see that my workstation is a germ-free environment from before the customer sits down until he walks out the door.

Before I begin I'll wash my hands with our strong all-purpose "green soap," then put on a pair of latex gloves. (I go through several pairs of gloves per job.) The gloves are more for the artist's protection than the client's, since you're dealing with their exposed blood. Then I'll use a germicide to thoroughly wipe down the counter, chair, and armrests. I always use a brand-new needle and load it in the tattoo machine. As I'm working I constantly wipe down the skin with A & D ointment (a salve containing vitamins A and D). The ointment lubricates the skin and helps keeps it clean during tattooing, which means the needle can make more precise punctures.

Nevada has some of the strictest health codes in the country regarding the tattoo industry. It pays to keep your station spotless at all times—you never know when the state health inspector will walk through the door. They'll check the cleanliness of all surfaces and make sure needles are disposed of properly and enough antibiotic soap is in stock. They'll also inspect the autoclave and ultrasonic (sanitizing machines) and even go in your toolbox, so spray bottles must be labeled accurately and bagged up.

ASHLEY SCHRADER

occupation: DANCER

artist: JESSE SMITH, HART & HUNTINGTON TATTOO

Talking about my tattoos always takes me back to my rebellious teenage years. The memory of my first tattoo is not a good one. I was trying to prove just how rebellious I could be when I walked into a shop on Venice Beach when I was fifteen (the legal age is eighteen) and came out with the lamest fairy tattoo you've ever seen. It was not cool. I don't know what I was thinking. I decided to wait a while before getting my next one since the rebellious way didn't work out so well. And besides, I wasn't always rebellious. I would say I had a pretty normal upbringing.

I've been athletic my whole life. My dad signed me up for tae kwon do when I was four and I competed for twelve years, making it to second-degree black belt by the time I was thirteen. I traveled the country competing in tournaments and won awards for form and technique. I've even broken wooden boards and bricks with my hands and feet and been in *Black Belt* magazine many times. But when I turned sixteen I started to get tired of it. I was more interested in cheerleading, so I went out for my high school team and eventually cheered all four years of high school.

When I graduated from high school I decided college wasn't for me so I needed to get a job. I wanted to make a lot of money really fast so I became a dancer. I've been dancing for three years now at the Spearmint Rhino in Las Vegas. I specialize in pole dancing, which a lot of girls are afraid to do because it requires some real strength and athletic ability. Depending on the move, I use my arm and leg strength or core muscles to pull off my tricks. My years of tae kwon do training are really paying off.

Around the time I started dancing, I got a pinup girl smoking a thin cigarette while sitting in a martini glass on my left side. It represents my crazy, glamorous Vegas lifestyle. On the other side I have an angel sitting on a stack of hundred dollar bills. She represents my future: happiness and wealth.

Between the two girls, on the small of my back, are the words FUCKIN' ROYALTY beneath a jeweled crown. I definitely see myself as royalty. I'm the queen bee of my own little high-maintenance world. And the good thing about that tattoo is that it covers up the fairy.

I plan to continue working on my tattoos. Mainly I'm going to focus on my sleeves and begin working on a chest piece. Until then I'll just be living my life according to my motto—CARPE DIEM, which is tattooed in cursive across the top of my back. I think it's pretty self-explanatory—I live my life like every day is my last. What did I do today? I got a massage, seaweed wrap, and pedicure. See, I told you!

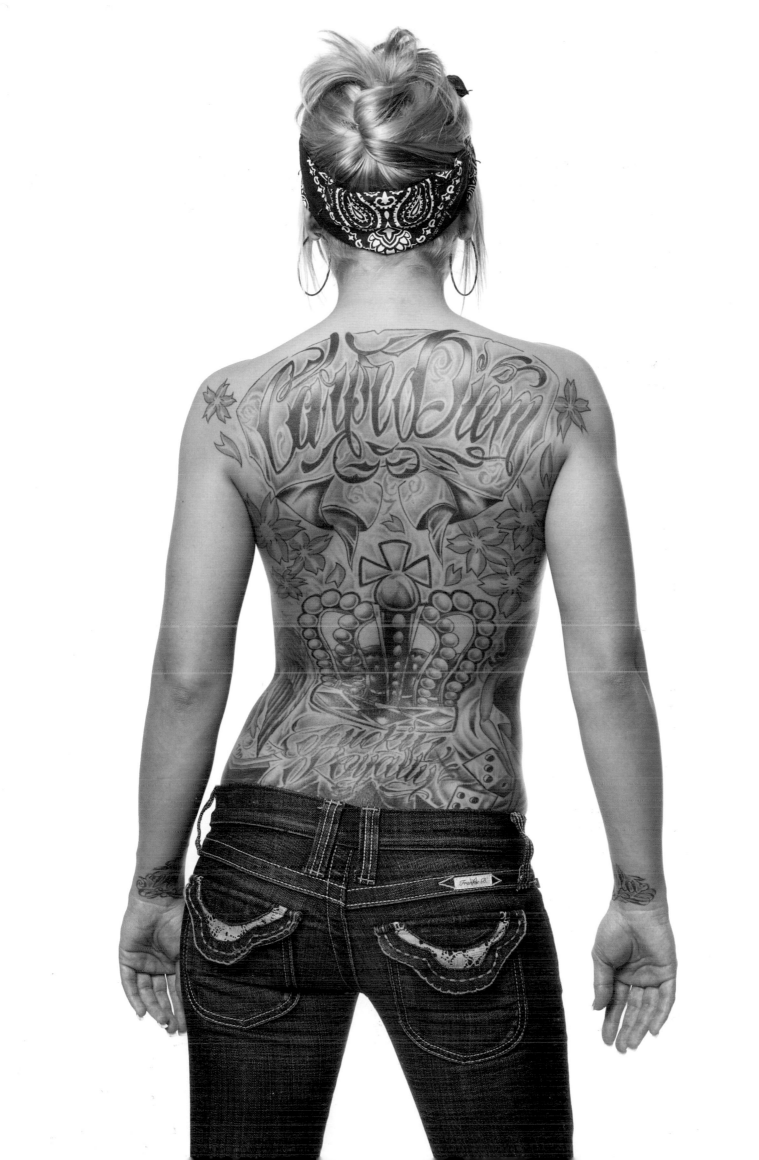

BLAINE
ROCKE

occupation: LIMO DRIVER

artists: TWIG, HART & HUNTINGTON TATTOO; BLANCO, HART & HUNTINGTON TATTOO; TEMPT

My first job was as a bellman at the Las Vegas Hilton in the 1980s.

Back then the bellman would drive celebrities where they needed to go. One of the first people I drove was Sammy Davis Jr. He walked out of the hotel wearing this white suit, and I went around to open the door for him. He looked at me and said, "What are you doing, man?" I was just twenty-one, so I didn't know if I had made a mistake or something. He said he wanted to be a normal guy and rode up front with me. He rolled the window down, and we talked as if we had been friends for years. I was blown away.

Soon after I was driving people like George Burns, Bob Hope, and Eddie Murphy. With that kind of excitement I knew this limo driver thing was what I wanted to do. I started getting tattoos at thirty-five and it's been an addiction ever since. I wanted to go with a Vegas theme because of my love for the city. I've got the Las Vegas welcome sign with 1963 on it, the year I was born. Vegas has changed a lot since the Rat Pack days, and so has the clientele. I drive a lot of hip-hop guys now. They've all been in the back of my limo: Lil Jon, LL Cool J, Snoop Dogg. They love Vegas, and I'm the man to call.

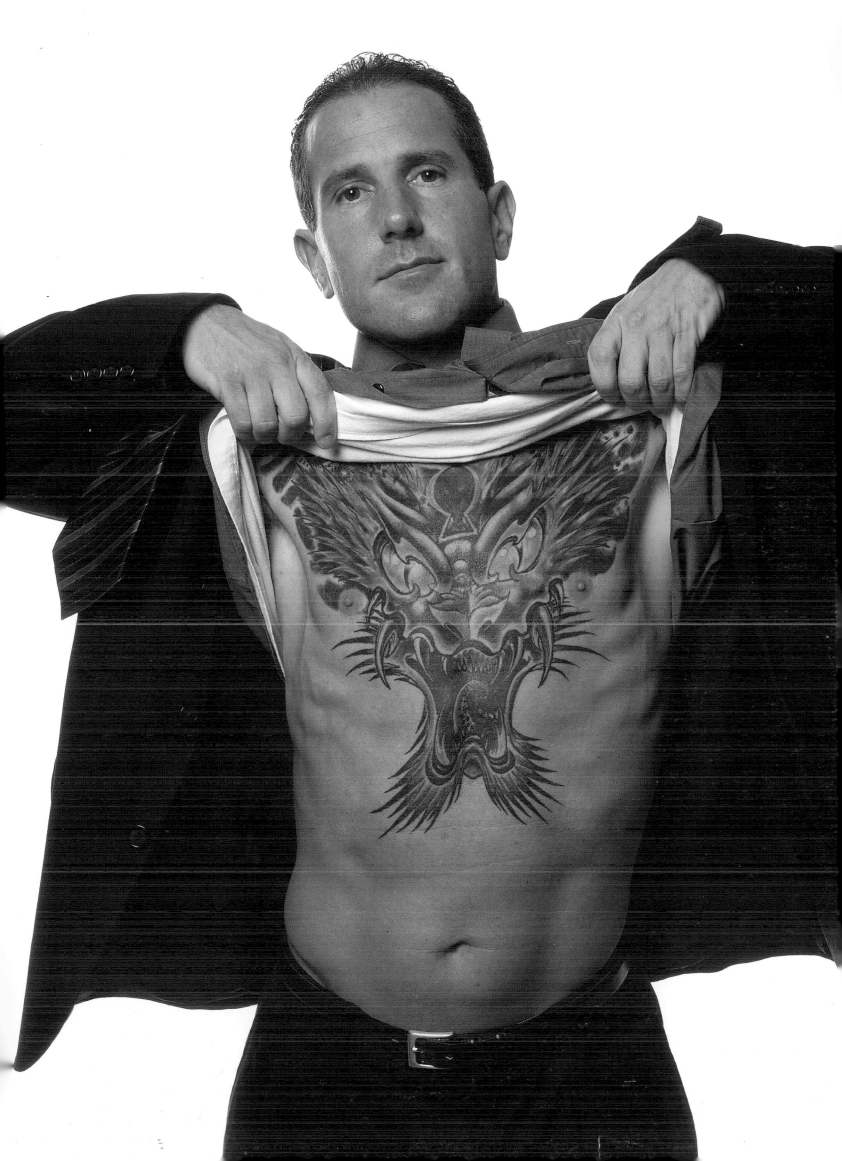

"I'M LAS VEGAS TO THE CORE, SO THAT'S WHAT A LOT OF MY TATTOOS REPRESENT."

vegas

Limo drivers don't get pensions, 401(k)s, or benefits so I'm earning money for retirement by driving every day. The happy and sad masks tattooed on my back mean I'm happy when I'm making money and sad when I'm not. And if I'm going to stay happy I've got to hustle. I've also got a pair of eyes watching my back, because in this town you always need someone looking out for you. On my chest I have a dragon tiger protecting the key to my heart because I've had my heart broken and I want to make sure it doesn't happen again. On my left leg I've got NHRA for the National Hot Rod Association, because drag racing is my favorite sport.

I wear a suit when I'm driving and you would never be able to tell how much ink I have. My grandmother is eighty-seven and still doesn't know. I have lunch with her every week, and she'd disown me if she found out. But I'm forty-three going on eighteen, and that's the problem I guess. I'm still the same person, just my skin has changed.

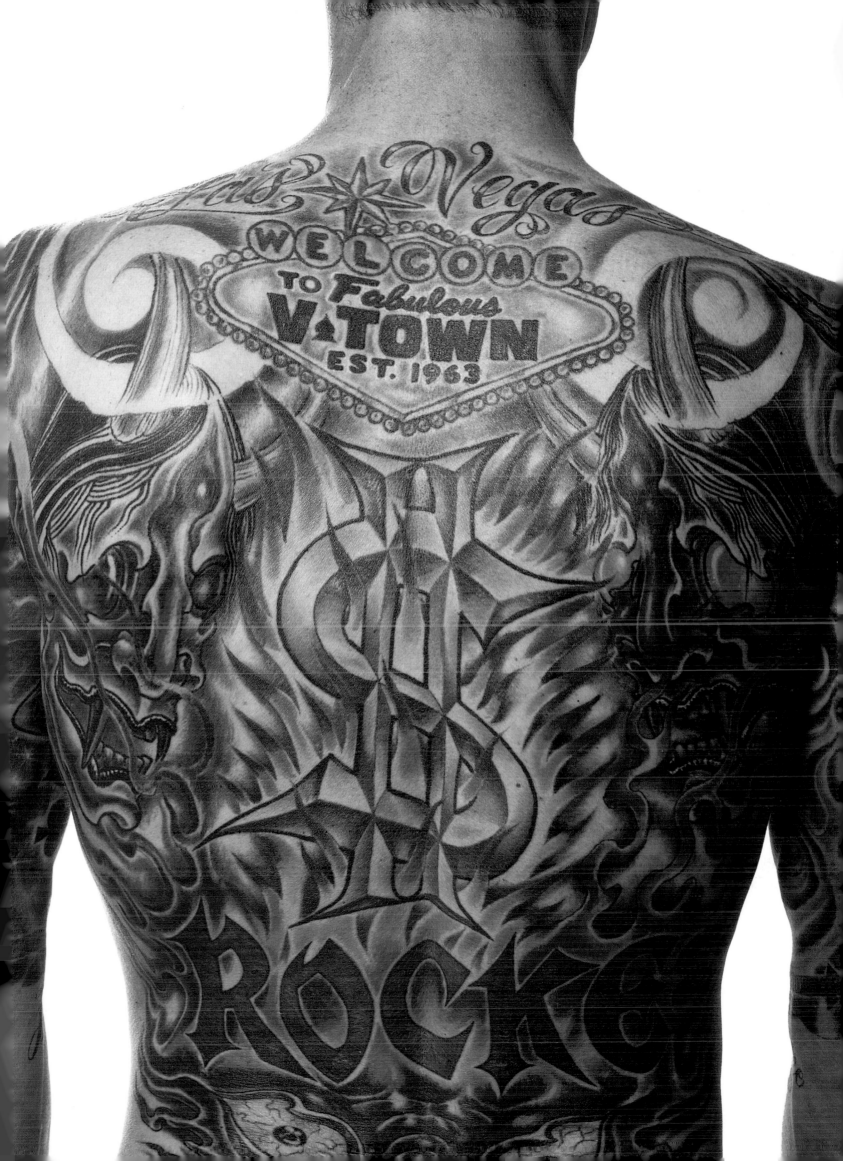

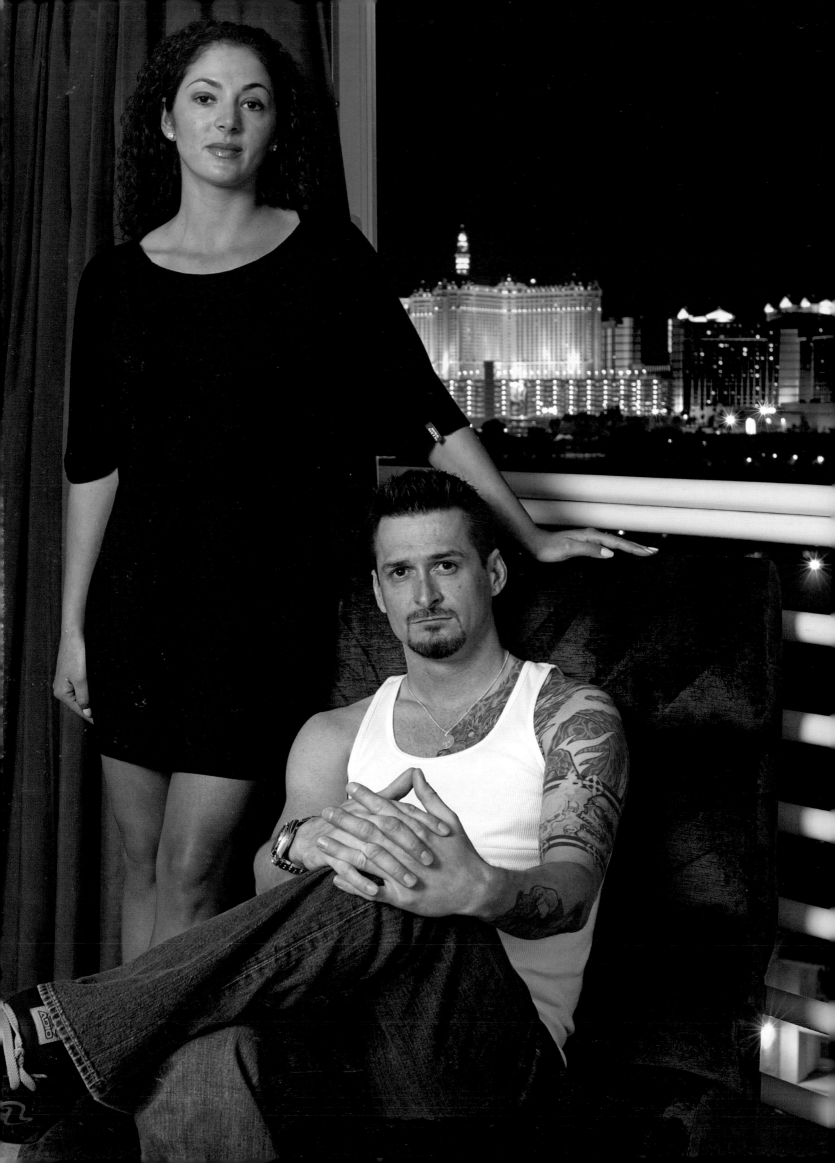

JOEY HAMILTON

occupation: TATTOO ARTIST, HART & HUNTINGTON

artists: DEANO COOK; TONY CIAVARO; JASON STEPHAN

born and raised: WOODWARD, OK

first tattoo: SKULL ON ARM

number of tattoos: ABOUT 8

best tattoo J've seen: A BIRD GOING INTO WATER, CATCHING A FISH—BY DEANO COOK

prior career: U.S. AIR FORCE FOR 10 YEARS

most time spent on one tattoo: ABOUT 80 HOURS OVER ONE YEAR

specialty: PHOTO REPRODUCTION, REALISTIC

passions: OAMBLINO, SPORTS, TRAVEL

CLARK
NORTH

occupation: TATTOO ARTIST, HART & HUNTINGTON TATTOO

artists: STEVE GADOY; MARK MAHONEY; RICK WALTERS; MIKE BROWN; JACK RUDY; KARI BARBA

When I was five or six our landlord was covered in tattoos.

I remember thinking, "This is what a real man looks like." On summer evenings we'd sit on our front steps and my mom would get him to make his chest tattoos dance by flexing his pec muscles. I used to draw the things I saw on him on myself— a pinup girl, a cross, a skull, and an eagle. Soon my friends wanted me to draw on them too. Seeing my little hand-drawn blobs running around the neighborhood made me so proud. It was the first time I can remember experiencing pride, and I associated that with tattoos.

I do a lot of portraits, and when you're lining up to do fifteen or sixteen hours of work on one person, there needs to be some kind of chemistry. You want to make your customer feel comfortable. I'm not saying make dinner plans afterward, but it's up to you as a tattoo artist to create a comfortable environment. The flip side is that if you're too nice people want to hang out with you and become your buddy. I just want to make sure personalities don't clash because I don't want to become somebody's bad memory.

There are several areas of the body that I won't tattoo if I don't know you: feet, hands, neck, and face. Those are reserved for friends. There used to be a time when only a tattoo artist had the privilege of getting those areas tattooed. It was a badge of honor. You asked to have

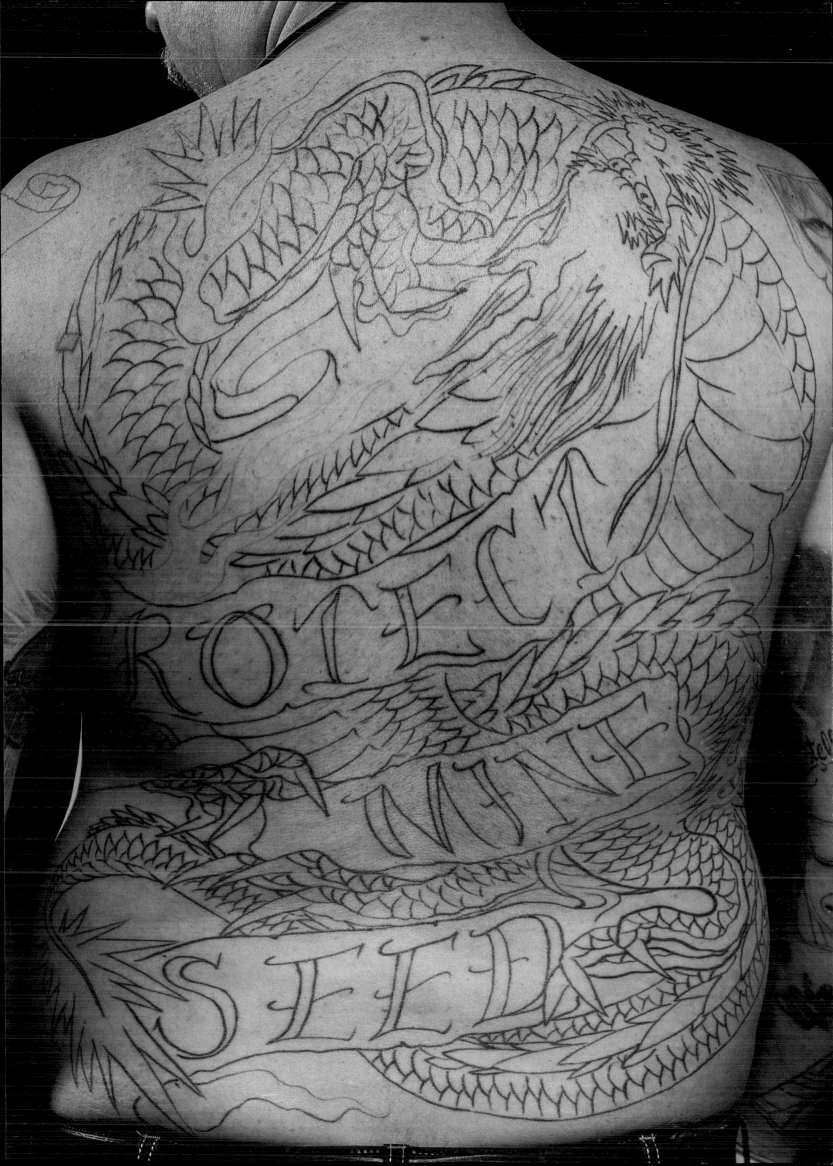

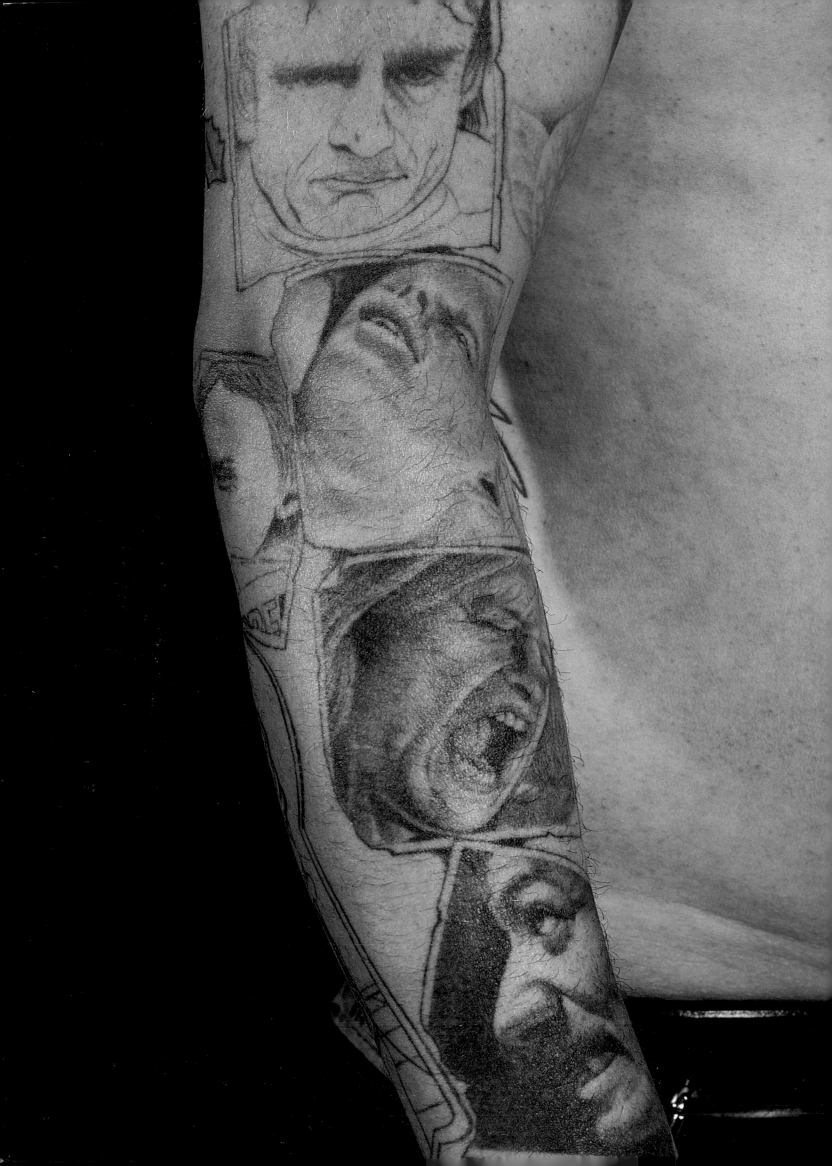

i am a craftsman

your neck tattooed, and they asked you what shop you worked in. Now anyone can walk in and get his neck done. Times are changing, I guess, but I'm still stuck in the old school.

I'm tattooed from my collarbone to my knees, but some of my favorite tattoos are the faces on my right forearm. The pictures are from an old art magazine I saved from when I was a kid. One face is coughing, another is having a nightmare. The expressions have always stood out to me.

I've been tattooing for sixteen years and the thing I love most is that it's something to do with your hands. It's one thing the computer will never be able to do. I believe it's always been a high art form, but I consider myself more a craftsman than an artist. There's no more precious canvas than the skin, and you would never decorate it with anything less than the best art.

FAVORITE TATTOO: Chest eagle
MOST TIME SPENT ON ONE TATTOO: 50 hours—
4 to 6 hours per session
MOST MEMORABLE CLIENT: My wife
FAVORITE STYLE: Traditional—Japanese and American
PASSIONS: Being a father, painting

TERRI NORTH

occupation: HOTEL RESERVATION ASSOCIATE

artist: CLARK NORTH, HART & HUNTINGTON TATTOO

When I was young I never really liked tattoos. I thought that people only got them because they wanted to seem cool or badass. My interest started to bubble when I met my future husband, who was a tattoo artist. His love of tattoos helped me see them in a whole new light, and I grew to appreciate them as pieces of art. My first tattoo was a fat little cherub on my shoulder. It didn't hurt as much as I thought it would, so I decided to get more. All kinds of ideas started swirling in my head. I decided I wanted my whole back done. Clark made me wait a year to be sure it was something I really wanted. When he started on the outline I couldn't believe how much it hurt! So much for not hurting. We had to do the whole outline in one session, and it stretched from the top of my shoulders to the bottom of my butt cheeks. I left mascara stains on the drop cloth. I went home that night with what felt like a big mushy diaper taped to my whole backside. The entire design took five three-hour sessions spread over five weeks. My back piece is just the beginning. Someday I'm looking forward to having a full bodysuit. Maybe by the time I'm seventy. That should give the kids something to talk about.

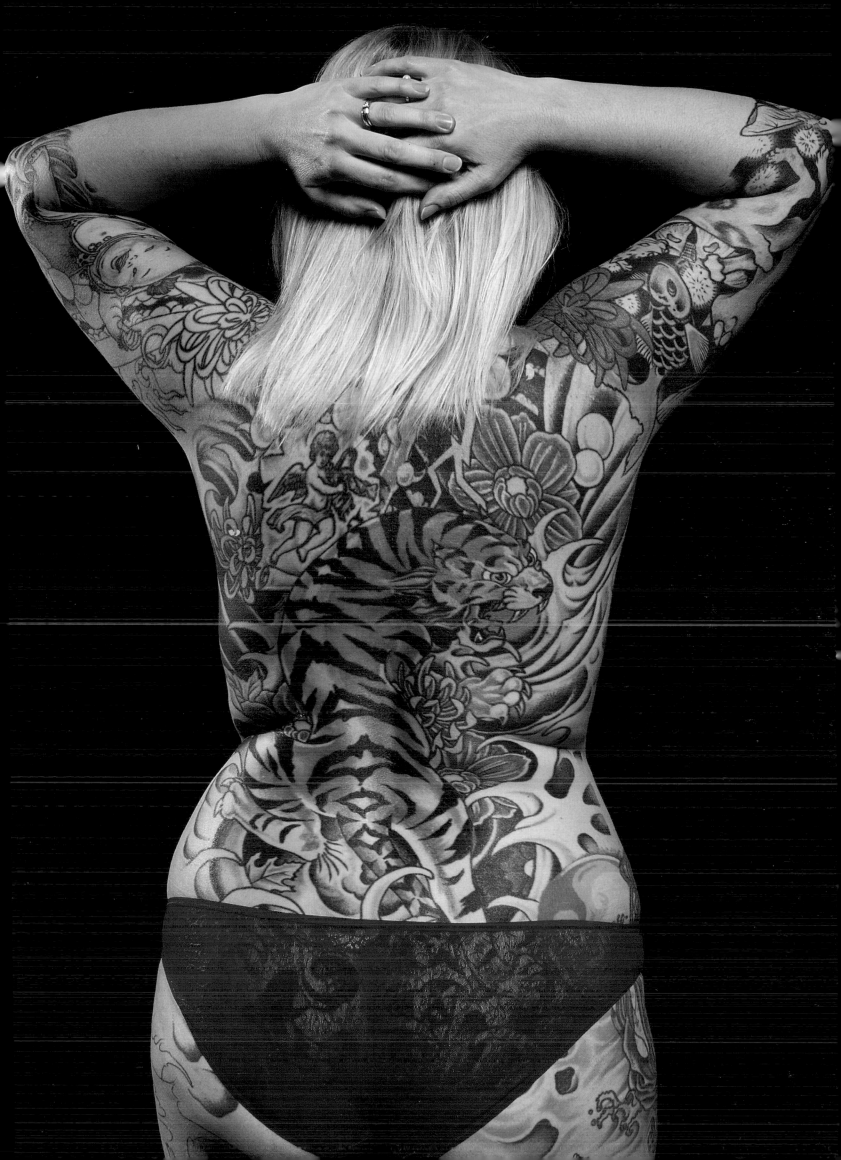

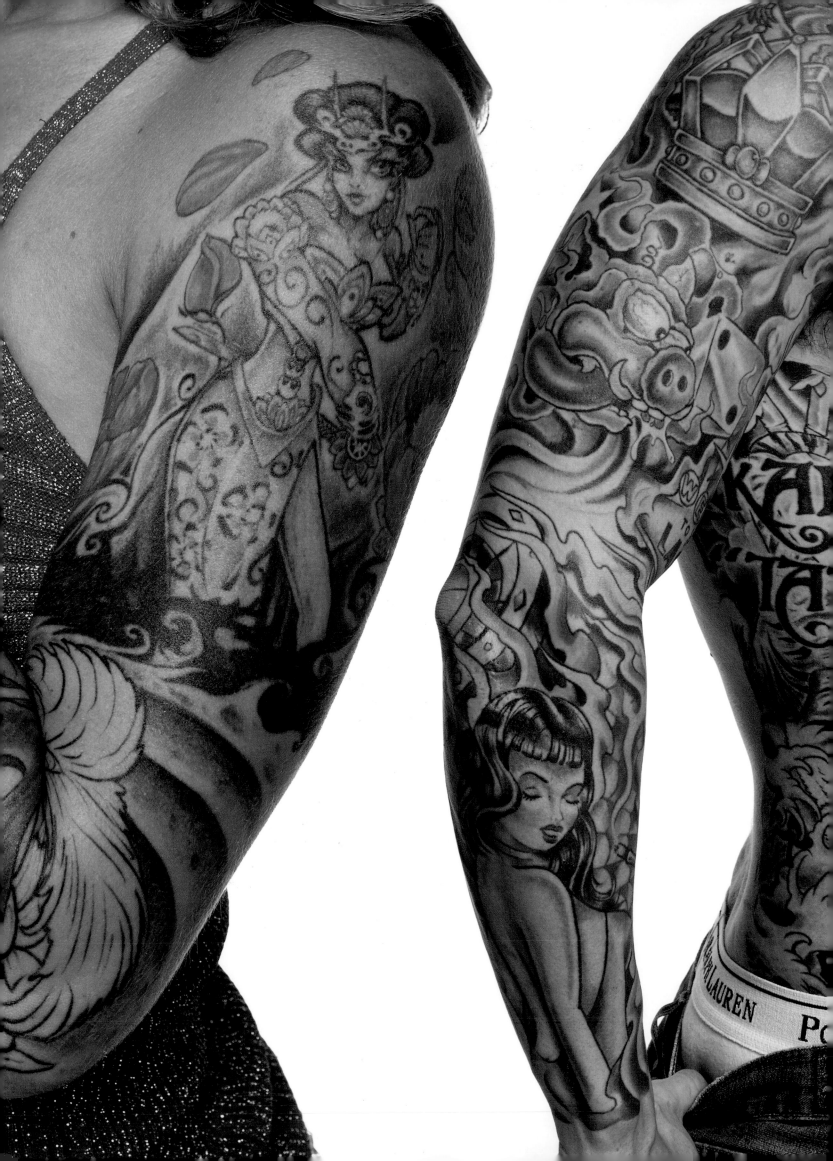

HOW TO CREATE THE PERFECT SLEEVE
WITH CLARK NORTH

Any tattoo artist with an eye for good work can look at a tattoo sleeve and tell whether or not the concept was carefully thought out or just slapped together. Preparation is everything. If a customer wants a traditional Asian theme I know I'm prepared because I've studied Asian mythology and the work of legendary Japanese artists. I cringe when I hear an artist say, "Wow, I've never done anything like that before." That's bad because the skin is the last place you want to practice a tattoo.

After a customer has chosen a theme, we work together to come up with ideas and images that I can turn into a sketch. Once I have a completed drawing to work from I'll study it for a few days to see if it can be improved upon.

Next I'll draw a detailed sketch study, almost like a blueprint, so I can see everything in front of me before I begin. That way I can play with the idea and continue to shape it and make adjustments. Afterward I'll draw right on the skin with an ink pen so I can see how the designs flow on a person's arm. I study their muscle movements, how the skin stretches and whether or not the tattoo bends in a desirable way. For example, a tattoo on the inside of a wrist shows well only in one position—when you hold your wrist straight out.

When I do the outline (the major lines of the tattoo), I'm constantly referring to my sketch. But I'm not bound to it. I'll work freehand and improvise when I feel that will make for the best art.

I want to satisfy the customers and meet their demands, but sometimes I can see that not all of the elements they want are going to flow. Traditional Japanese images such as dragons and koi fish tend to have a natural panoramic flow. You can use water, wind, and other elements to flesh out a design. But with some of the more American themes—naval ships, anchors, eagles, American flags—a lot more work is required to get them to work as a single theme.

When putting together a sleeve it's important to understand that skin is a low-contrast medium. There are no solid blacks or bright whites. For example, if you look at a black velvet painting the colors will appear different from what they are. The black velvet tricks the eye into thinking there is more contrast than there really is. Skin doesn't do that, so I use blacks and grays for rivers and rocks and colors for tigers, fish, and birds.

A sleeve generally takes fifteen to thirty hours (depending on the level of detail) broken up into one- to four-hour sessions. I do the entire outline in the first session. I never consider a sleeve to be totally complete because in many cases a sleeve is part of an even larger piece of work, be it a jacket or a robe.

KRIS OESTERLING

occupation: SHOP HELPER, HART & HUNTINGTON TATTOO

artist: MATT VICTOR, HART & HUNTINGTON TATTOO

born and raised: LAS VEGAS, NV

first tattoo: STARS

passions: MUSIC, DRUMS

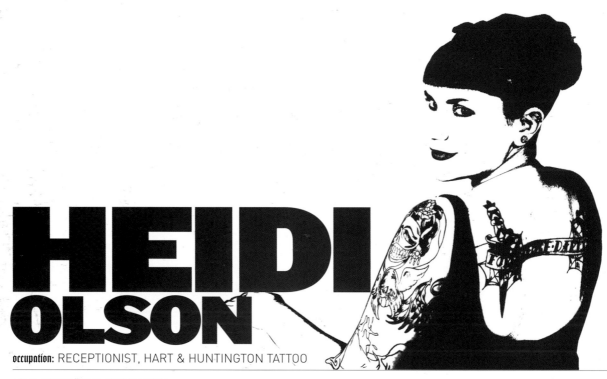

HEIDI OLSON

occupation: RECEPTIONIST, HART & HUNTINGTON TATTOO

artists: NICKHOLE; IRISH MIKE

I am very much into recording all my triumphs and tragedies on my skin. When my tattoos have grown old along with me, when the colors have faded to Monet-like wisps, when the beautiful depictions of my life have distorted and become unrecognizable, I will not regret them. On the contrary, I will appreciate them that much more. For me, while being aesthetically pleasing and empowering, tattoos also represent a carpe diem–style rebellion against a world that is constantly telling us to tone it down and fall in line. The sense of individuality my tattoos give me is so addictive that I plan to keep getting tattoos until I run out of skin.

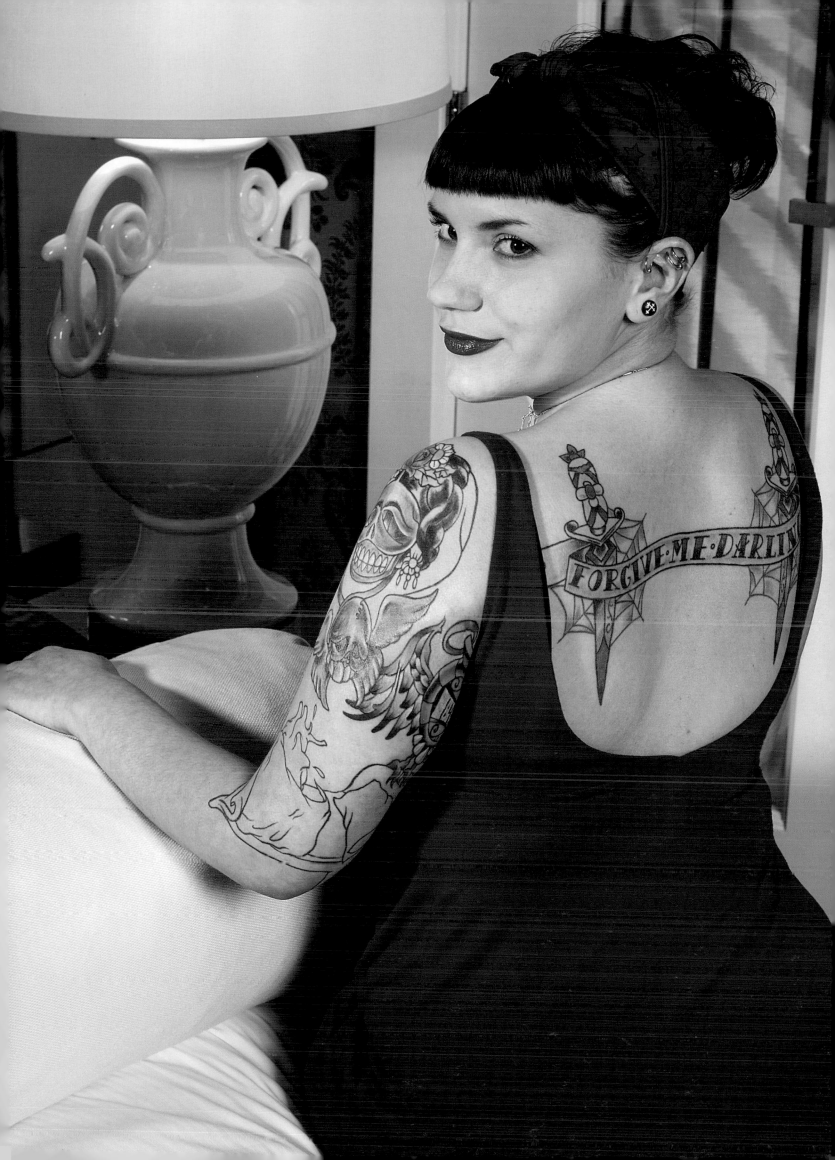

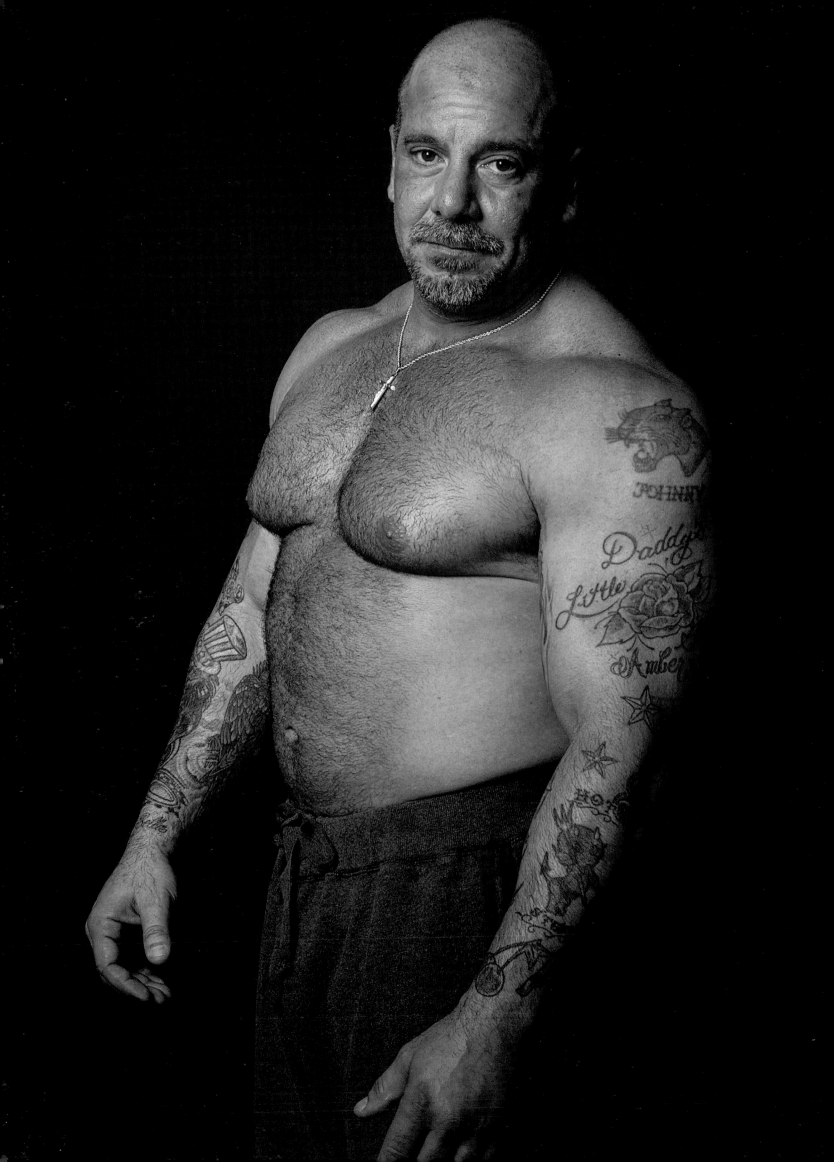

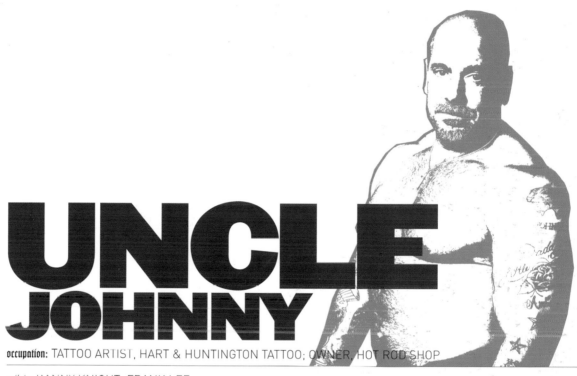

UNCLE
JOHNNY

occupation: TATTOO ARTIST, HART & HUNTINGTON TATTOO; OWNER, HOT ROD SHOP

artists: DANNY KNIGHT; FRANK LEE

Back in the 1970s my dad owned a transmission shop in Florida where my brother and I worked part-time. Once, a guy who owned a tattoo shop brought in his car and said he'd hook me up with a tattoo if I spun a couple of wrenches for him. So I did the work, and he gave me a panther's head on my left shoulder. It's still held up, after thirty years. But it wasn't like my first tattoo launched me into a career in tattooing. I had other career goals in mind.

After high school I played semipro football, and it was a dream of mine to play for the New York Jets. At five nine, 245 pounds, I was a pretty big guy, but I realized I was out of my league compared to the pros. After football I set my sights on becoming an actor. I studied acting for four years. Early on I got a couple of guest spots on *Miami Vice*. A lot of people who were trying to make it would sell their soul to succeed. They'd do drugs and hang out with people they didn't care about just to get parts. But I wouldn't compromise myself, so I left the acting business. For the next twenty years or so my brother, Danny Knight, and I ran several pizzerias and a nightclub. In 1998 we opened Rockabilly Tattoos in Fort Lauderdale.

That's where I fell in love with decorating the human body. I learned from my brother and developed a penchant for working in blacks and grays.

People will always judge you by the way you look, especially if you have tattoos. Back when I was into bodybuilding a woman who saw my tattoos asked me if I had spent time in prison. I just laughed and told her I don't smoke, I don't drink, and I've been married to the same woman for fifteen years. And I've definitely never been to prison.

Tattooing has changed so much in the last twenty years, both the technical aspect and customer care. Thirty years ago when I got the panther, the guy who tattooed me used the same needle on the next six customers. He wiped my shoulder down with soapy water from a bucket and didn't empty the bucket until the end of the day. Today cleanliness and sterilization are a top priority.

Some people are intimidated by my size, but as soon as I sit down, put my glasses on, and start joking with them they turn into putty. Putting someone at ease and making them feel good about their new piece of art is part of my job. They will always remember when and where they got their tattoos. That means they will never forget you.

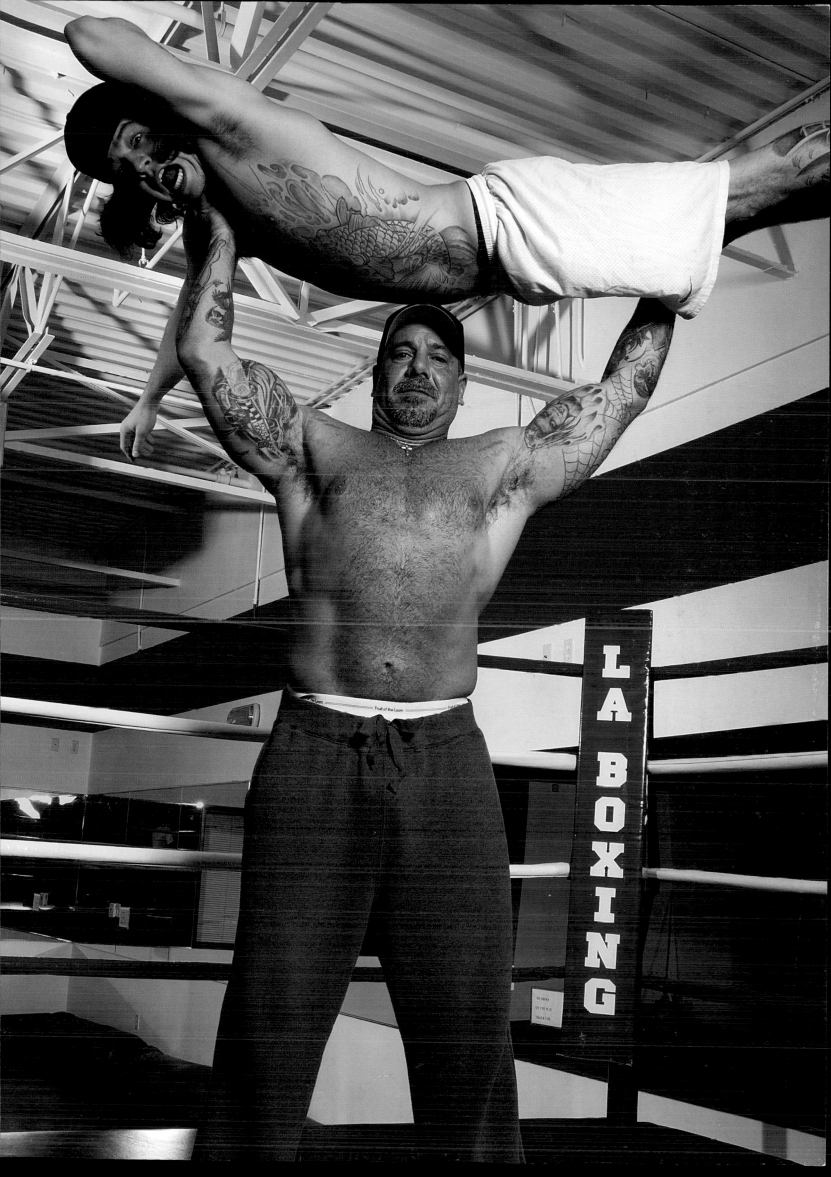

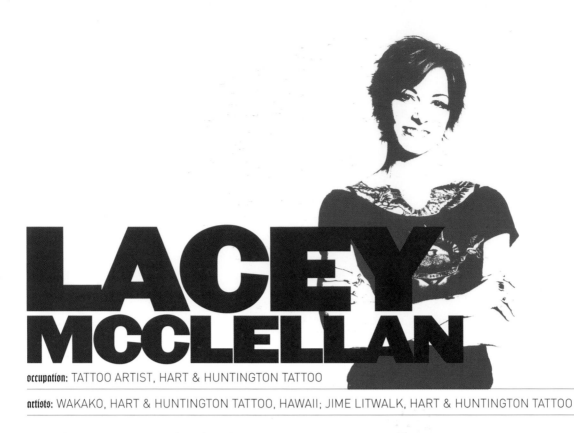

LACEY MCCLELLAN

occupation: TATTOO ARTIST, HART & HUNTINGTON TATTOO

artists: WAKAKO, HART & HUNTINGTON TATTOO, HAWAII; JIME LITWALK, HART & HUNTINGTON TATTOO

Looking back, I was destined to become a tattoo artist. Even as a kid I drew on walls, clothes, dolls, and myself. It just felt natural for me to create art. I'm from a small town an hour south of Salt Lake City where there wasn't much in the way of a tattoo culture, so I didn't grow up around anyone with tattoos. I became interested by reading books and magazines about tattooing.

I started getting tattoos when I was seventeen. My mother took me to a tattoo shop in Salt Lake and waited as I got an eternity symbol on my back. The more I got, the more comfortable I started to feel in my own skin. I don't regret any of my tattoos, but if I had known that I would become so heavily tattooed I probably would have gone in a slightly different direction so they all flow together. I just try to remember that even your mistakes make you who you are. After roughly sixty hours of work I'm nowhere near done. Most people who are heavily tattooed start with their arms because they're the most visible part of your body. I wanted to do the opposite and save my arms for last, so I began with my back, torso, chest, and legs.

Two of the tattoos that mean the most to me are the fire beetle and water beetle I have on my wrists for my parents. I put them there so that I can see them all the time, and when I put my hands together they make one design. But not every tattoo I have has a deep meaning, like the tiger on my leg. To me it just represents pure beauty and nothing more. The largest tattoo I have is a dragon that from the head on my shoulder to the tail by my knee is over ten feet long. It wraps around me four times! Why so big? Why not? While most people fear the permanency of tattoos, that's what appeals to me the most. Everything else in life is so temporary.

People always ask me, "What about when you get old?" I think this is a strange question. I'm going to be concerned less with how I'll look as opposed to how I'll feel. And who you really are has nothing to do with the body you're in. I also hear a lot of "your body is your temple." And that's true, so I put a lot of time and dedication into decorating my temple.

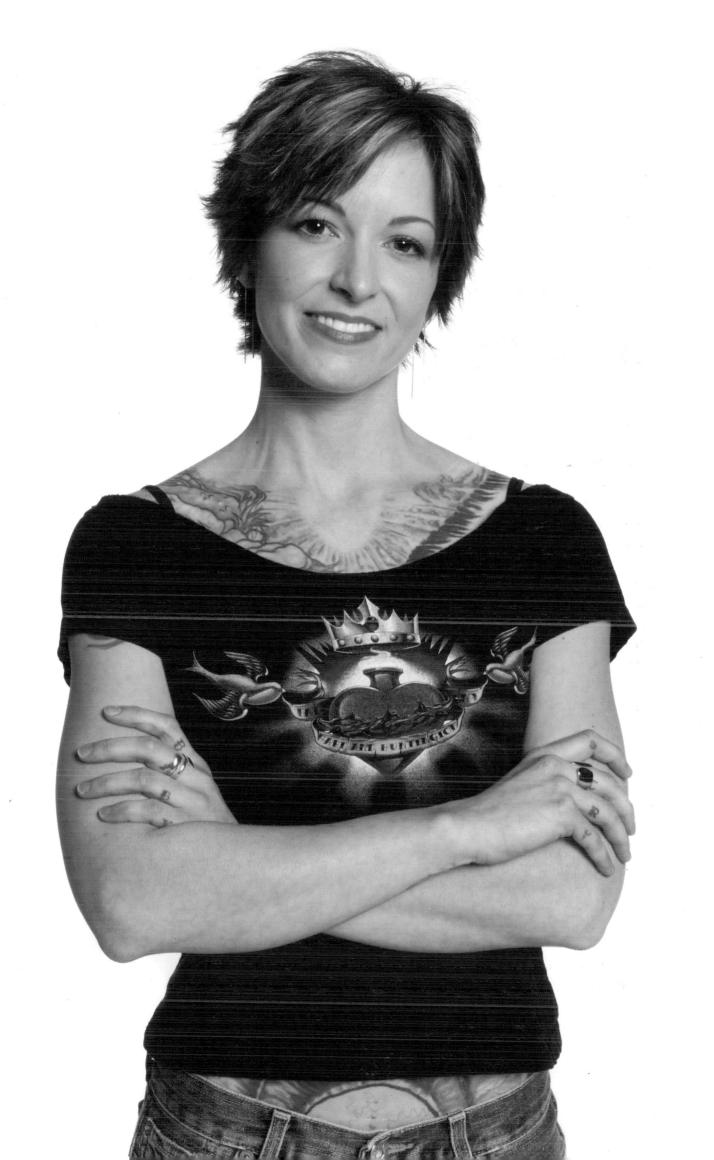

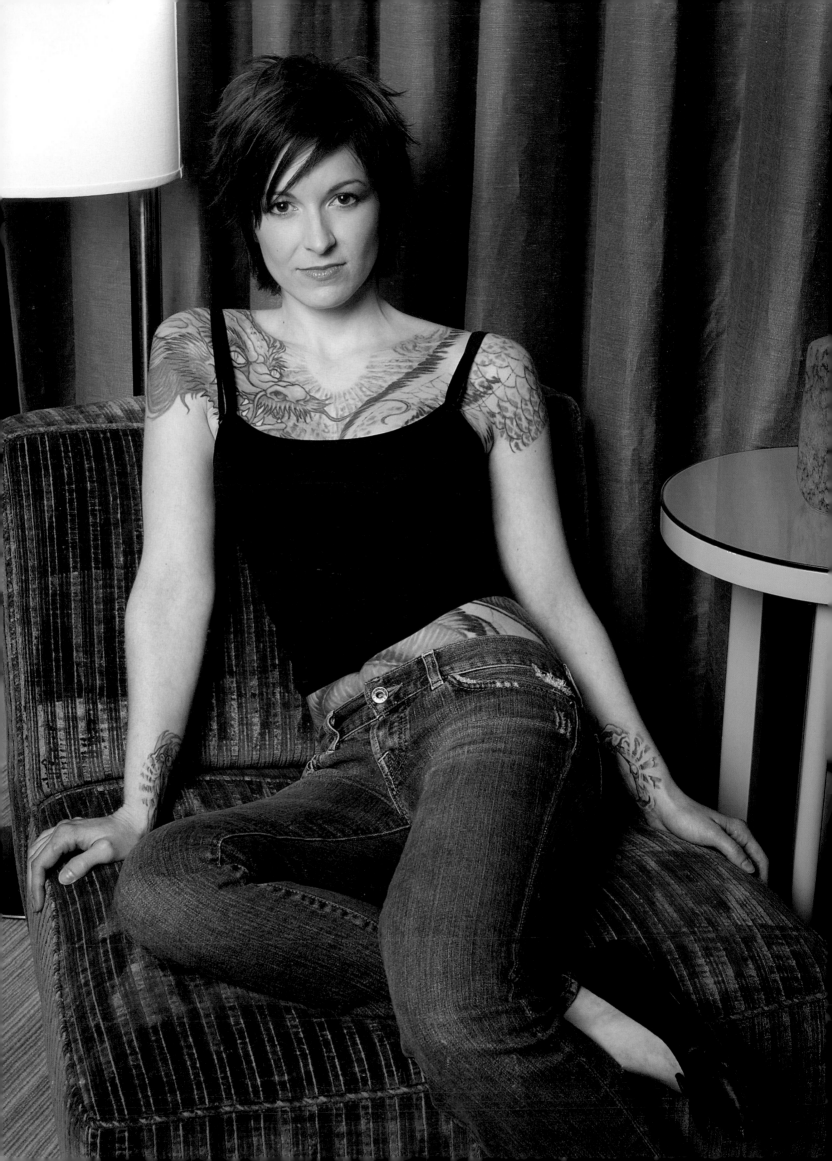

"EVEN AS A KID I DREW ON WALLS, CLOTHES, DOLLS, AND MYSELF."

I started giving tattoos in 1994, when I was nineteen, just two years after I got my first one. I served as an apprentice at a shop in Salt Lake City for over a year and believe that's how it should be done. To become a tattoo artist you have to pay your dues and learn the ropes under someone who knows what they're doing. Not that it's an easy route. And trust me, it looks much easier than it is. Pain is definitely a consideration for anyone thinking about getting a tattoo, and I can tell you with all certainty that the rib cage is one of the areas that hurts the most. When I got part of the dragon on my ribs it felt like scratching a bad sunburn.

Being a female tattoo artist in a male-dominated industry is just another obstacle I've had to climb over. When I started, guys were reluctant to get tattooed or even talk about designs with a girl. Now partly because of television, being a female artist is much more accepted. But I've proven myself with my work. Still every now and again a guy will walk into the shop and think I'm the receptionist. I don't let it bother me because once he sees my work he understands who I am.

Over the past ten years I've met so many great and talented people, artists and clients alike, who have helped me along the way. There is a certain camaraderie in the tattoo industry that is genuine and irreplaceable. I love what I do and can't imagine life without tattoos. And as the saying goes, temporary pain for permanent pleasure!

TATTOO I'M PROUDEST OF: The ones I did on my parents
MOST TIME SPENT ON ONE TATTOO: 20 hours
MOST MEMORABLE CLIENT: Cher impersonator

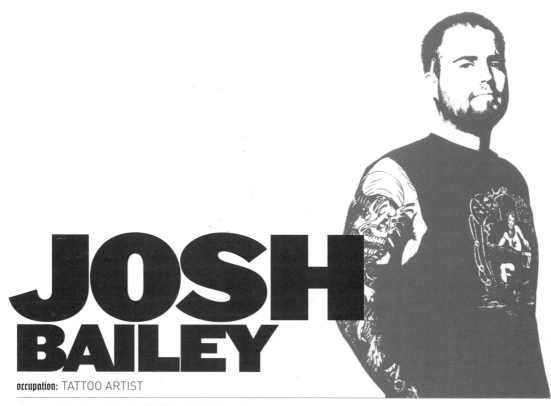

JOSH
BAILEY

occupation: TATTOO ARTIST

artist: JEROME, HART & HUNTINGTON TATTOO

I've always drawn a lot with colored pencils so I knew I wanted to have some kind of career in art. I thought the easiest way for me to do it was to go to art school. I'm from Montana but I decided to enroll at the Green Valley Art Institute in Las Vegas. During that time I started hanging out in tattoo shops. After a year in art school I decided to become a tattoo artist and figured out the quickest way was to become an apprentice and start working in a shop, so I dropped out of art school. As an artist I like to work in vivid colors; the same goes for the tattoos that I get. I'm into pirate stuff and some of the more traditional designs. On my right shoulder I have the skull of a pirate. Skulls can have a wide spectrum of meaning. Some people get them to represent a heavy side of death. But to me they symbolize a rebirth.

I really believe that no two artists are alike, which is why no two tattoos are alike. What makes each artist different is his personal preference when it comes to the way he works. If you gave two different artists the same idea you would get two totally different tattoos. Each artist's style and personal preferences differ and can really produce some unique work.

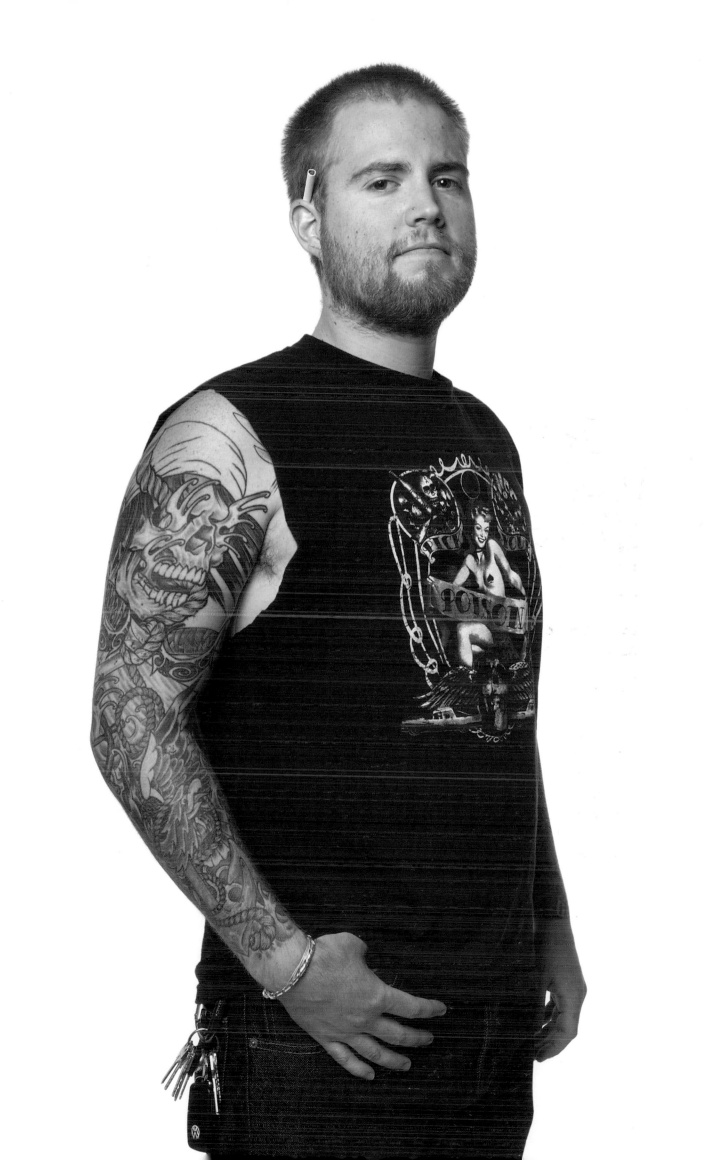

THE SKIN YOU'RE IN WITH TWIG

When an oil painter needs a new canvas he simply heads for the nearest art supply store to pick one out. But when you're a tattoo artist, the canvas chooses you.

You don't need a degree in dermatology to become a tattoo artist but it pays to have an intimate knowledge of the living, breathing canvases you work on every day. When you get a tattoo, it's not actually on your skin, but *in* the skin. The needle pokes through the epidermis, the outer layer of skin, to the underlying dermis where it deposits the ink. Some people are afraid the needle is going to hit bone but it doesn't come anywhere near it. When a tattoo heals, sometimes the colors will dull slightly. Imagine drawing a line on a piece of paper with a felt-tip pen and covering it with a transparent piece of paper. The felt line is still the same, it's just not as clear because it's been covered. That's what's happening to the ink in your skin.

Normally the lighter the skin, the more the color will show. Not long ago I had a young lady from Ireland in my chair. Her skin was almost white and I had never seen my colors pop so much. On the other hand, this dark skinned brother came in and I thought I was looking at Mother Africa. I tattooed his brother's name on his shoulder. He comes back a few days later and says that he can't find his tattoo. He wasn't lying. I couldn't find it at first either. It wasn't even raised from swelling.

The mark of any great tattoo artist is how little damage he does to the skin while applying a tattoo. The idea is to puncture the skin as cleanly as possible, which makes it easier for the skin to take the ink.

That's why a lot of artists don't like tribal tattoos—they don't feel creative and require the artist to stay in the skin much longer because there is so much area to color in. Generally, the longer you stay in the skin the more chance there is of tearing it because you're making so many punctures. It's like driving a top-fuel dragster, if you're going to be successful you've got to keep it wide open for a long time without blowing it up.

I've seen every type of skin imaginable: light, dark, smooth, rough, stretchy, loose, young, old. In Las Vegas we see a lot of people in the construction industry who've spent so much time out in the sun that their skin is rough, calloused, and leathery a difficult canvas to tattoo.

Sometimes if the skin is too loose it just won't take the needle. Imagine a bunched up piece of silk. If you gently drag a razor blade over the silk, the razor won't cut it. In extreme cases you have to get another artist to literally stretch the skin out and hold it while you tattoo. The flip side is really tight skin. Take the same piece of silk and pull it tight. Now run the blade over it and watch how easy it is to slice through.

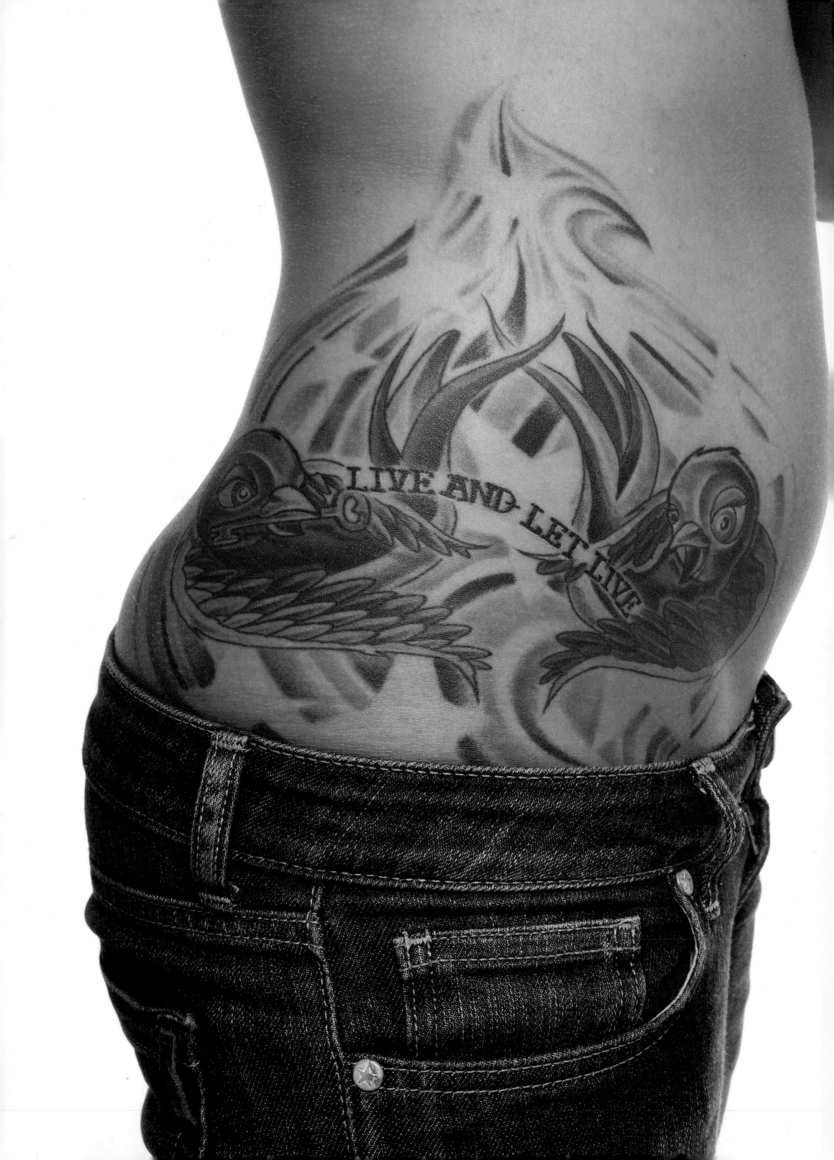

NIKITA BENEVIDES

occupation: COCKTAIL WAITRESS

artist: JESSE SMITH, HART & HUNTINGTON TATTOO

I've been on my own since I was seventeen, so I'm a pretty independent girl. I'm from Boston, where I had a lot of friends and was a cheerleader for about ten years. But tattoos were something I've just always been interested in. My family has a military background so one of the first things I got was a tattoo of sparrows and swallows on my side. These are what sailors first see when they're returning back to shore, and they also symbolize that you've made it back home. This tattoo helps me stay grounded and never lets me forget where I came from.

On my other side I have a sacred heart wrapped in chains, which is in memory of a friend who hung himself. The tattoos I get must have meaning. I wasn't going to get some dude's name and regret it two months later. I wanted to get something that felt permanent to honor the people in my life. One of my favorite tattoos is a geisha with a fan. My mom is Korean and this tattoo was taken from a painting that has been in my family for more than six generations. That painting has been around the world and was even lost several times, but it has always managed to find its way back into our hands.

When I left home I wasn't exactly sure where I was headed or what I was going to do. A friend said I should try Las Vegas so I did. Right now I work at a nightclub doing bottle service (bringing champagne around to people who reserve a table for a night).

When I'm not at work I spend most of my time in the kitchen. One of the things I'm most passionate about is cooking. I love food because it brings people together. Often I'll have friends over and throw dinner parties. My specialties are Thai, French, and Italian—especially spaghetti. I've been cooking ever since I was a little girl, when I would make dinner for my father and my brothers. For some reason when I was growing up my mother wasn't a very good cook, so I learned how to cook everything at a young age. People always ask me why I don't work in a restaurant, but I could never cook the same thing every day. I want the freedom to make something completely new from one day to the next. Some day I hope to have my own cooking show. I want to be among the first tattooed female chefs. That sounds pretty good to me.

JAMES FERREIRA

occupation: TATTOO ARTIST, HART & HUNTINGTON TATTOO

artists: CHAZ LAGUNA; BROTHER GREY; TODD NOBLE; WILL THOMPSON; BART BINGHAM; JIME LITWALK, HART & HUNTINGTON TATTOO

born and raised: ORANGE COUNTY, CA / NASHVILLE, TN

first tattoo: TALL SHIP ON LEFT ARM

favorite tattoo: DAY OF THE DEAD SKULL / BUTTERFLY ON MY THROAT

hardest part of the job: STAYING FRESH AND ARTISTIC

most time spent on one tattoo: 11 HOURS

most memorable clients: TONY HAWK; HULK HOGAN

specialty: NEOTRADITIONAL; TRADITIONAL AMERICAN

professional tip: KEEP IT SIMPLE

passions: VINTAGE BIKES

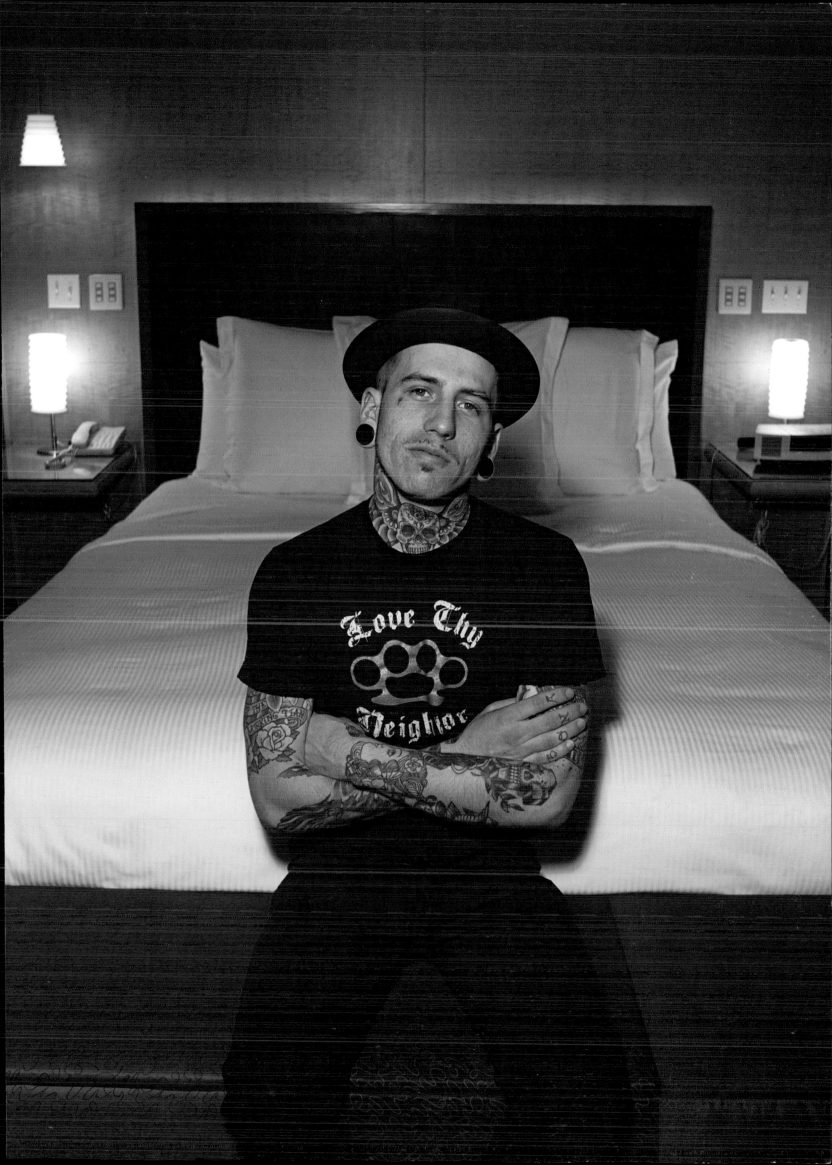

TOM
HART (CAREY'S DAD)

occupation: OWNER, CONSTRUCTION COMPANY

artists: DAN ADAIR; DAVE LOGUE

I had always been against the idea of tattoos. I was born in the 1950s and my generation thought tattoos belonged only on marines and sailors. I grew up with the notion that they just weren't for socially respectable people. When Carey was younger I knew he wanted to get one. I also knew when he turned eighteen there wasn't much I could do about it.

Needless to say, when he came home with his first one, I wasn't thrilled. Being a father it was like I had spent eighteen years building a car and someone came along and tagged it with spray paint. But he was an adult. It was his choice. My opinion of tattoos didn't change just because my son had one. I couldn't just erase all the negative stereotypes from my mind. Even when Carey was twenty-five or so and had two full sleeves he still tried to hide them from me. He'd be home from racing for the summer and would wear long-sleeved T-shirts around me. Being in construction, wearing long sleeves in hundred-degree heat was nothing new to me, so I didn't pay it any mind. But his little brother, Anthony, would rat him out. Again, I wasn't thrilled, but it was his life.

Carey always knew how to work me. His plan was to bring me around slowly but surely. He would point out that he got my initials on his sleeve. He would make his case, and it became hard to argue. But he wasn't going to rest until I had a tattoo of my own. I wouldn't budge on it, though. Then Carey tricked me into getting my first tattoo.

" BEING A FATHER IT WAS LIKE I HAD SPENT *EIGHTEEN YEARS* BUILDING A CAR AND SOMEONE CAME ALONG AND TAGGED IT WITH SPRAY PAINT. "

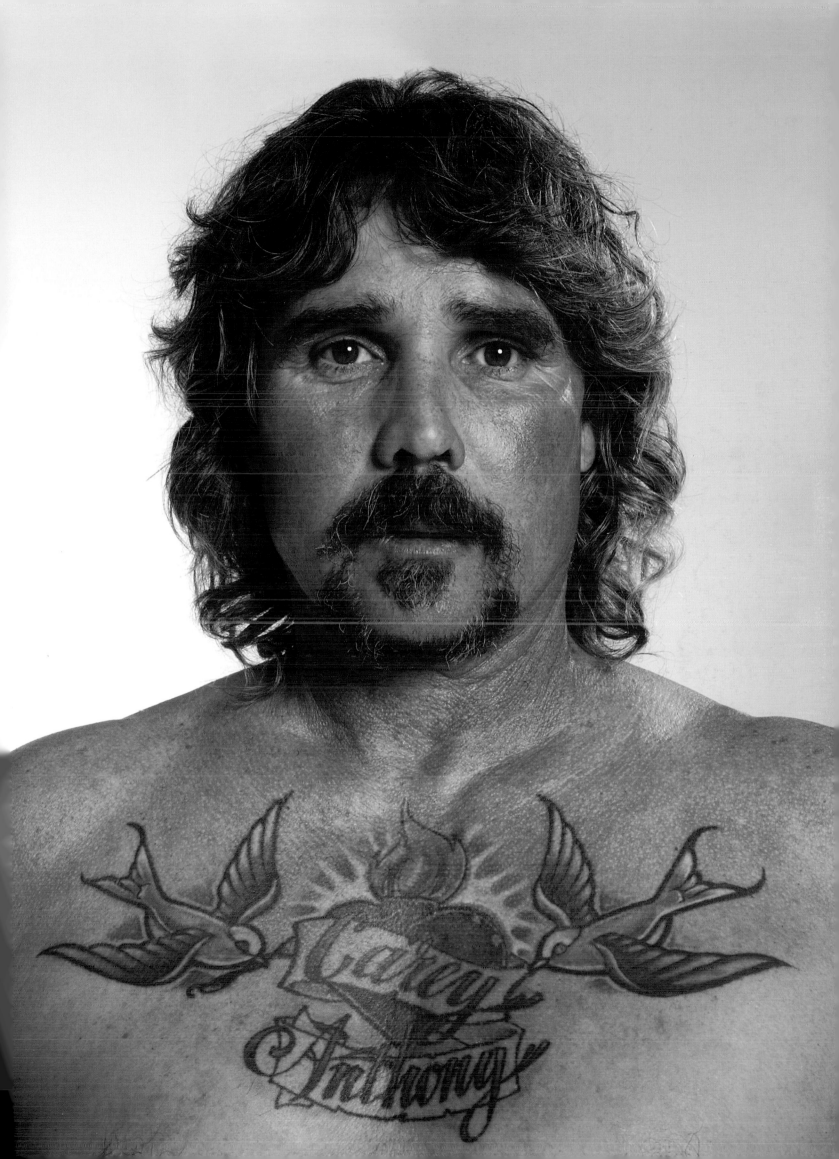

my father
my friend

He was living down in Southern California and had made enough money from freestyle to buy a house, but called me and said I needed to cosign or the deal would fall through. So I jumped in my car and hauled ass three hundred miles from Vegas like a bat out of hell. He gave me directions that led me not to his house, but to a tattoo shop, Soul Expression. There wasn't a mortgage place in sight (he had already closed on his house). Outside the shop were five of his fully tattooed freestyle buddies who goaded me into getting tattooed. I caved to the peer pressure and got two doves on my chest. I told them when I puffed up they would turn into screaming eagles. They all said that I was finally like them. I said, "No, now you're like *me*."

About four years later Carey got a sacred heart on his back between his shoulder blades with my name and the words MY FATHER, MY FRIEND. That meant so much to me. A few months later I was diagnosed with cancer. The realization that I could die scared me. I didn't know if I was going to be around in six months. Carey gave me a gift certificate to a local shop and I got the same sacred heart with both my sons' names, Carey and Anthony. When Anthony was old enough he got a sacred heart too. Now it's something that bonds us together.

It seems like such a long time ago I was telling my kid not to get tattoos, and now he's at the forefront of making them more acceptable to the mainstream. Today everybody's got tattoos—doctors, lawyers, grandmothers. Carey helped make that happen. I thought he was just going through a phase. But like everything else in life, he's been so smart about it. I should have known, Son.

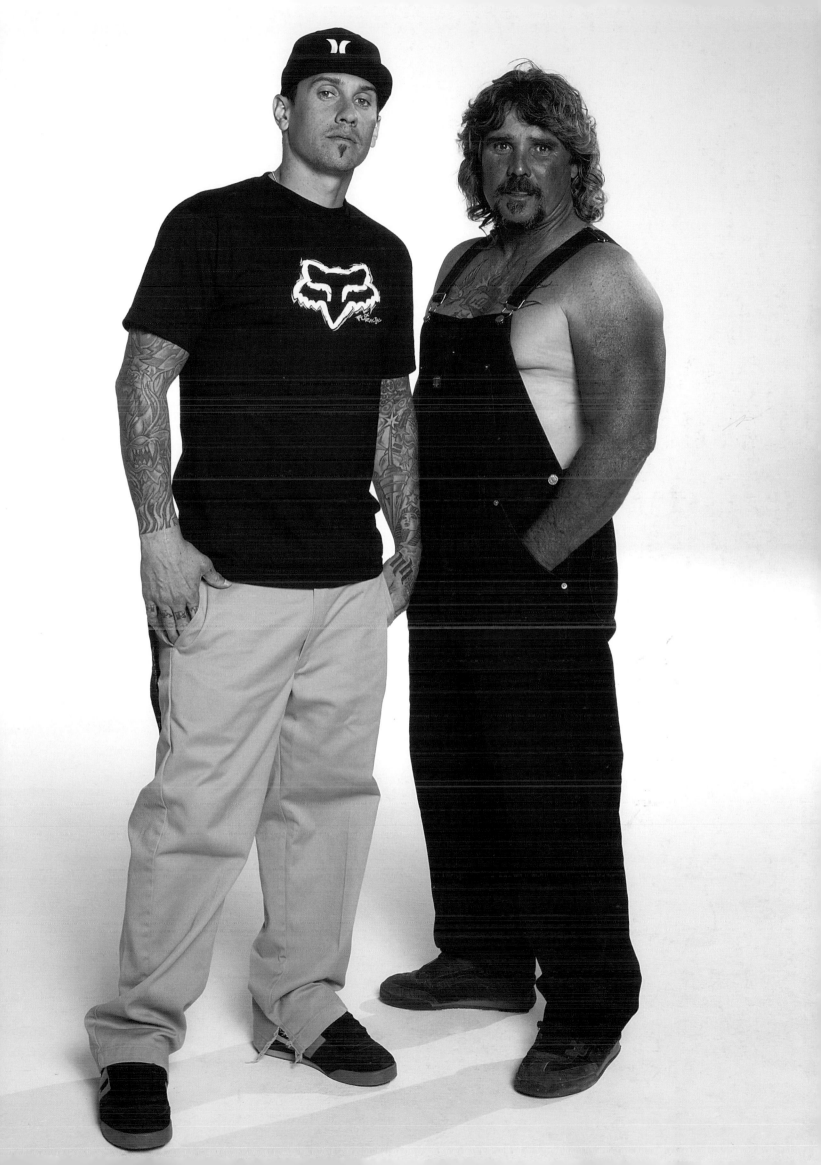

SHANNON TOMSIK

occupation: DANCER

artists: BOOM; PHIL SPEARMAN; ROBBY SLAUGHTER

The tattoo that holds the most significance for me is the angel wings on my back. Four years ago when my son Dylan was born I was going through a really tough time. His father wasn't in the picture and I had to be strong and make do for both of us while I was on my own. My wings symbolize that I've risen above all of the obstacles in my life, higher than I ever thought I could. Instead of getting traditional feather wings, I went with a tribal design, partly because I wanted them to flow well with the tribal designs on my lower back.

Really it's about strength. I just deal with whatever I have to because everything I do is for my son. The tattoo of Dylan on the inside of my right forearm is really special to me. I got it at a tattoo convention and the artist won a prize for it.

I've been an exotic dancer for nine years, and I've noticed how the perception of me has changed the more tattooed I've become. The clubs don't mind smaller, more discreet tattoos, but usually restrict heavily tattooed girls to the early shift. But I've found that some of the older customers are really into it because it's something they haven't seen before. But I can't take my tattoos off before I go to work—they're always a part of who I am.

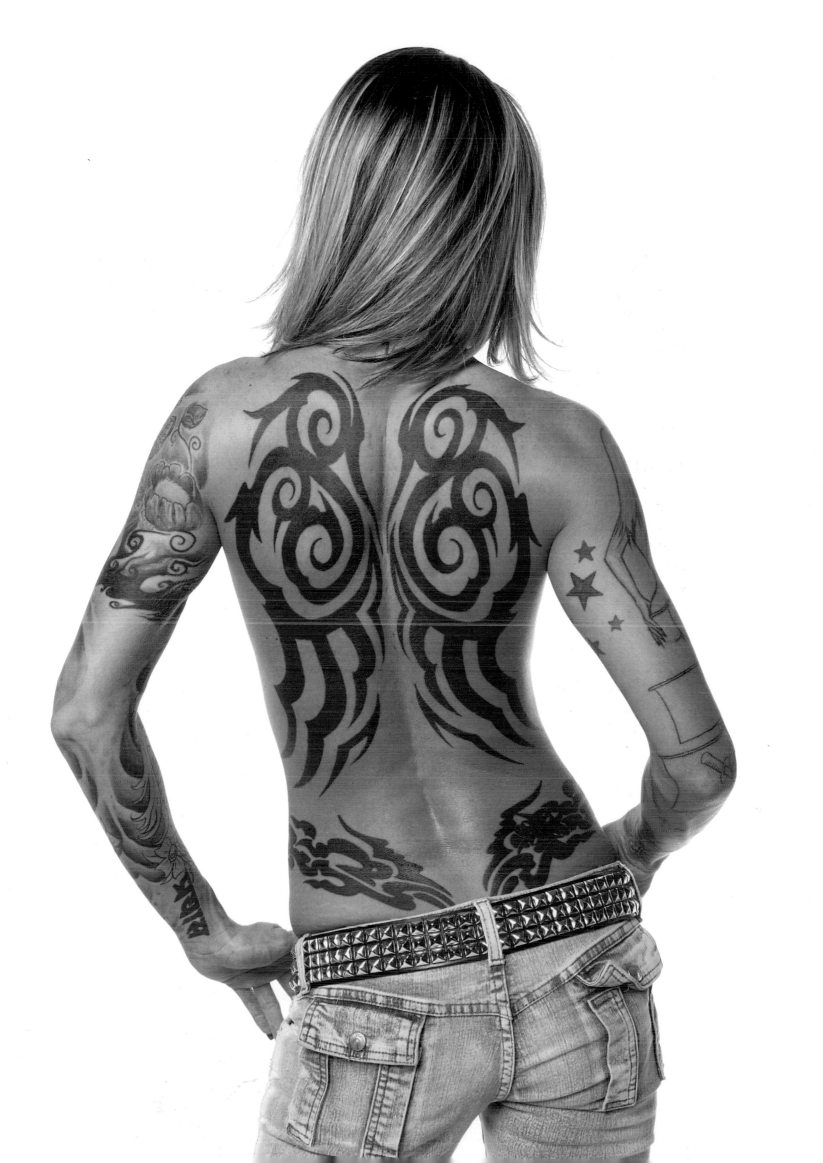

JEROME SWANSON

occupation: TATTOO ARTIST, HART & HUNTINGTON TATTOO

artist: GERRY ZUK

People always ask me why anyone would pick a random tattoo out of a book at the shop, but I think even those stupid tattoos have meaning. Or at least they create meaning. They mark a time, put a Post-it on a memory. It's like when you hear a certain song and it brings you back to a place or moment in life twenty years ago. Seemingly meaningless tattoos do the same thing. When it's all said and done, all we have are the memories.

A lot of times I'm more of a therapist than a tattoo artist. People come and get tattoos as a way of releasing whatever's on their mind, be it a divorce, the death of a loved one, or a celebration. Getting to help people through a rough time makes me more proud than actually tattooing them. I like to think I'm a better therapist than most of the professionals out there.

For me, after fourteen years, tattooing has gotten a little monotonous. After a while no matter what you do, if you have to set the alarm clock to do it, it gets to be less fun. Then it just becomes work. Still, I tattoo because it is the only thing I can do, and I think I do it pretty well. If I could get paid to hang out in my garage and drink beer with my friends, I would.

"GETTING TO HELP PEOPLE THROUGH A ROUGH TIME MAKES ME MORE PROUD THAN ACTUALLY TATTOOING THEM."

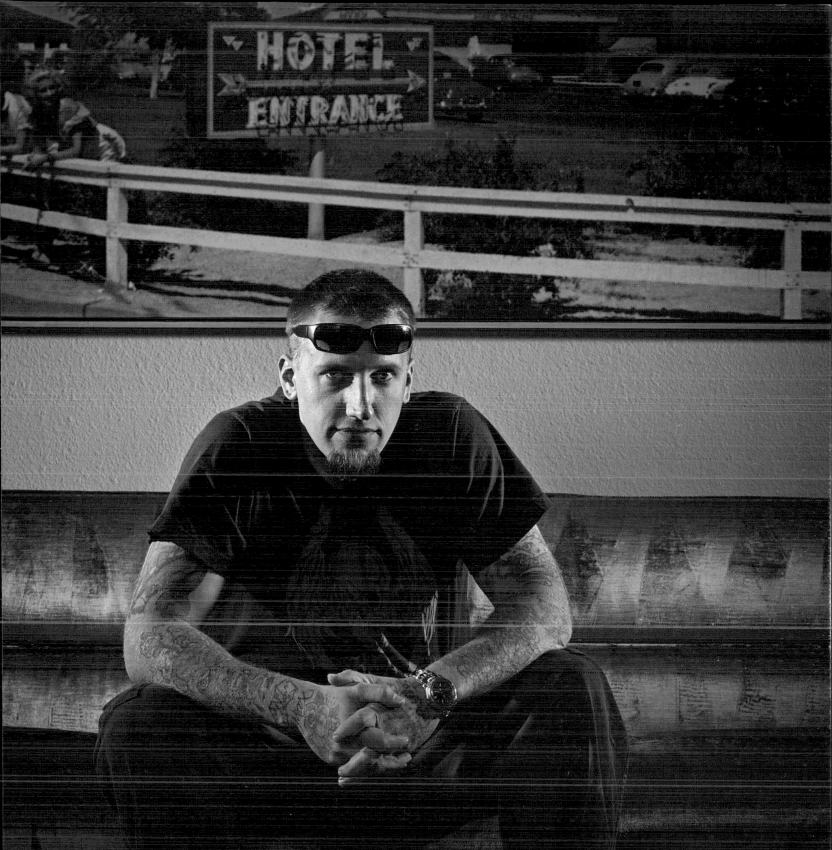

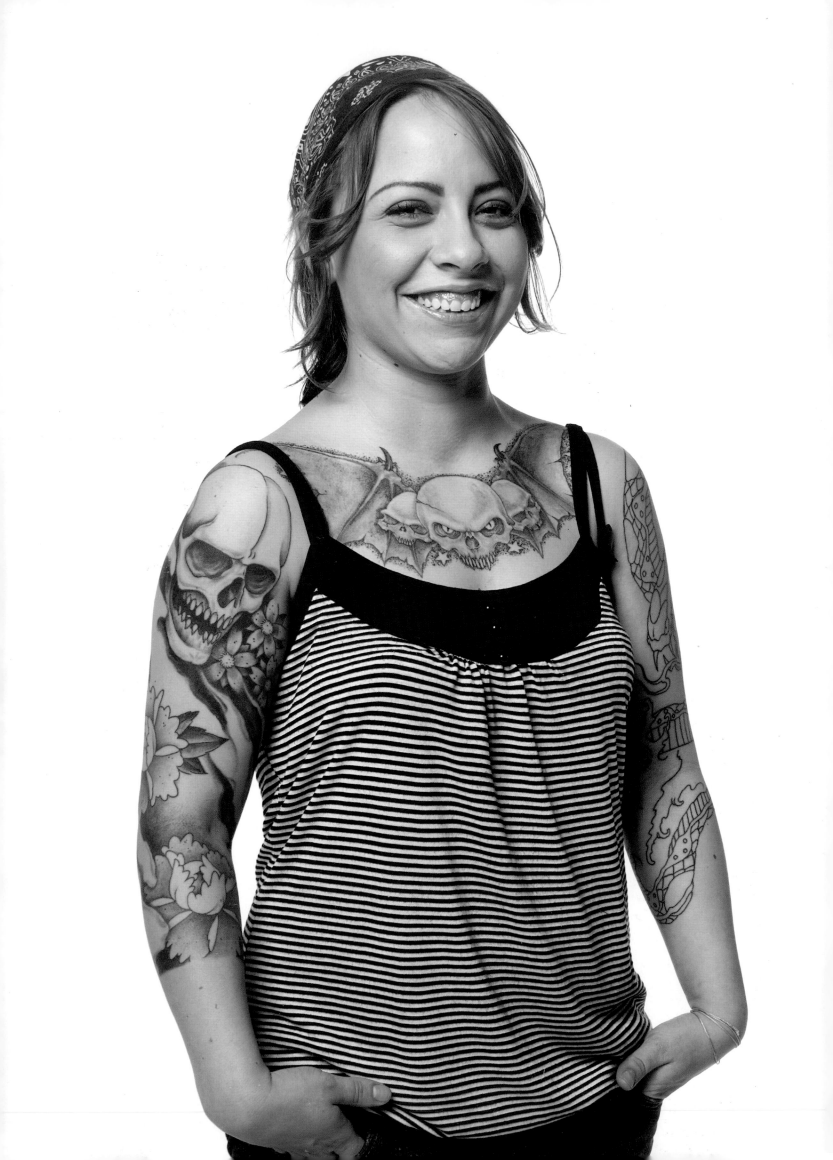

RACHEL HUGHES

occupation: RECEPTIONIST, HART & HUNTINGTON TATTOO

artists: MERDOK, HART & HUNTINGTON TATTOO; CLARK NORTH, HART & HUNTINGTON TATTOO

I've been getting tattoos since I turned eighteen, but my tastes have changed. There are a few that I don't like that much anymore. The second tattoo I ever got was a sun on the back of my left leg. I'm in the process of covering it up with a skull and some roses. So far skulls have been the major theme of my tattoos. I've got several skulls on my chest, and my right sleeve is made up of more skulls and flowers. Most of my tattoos don't have any specific meaning, I just like how they look. I just think they look cool.

If it were up to me my body would be covered with tattoos. But I definitely want to choose them more carefully from here on out. Working at a tattoo shop around so many skilled artists, I've really learned the difference between good and bad artwork. On a good tattoo everything—from the quality of the outline to the imagination of the artist—affects the finished product. When I come up with a concept I try to explain it as best I can to the artist, then put my trust in him. At the end of the day your skin is in his hands.

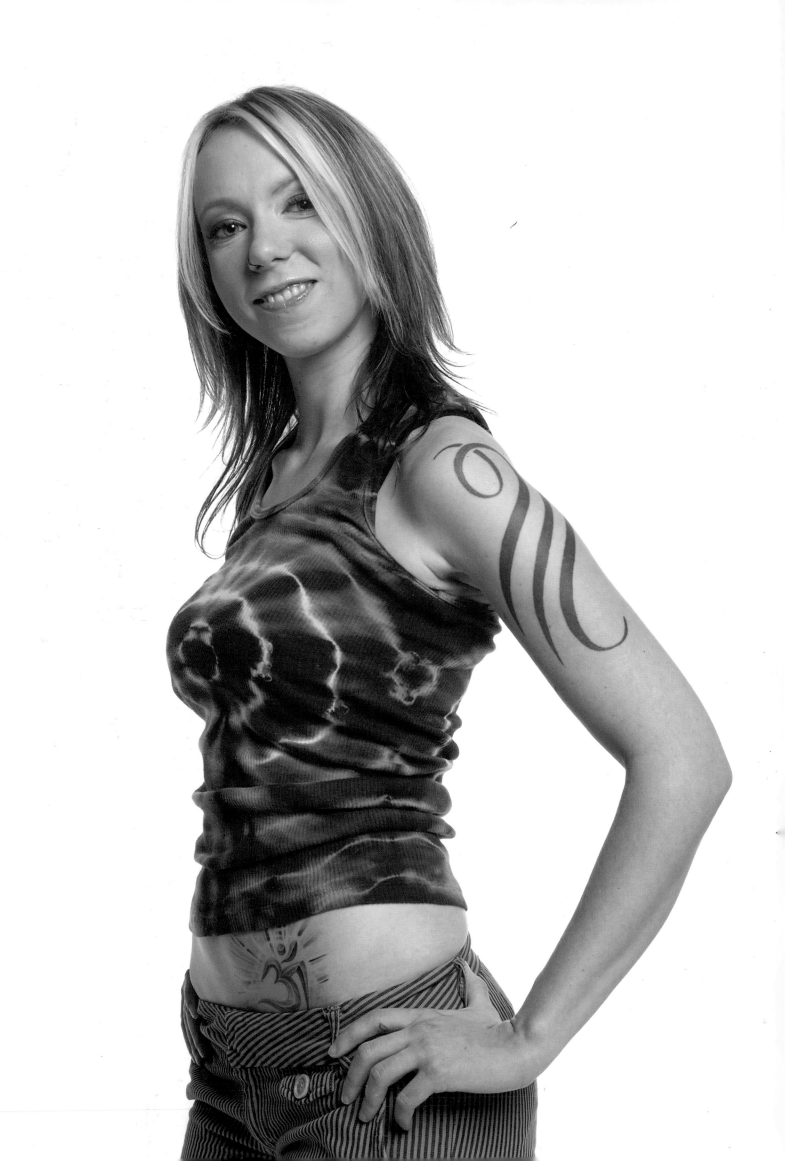

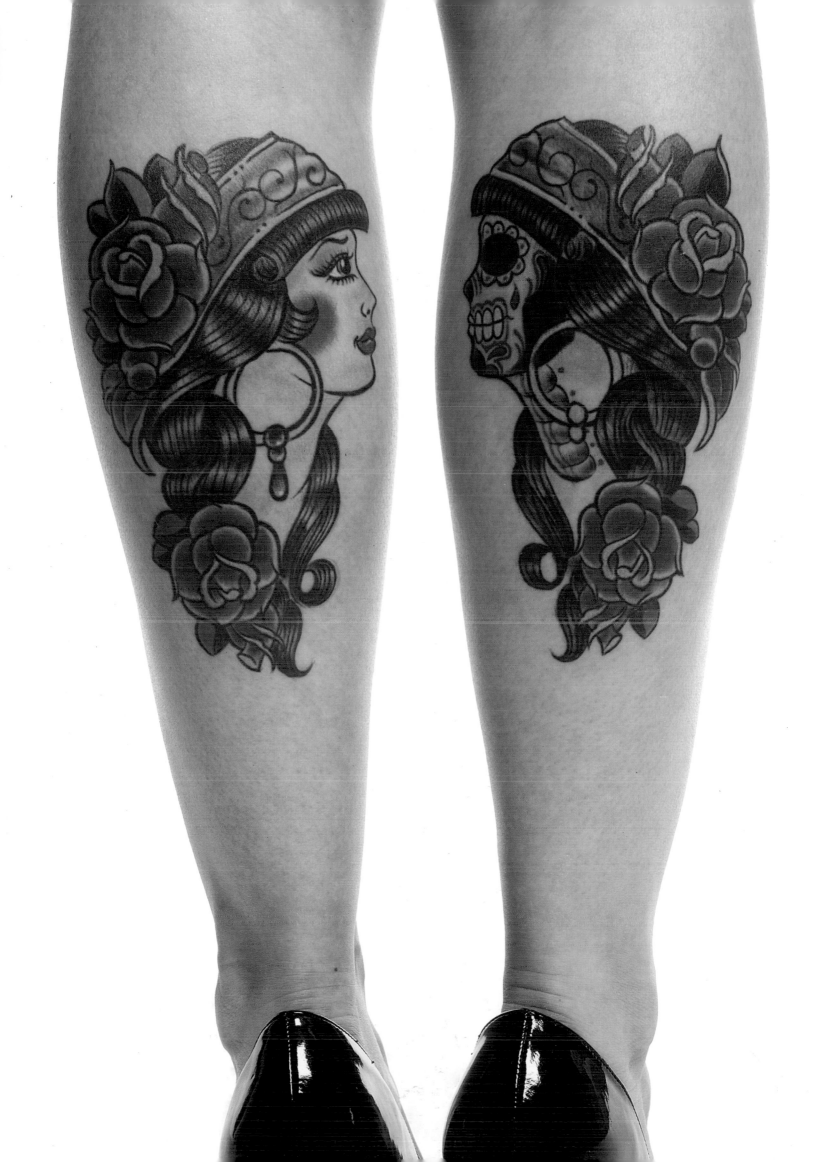

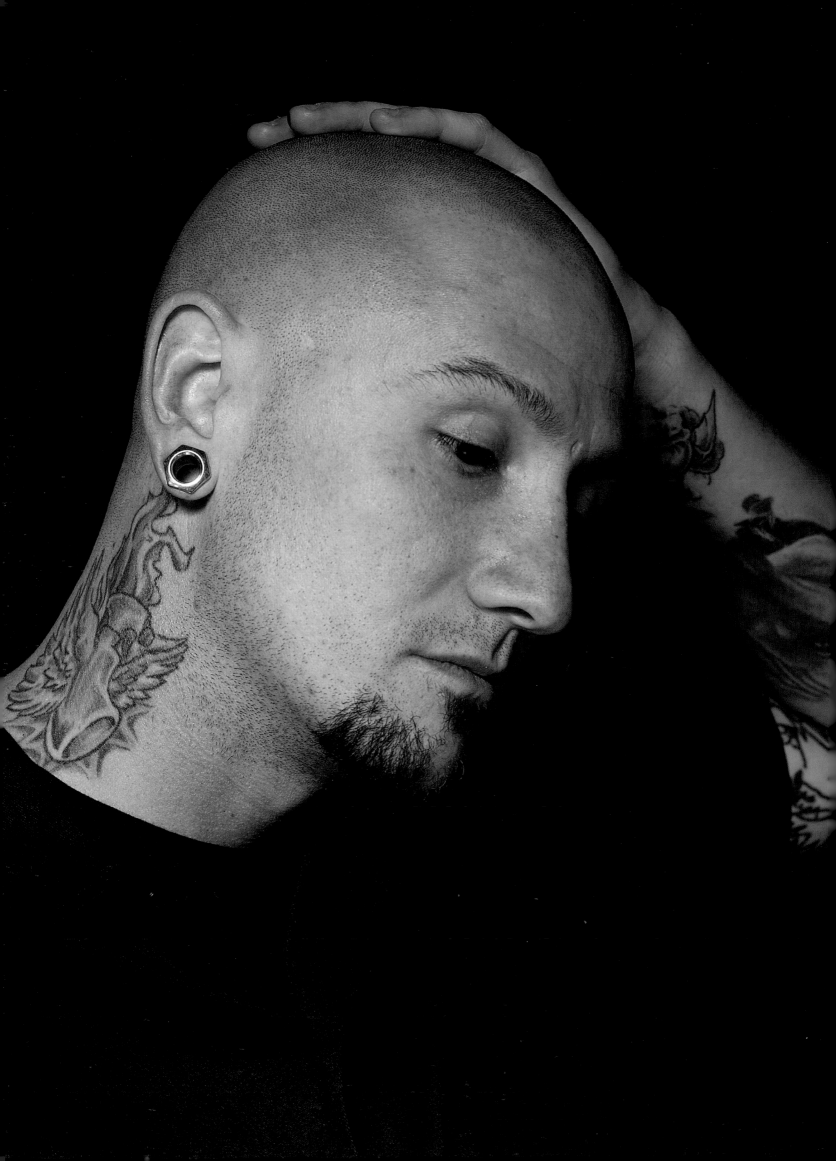

MATT VICTOR

occupation: TATTOO ARTIST, HART & HUNTINGTON TATTOO

artist: UNKNOWN

I never thought, "When I grow up, I'm gonna be a tattoo artist."

But then again, no one really does. My mother was a professor and a very accomplished painter, so growing up I was always encouraged to draw, paint, or even sculpt. Year after year I would get art supplies for my birthday. Not the most exciting gift when you're a kid more into playing with toys than learning to draw. One year my grandfather gave me a set of 120 Prismacolor pencils. I returned the thought by drawing him a birthday card. I'll never forget the way he lit up when he saw my artwork. It was the first time in my life that I'd ever been appreciated for something. From then on I was an artist, learning any medium I could and making art the focus of school.

It was only after I adopted the peculiar habit of using Magic Markers to draw on the limbs of my friends that I even thought about what it might be like to do a tattoo. Drawing those faux tattoos was fun, and I loved the way it brought joy to those I drew on. The more I did it, the more I wondered if tattoo artistry was my calling. I was finally creating art that I wanted to do instead of art that I had to do. I started making sheets of popular tattoo images and drawing up custom designs for my friends who were getting tattooed locally.

One day after school I was approached by a local tattoo artist who had done some of the custom stuff I'd made for my friends. He offered to teach me the art of tattooing in exchange for assisting him full-time in his shop as well as helping him create custom artwork for his clients. The offer couldn't have come at a better time. I didn't have a respectable job or even a place to rest my head at night. I jumped at the chance.

After my apprenticeship, I found myself in Colorado at a cozy little shop with a new crew of guys. I developed a loyal clientele that I worked with for the next ten years until coming to Las Vegas to work at Hart & Huntington.

Every day I come to work I do more than just slap tattoos on people. I listen to them and try to understand what's going on in their heads. Then I create a visual representation of what they want. From the moment I pull my first line my goal is to elicit the same kind of response my childhood friends got from my Magic Markers. My clients look at their new tattoo in the mirror and smile—or cry tears of joy. When they are so friggin' stoked I just think to myself, "Yeah, I did that."

TWIG SPARKS

occupation: TATTOO ARTIST, HART & HUNTINGTON TATTOO

artist: DANNY KNIGHT

When I graduated from high school the only thing I wanted to do besides be an artist was escape Cleveland, so I joined the navy.

I was in the presidential honor guard in D.C., where I gave tours of the Pentagon before going out to sea for the last three months of my enlistment. But painting ships wasn't my idea of a career in art. After my tour I decided I had had enough of a sailor's life. No more mandatory haircuts. No more revelry. Now it was time to find a job.

I made ground in Norfolk, Virginia, and got a job airbrushing at Alive Art Studio. Things were looking up because now I was doing something creative. For ten years I airbrushed everything from T-shirts to cars to motorcycle helmets. Airbrushing led me to jobs up and down the East Coast and eventually back to Cleveland—the place I had so desperately wanted to escape all those years ago. Then a friend who was heading out to Vegas asked me to help with the driving. Facing a frigid Cleveland winter as a bike messenger, I jumped at the chance.

I wanted to make a living using my creative abilities, but I had squeezed everything I had out of airbrushing. Soon after I arrived in Vegas I got a job working the front counter at Diversity Tattoo on the Strip. My mentor had a very traditional approach—aspiring artists learn the ropes by apprenticing and studying proper technique—which taught me the technical aspects of the trade. After about three or four months in the shop I was totally consumed by tattooing.

Tattooing is the most challenging thing I've done artistically. If I made a mistake airbrushing a T-shirt I could always throw it away and start again. If I mess up someone's skin there's no going back. I believe tattooing is the highest form of art because it's done on the most precious surface in the world.

FIRST TATTOO: My name (so I wouldn't forget it)
MOST MEMORABLE CLIENT: Dontrelle Willis (Detroit Tigers)

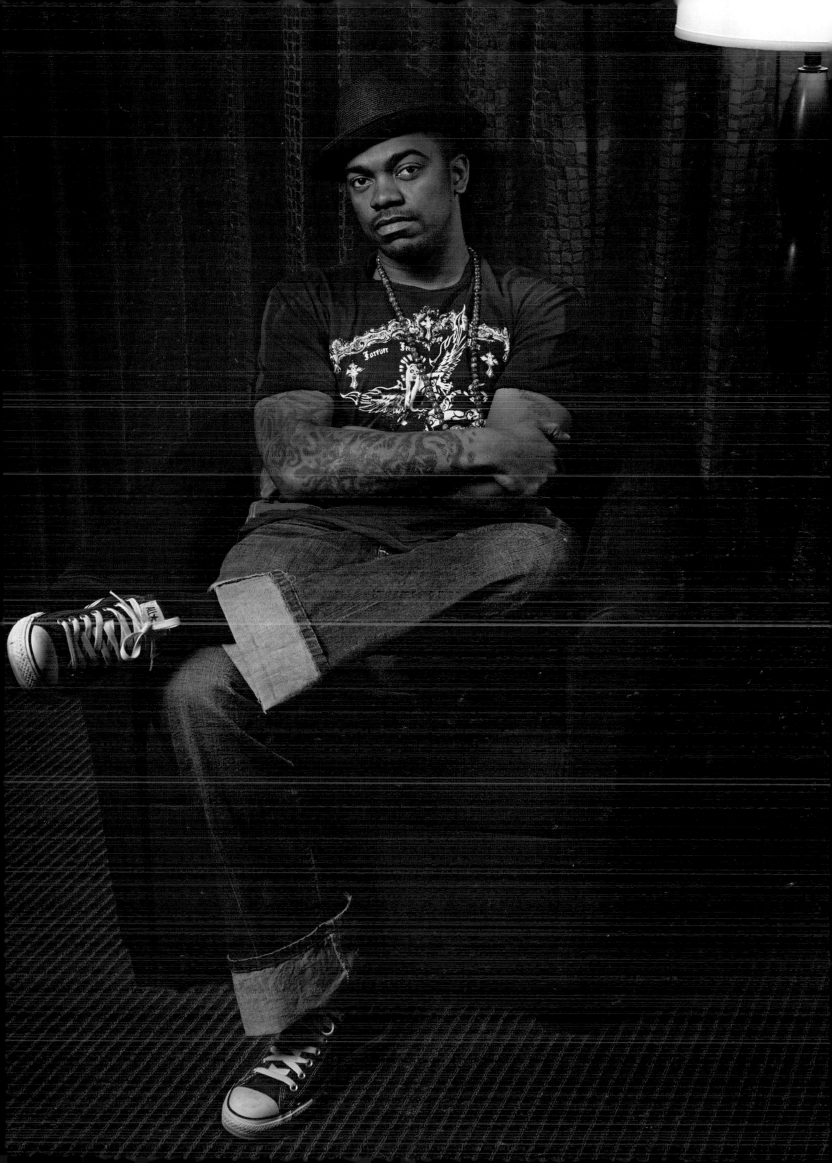

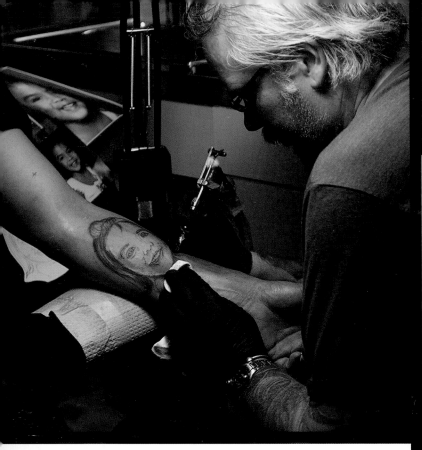

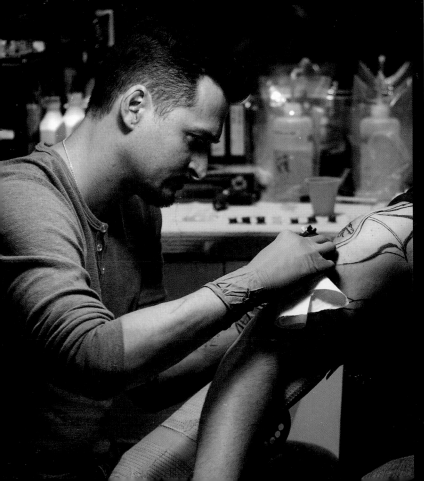

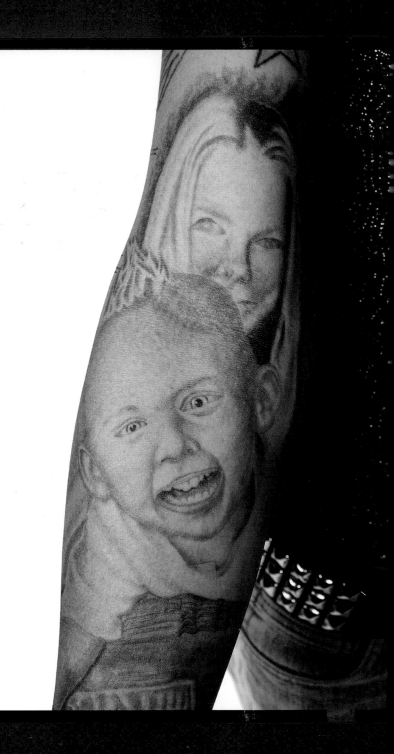

HOW TO MAKE THOSE PORTRAITS COME ALIVE WITH TWIG

The key to beautiful lifelike portraits is to capture the eyes, nose, and mouth. The first thing I do is focus on creating a transferable stencil from a photograph that the customer brings in. If you simply trace the photo onto tracing paper you'll lose important details. Instead, I like to photocopy the picture onto transfer paper and then draw touch-ups directly onto the transfer paper. I can then take this stencil and press it directly onto the skin. This way I've captured every possible detail.

When tattooing a portrait, I begin with the outline. The thickness of the lines depends on the picture. I'll use lines of varying thickness to add three-dimensionality to the portrait. The next step is the shading, which can be any level of gray that's not solid black. Shading adds highlights and shadows and prevents the portrait from looking completely two-dimensional. With black and grays I work from dark to light, starting with black. The third step is adding the color. Unlike black and grays, I work from light to dark when it comes to color. When you work with colors you have to be careful not to contaminate the ink you lay down first because the pores are open. The result can be an unintended mixing of colors.

I like to work from the bottom up because it gives me a better sense of how the portrait will come out. But if that's not feasible based on the placement of the tattoo, I'll begin with one area and work my way over. I don't like to jump around from the nose to the eyes and back to the mouth. Another consideration is each person's tolerance for pain. Sometimes you just have to feel your clients out or talk to them to see how they're doing. If they need to take a break then I give them a few minutes.

Portraits require excruciating detail and there are so many things that can throw an artist off: how much the person is moving, the tension of the needle, the steadiness of your hand, the reaction of skin to needle. All these factors affect the final product.

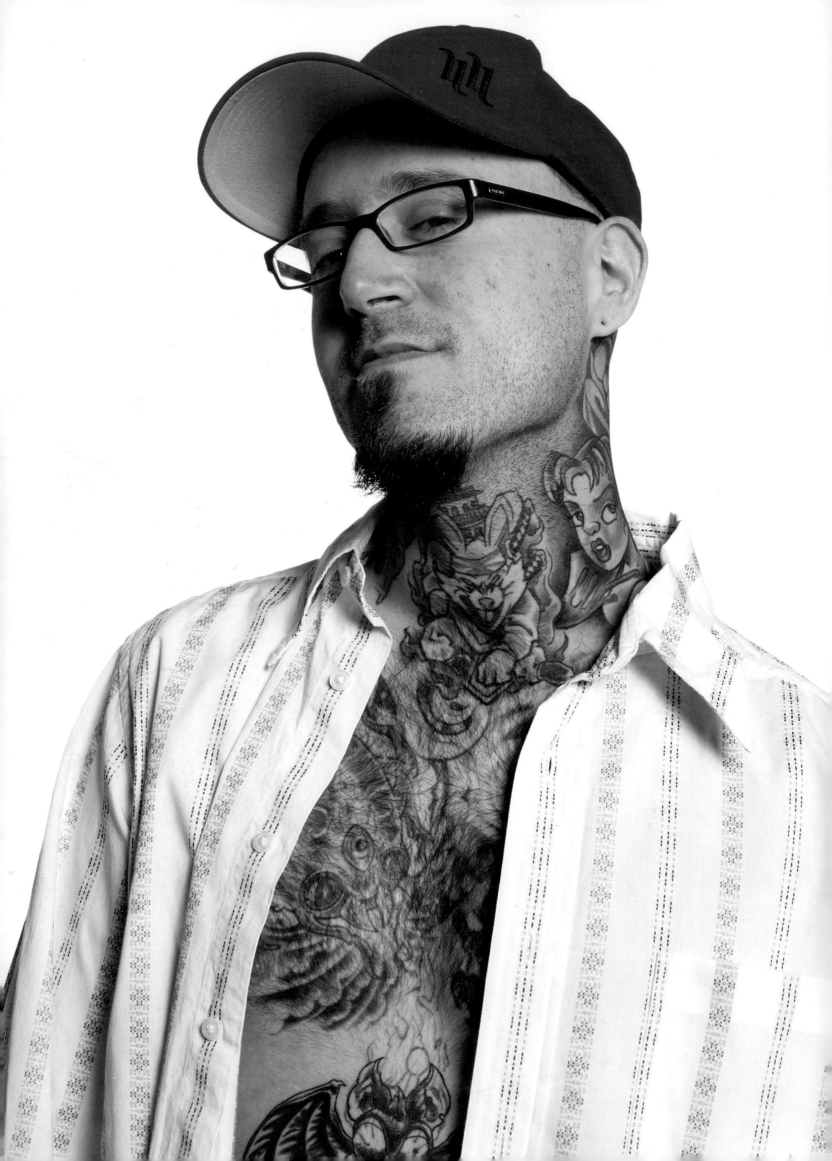

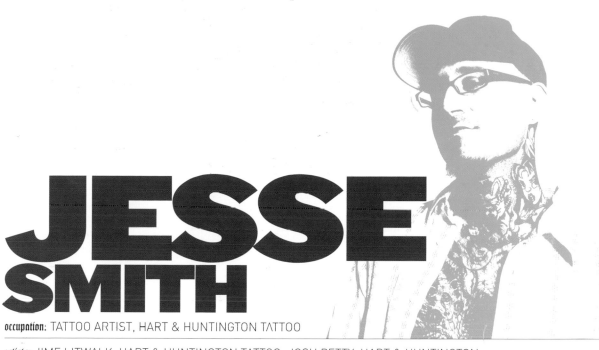

JESSE SMITH

occupation: TATTOO ARTIST, HART & HUNTINGTON TATTOO

artists: JIME LITWALK, HART & HUNTINGTON TATTOO; JOSH PETTY, HART & HUNTINGTON TATTOO; KIM SAIGH; RYAN DOWNEY; RON AREHART

My first tattoo was pretty sketchy. When I turned eighteen a friend did it at his house. The movie *The Nightmare Before Christmas* had just come out and I got the character Lock tattooed on my upper right arm. We just sat around for five hours getting drunk while I got tattooed.

For my next experience I went straight to a real tattoo shop. It was an old-school biker shop in Las Vegas with rough-looking artists who weren't exactly there to make you feel good. Those environments weren't like Hart & Huntington, where you walk in and somebody greets every customer at the door. I got the Star of David to represent my Jewish heritage.

After that I really began to look at the stuff artists were doing and just felt I could do better. So I decided to become an artist as I worked on my own collection. I never planned to become covered with tattoos; it just happened naturally. Right now I've got about 75 percent of my body covered.

I waited a while to do my back. Most people do their back a piece at a time. But I developed a concept and thought it out for a couple of years. The theme is Pissed Off Grown-Up / Scared Little Kid. Those are really the two sides of who I am. I wanted the grown-up, the dominant figure on my back, to really jump out at you. I had the artist color him red, as opposed to more lifelike tones, because he's merely a rendition of me. Farther down on my back is the scared little kid because I definitely have him in me too.

Growing up I dealt with a lot of mental stuff, particularly OCD, and the little kid represents that. The way I dealt with it and how those things affected me resulted in the grown-up. With OCD I would do things like check and make sure the door was locked over and over even when I knew it was. Sometimes I'd turn the car around to go back home and check it again. Oftentimes people with OCD have numbers they associate with. My numbers were four and seven. I'd usually check things either four or seven times over. So I decided to get those numbers tattooed on my back. I've pretty much overcome OCD by just working it out in my head and realizing that it's all mental.

KIT COPE

occupation: MIXED MARTIAL ARTIST

artists: LACEY McCLELLAN, HART & HUNTINGTON TATTOO; DICK VERMIN

My father was in the air force, so like most military families we moved around a lot when I was young. I've lived in Oklahoma, California, Wyoming, and Arizona. When my older sister was pregnant with her first child I moved to Las Vegas to help her out. Soon after, I got involved in kickboxing. I started training with a coach and became good enough to make the U.S. kickboxing team and competed in the world championships in Thailand when I was seventeen. I got my first tattoo then—a tribal armband that originated from the old hill tribes in Ireland centuries ago. Since I'm Irish it was a way to pay tribute to my heritage as well as decorate my body, which I consider a beautiful temple.

All of my pieces have connected meaning. The armband says MUAY THAI in Thai script. *Muay Thai* means "my job, my passion, my love." My job is another reason I value my body. Right now I'm trying to make the transition to mixed martial arts (there are many different fighting styles), which has been challenging since for so long I trained in just one. The ring is dangerous enough, so it didn't help that I flipped over my bike's handlebars while out riding with Carey one day. Slammed right on my shoulder and popped my AC joint. Not pretty. Sometimes I feel like I need someone to watch over me.

I thought about getting angels on my shoulder but that just seemed too wussy. I decided to go with two heraldry dragons, one on each shoulder, a kind of yin and yang. I chose the dragons because they are wise, noble symbols from Gaelic culture and I wanted something powerful. But something was missing. They didn't feel powerful enough. When I step into the ring I have to project power. That's what I want my tattoos to convey. I don't want them to be little trinkets of decoration. I decided to add a large dragon down my back that really captures who I am. It's fierce and powerful and took about thirty-eight hours of work.

Finally, on my left ribs is a Celtic trinity knot I designed as the trademark of my company. I took a knot in the Celtic style and twisted it to give it a jagged effect. The three points symbolize the holy trinity and the bond I have with my parents. I chose that location as a way to honor Jesus Christ and the Crucifixion—my shout-out to the Big Guy. And why not?

There is a lot in store for me. I still have a long way to go before I peak as a fighter, and the opportunity to cohost the show *Wide World of Spike* with pro skater Jason Ellis has opened many doors for me. As far as my tattoos go, the future is wide open.

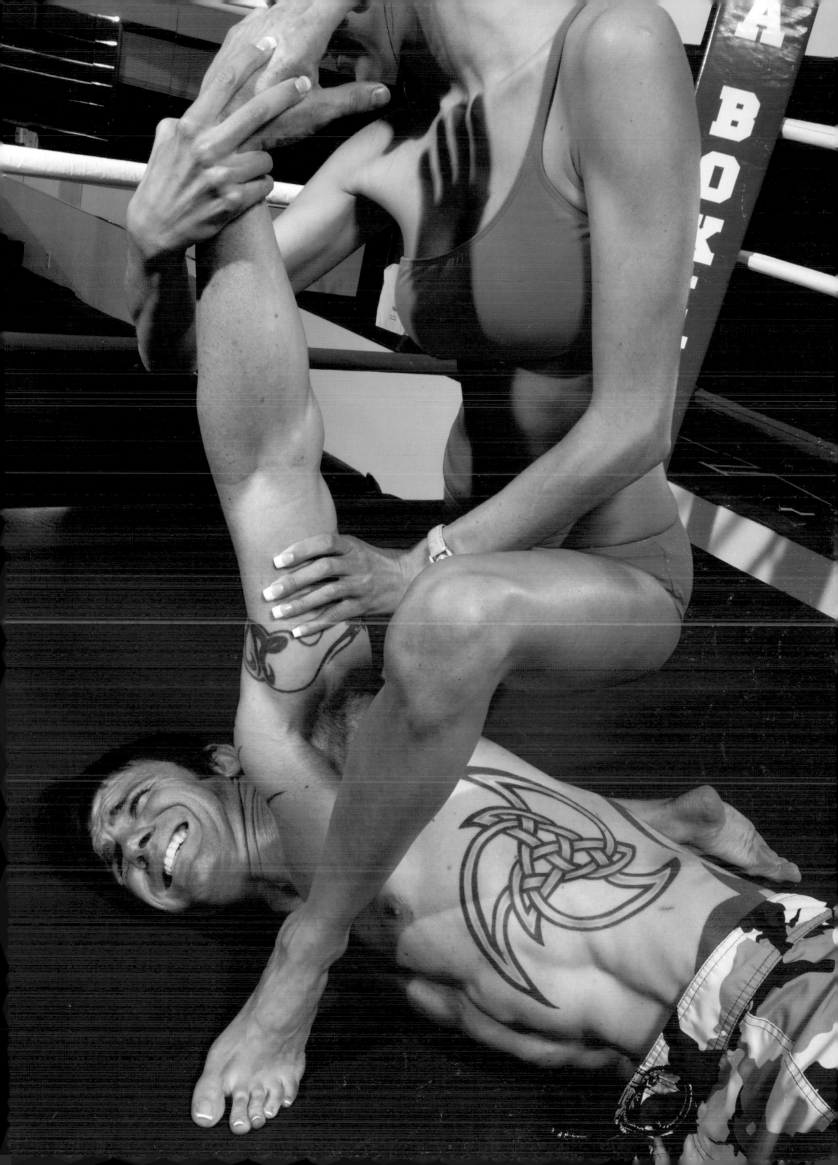

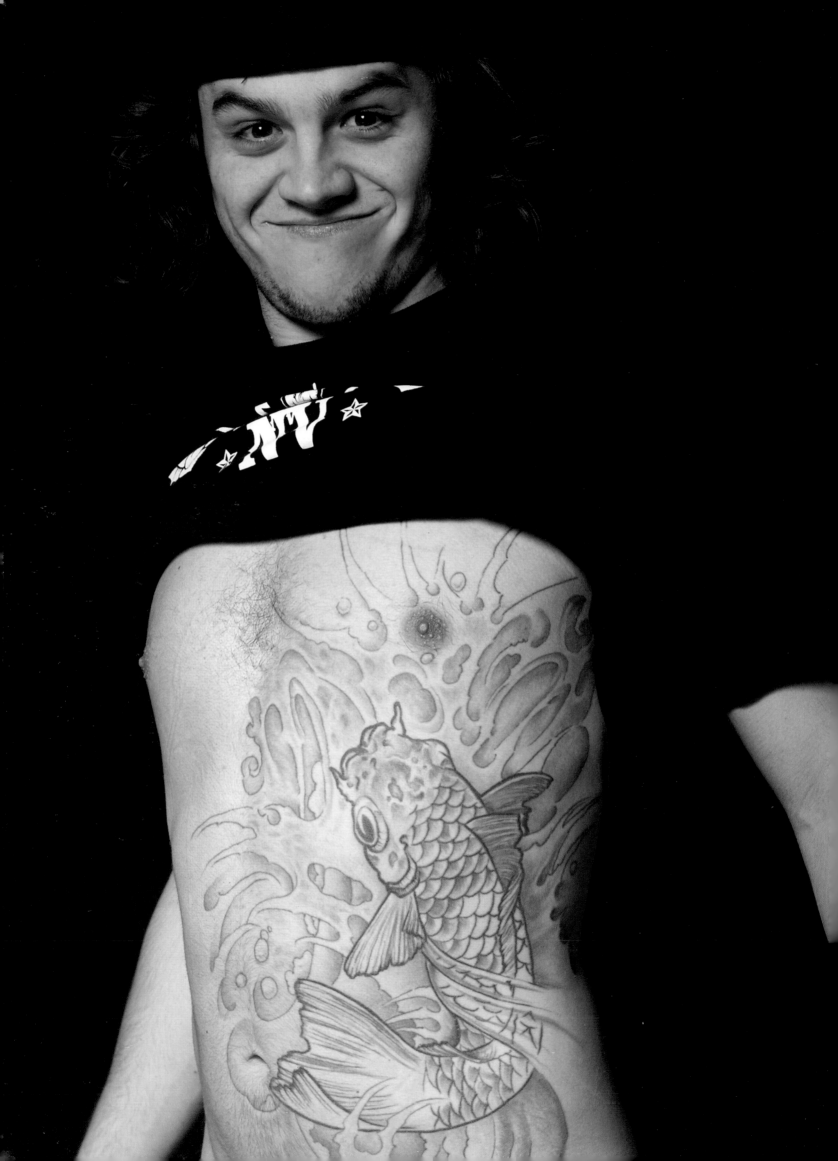

DIZZLE

occupation: TATTOO ARTIST, HART & HUNTINGTON TATTOO

artist: CLARK NORTH, HART & HUNTINGTON TATTOO

I started out as a helper at Hart & Huntington in Las Vegas. It was my dream to become a tattoo artist, so as a helper I spent as much time as I could watching and learning from the many talented artists. I learned how to prep equipment and work with customers, and I developed techniques to hone my skill. In the beginning I was drawing a lot and tattooing on grapefruit as practice. No one cares if you mess up a piece of fruit, but someone's skin is a completely different story.

Before I tattooed another person I wanted to give myself a tattoo. So I tattooed a rose on my thigh with black and gray shading, but it looks horrible. I could have it fixed but I keep it to remind me how much I've learned and where I started. It showed me how much more dedication and training I needed as well as how seriously I had to take this job.

I've come a long way from grapefruits and am now a full-time tattoo artist. I love everything about tattooing except how it feels to get tattooed. I'll never get used to it. The most painful experience of my life was the Japanese koi fish on my ribs. Hands down the worst physical pain ever.

Right now I'm tattooing at the Hart & Huntington shop in Cabo San Lucas, Mexico, and pretty much living my dream. I can't ask for much more than to be able to tattoo and surf. Not bad for someone who didn't graduate from high school.

NUMBER OF TATTOOS: 13
FAVORITE TATTOO: Koi fish
FAVORITE STYLE OF TATTOOING: Japanese
MOST MEMORABLE CLIENT: DJ Paul from Three 6 Mafia

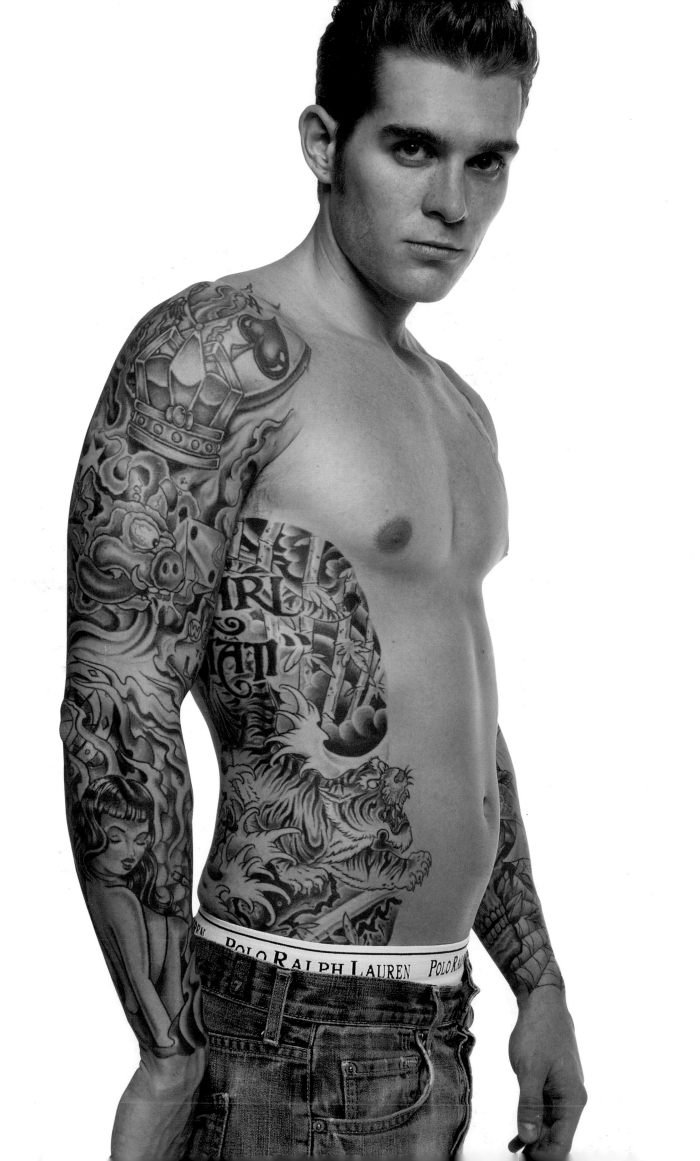

KAMIL ZENMANN

occupation: BARTENDER

artists: JESSE SMITH, HART & HUNTINGTON TATTOO; KENT KELLEY

When I was about six years old we were living in Hawaii across the street from a tattoo shop. My mother used to draw fake tattoos on me with a ballpoint pen, and I thought it was the coolest thing. She'd draw skeletons nailed to brick walls and all kinds of skulls. One day I just decided to walk into the tattoo shop. One of the artists, this old-school guy with a long white beard, comes up to me and asks if I want to see something funny. Being a little kid I said, "Yeah." He comes back and shows me a centerfold of a girl in a white wedding dress bending over with no underwear. He was right, I thought it was pretty funny. Ever since then I just kind of hung out in tattoo shops.

Around the time I turned thirteen my family moved to Las Vegas, where I ended up getting my first real tattoo, a small gecko on my chest. Now I've got two full sleeves and both my sides done, and I'm working on my legs. I dedicated my sides to my parents. On my left side I've got the words ALICIA MAMI surrounded by flowers, for my mother. My right side says KARL TATI over a tiger creeping through some bamboo, which is for my father.

I've got a girl on my right arm with a rose in her hair. People ask me if that's my mother but it's not. It's just some greaser chick. Why did I get it? I just love women. The thing I like about her is that she's even got her own tattoos.

Every day someone comes up to me with questions. Usually they ask where I got the work done and who was the artist. After a while you just get fed up. When I'm at

the gym people tap me on my shoulder when I'm in the middle of my reps. Even if I have headphones on. Sometimes just to avoid that I'll wear a long-sleeved shirt to work out.

But I'm not complaining about tattoos, because they've saved me before. I've been through some tough neighborhoods with my sleeves showing and people decide not to mess with me. Criminals prey on the weak. They don't want to mess with somebody who looks like they'll put up a fight. I'm 6 foot, 195 pounds with 6 percent body fat, and covered with tattoos so they think twice.

It doesn't hurt with chicks either. But I don't show off my tattoos to impress them. If you're wearing a suit and they're impressed by you, when you get to their house and take off your shirt to reveal one hundred hours of work, they're going to go crazy. They look at you as everything their boyfriends aren't.

love women

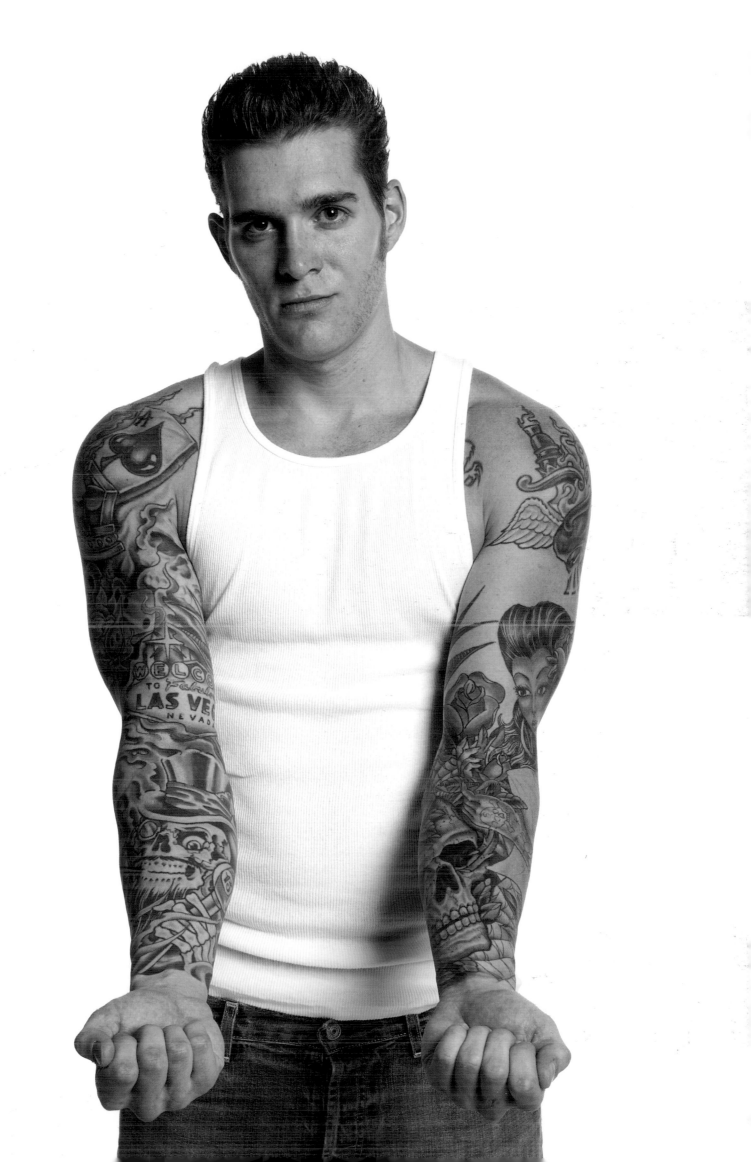

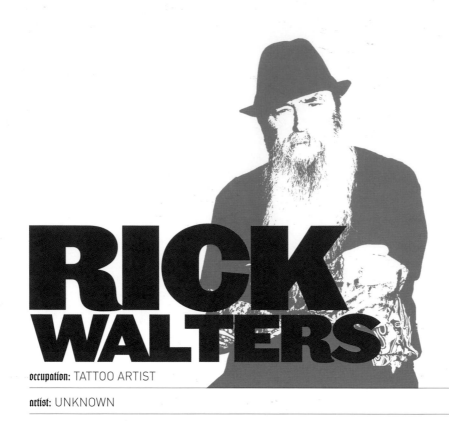

RICK WALTERS

occupation: TATTOO ARTIST

artist: UNKNOWN

I started tattooing at Bert Grimm's in Long Beach forty years ago and worked out of that shop for twenty-five years. I was a certified welder and machinist but nothing gave me freedom like tattooing. In the early days we did a lot of sailors, bikers, and people who worked in the oil fields. We'd get the occasional waitress too, but tattoos weren't accepted by many outside the working class. Middle America was tattooed, but not heavily. And most people who had tattoos got them in places that were easily hidden.

Since then tattooing has exploded into the mainstream, becoming so much more acceptable. Doctors, lawyers, and executives come to me every day to get tattoos. When I started tattooing there were only about twenty-five tattoo shops in Los Angeles and Orange County. Now there are almost two thousand.

Nowadays with television and celebrities making tattoos more acceptable people want to become tattoo artists from a young age. I respect the younger artists of today but they aren't really doing anything that wasn't being done thirty years ago. Their artistic ability is impressive but there have always been great artists in the tattoo industry. The younger generation likes to do portraits and bigger pieces without outlines. The problem with this is that the colors run and get mushy.

I've given just about every type of tattoo on just about every part of the body to just about every kind of person. But there are some things I won't do. If a guy walks in off the street and wants something done on his hands, neck, or face I'll tell him to get out. He doesn't know what he's doing. Those places are reserved for people who are already fully covered. Get some work done, then come back. As an artist, I would be irresponsible to give someone like that a neck tattoo.

I love this job—being an artist and getting paid for it. Believe me, there are plenty of artists walking around who are starving. It's an honor to do this for a living.

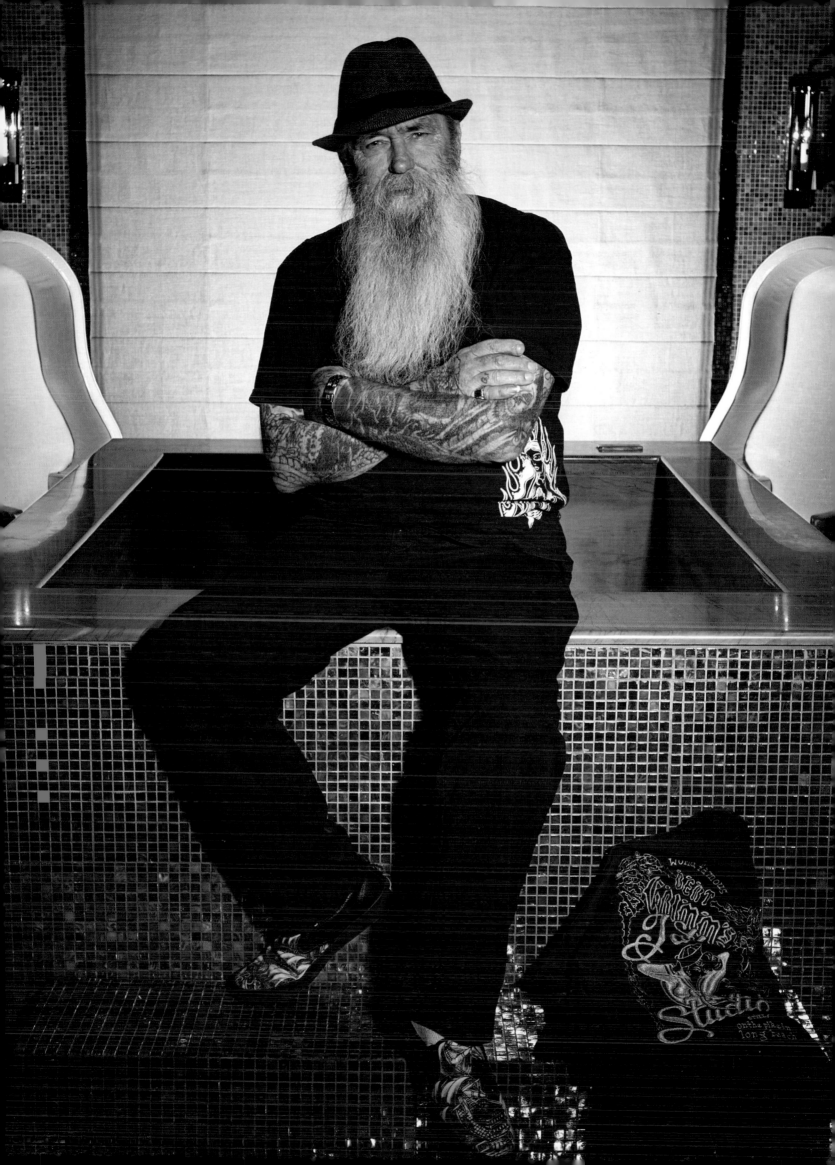

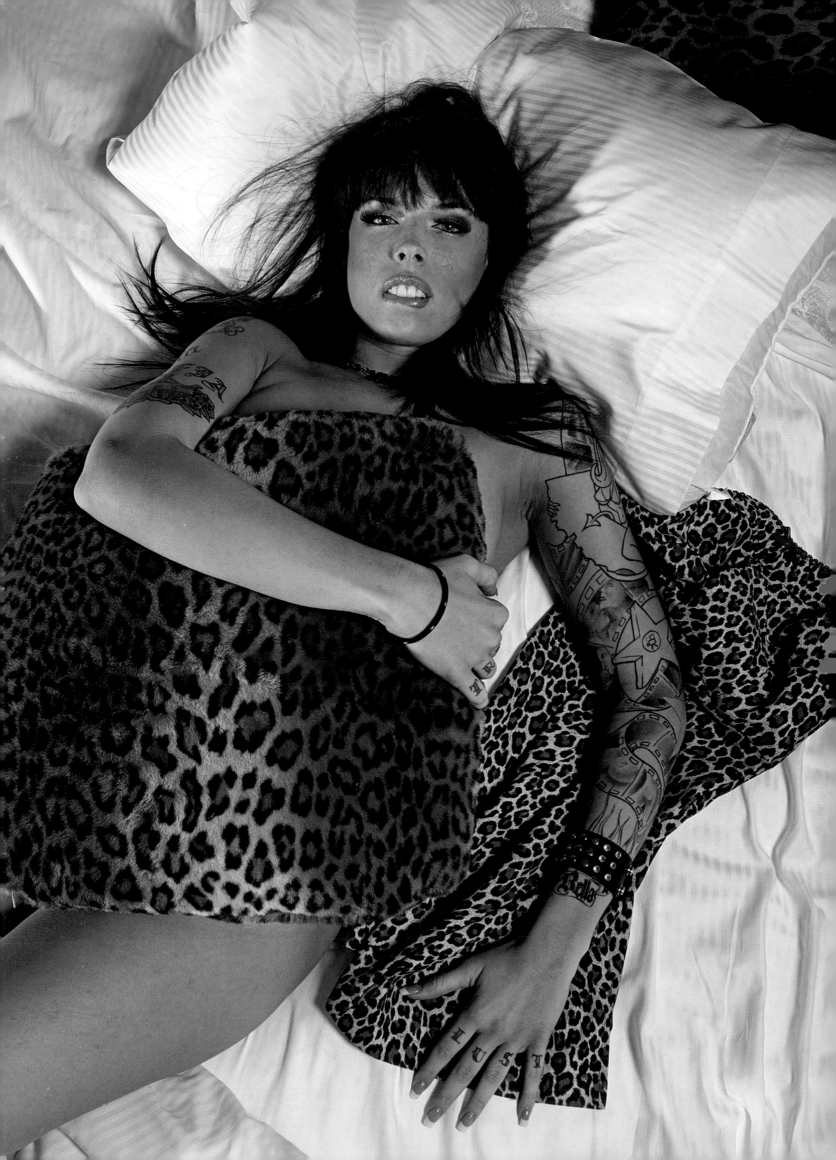

DEMI
MARX

occupation: ADULT FILM STAR

artists: AUSTIN SPENCER; KNUCKLES JOE

Growing up I was always a bit of a wild child, you know, smoking weed, staying out late. Just bad-girl stuff. My parents were bikers and led a really wild life. Many of their friends were also bikers and that's how I was initially exposed to tattoos. Some of my earliest memories are of going to biker rallies with my parents and scurrying around our backyard during the many parties and barbecues they would throw for their friends.

I was always their little girl so when they saw me starting to veer off path they sent me to a militant convent-style Catholic school in Texas. That was a complete nightmare. There were eighty-five girls and no boys. The nuns kept us under strict surveillance twenty-four hours a day and spied on us with a two-way intercom system when we were in our rooms. We weren't allowed to talk, read newspapers, or watch TV, and we had to walk in straight lines with military precision when we went from class to class. Two weeks after graduation I found myself bent over a tattoo chair getting the Celtic symbol for "soul" on my back.

After I got into the adult entertainment business I started collecting more and more tattoos. I'm constantly being pushed and pulled by my good and bad sides, and that's what I want my tattoos to represent. Most of my tattoos hold deep meaning from both my innocent side as a Catholic schoolgirl and my chaotic life in the adult film industry. My left sleeve is devoted to my career. I have a film strip, stars from the Hollywood Walk of Fame, the state of California, and a she-devil. I'm currently working on a dark religious theme for my right sleeve. So far I have a strict-looking old-school nun, a skull, and a dedication to my father, who was killed shortly after I graduated and returned home.

I believe I'm a good person but sometimes you can't win. It seems like I make good decisions, just in a bad field. I work hard, but to some people it doesn't make a difference. There will always be two sides to Demi Marx: porn on Saturday, church on Sunday—sometimes.

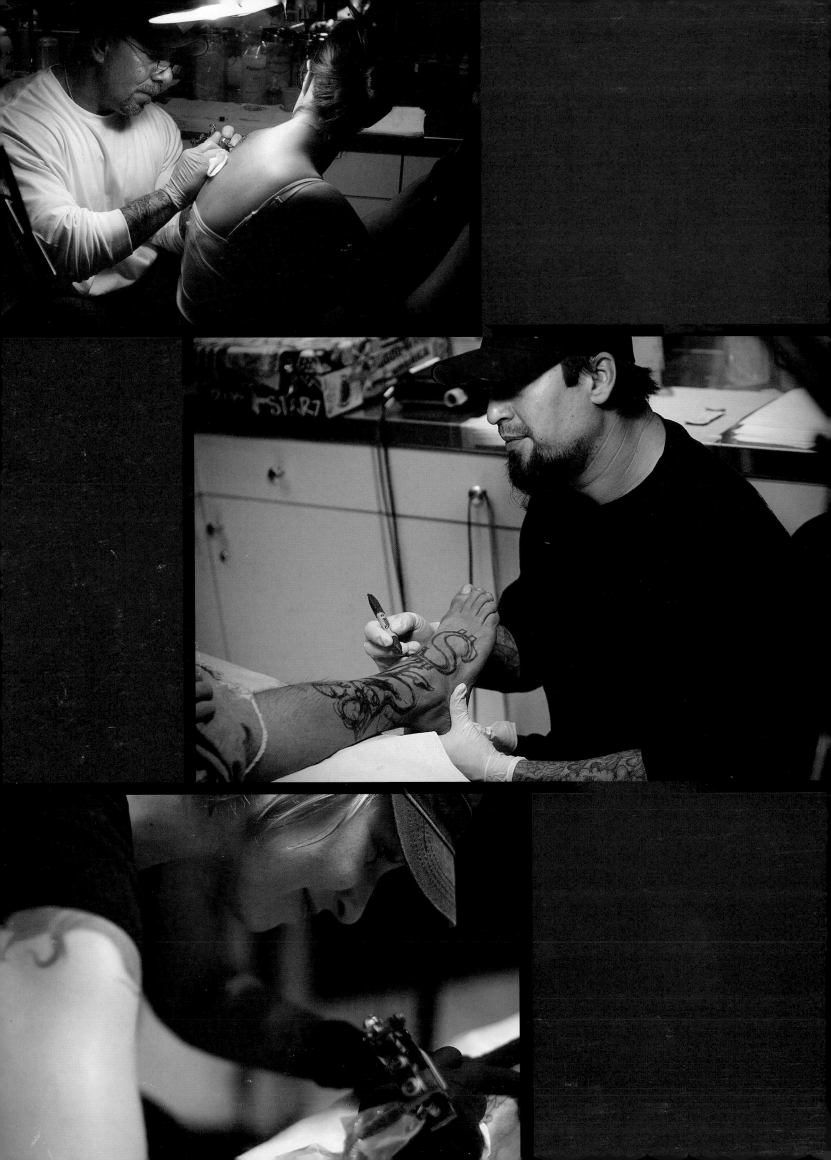

THE TATTOO ARTIST AS THERAPIST WITH UNCLE JOHNNY

I've often heard people say hairdressers are like therapists because people just seem to open up to them. The same goes for tattoo artists. Over the course of my career I've heard a thousand stories from all walks of life. While I'm putting permanent ink in their skin people often run through the most intimate details of their lives.

When someone sits down in my chair my main goal is to make them feel comfortable. Most people, no matter how much work they've had done, are going to be nervous when they begin thinking about the pain. I usually start by asking a few basic questions. After that, the floodgates open.

One time I was tattooing a Chinese symbol on a middle-aged woman who was starting her life over. She was tired of her husband of seventeen years cheating on her and she had worked up the courage to leave him. She poured out her whole life story. A lot of times people don't have anyone in their lives to talk to, so when they've got you one-on-one for a few hours they need you to listen. I wasn't going anywhere so the least I could do was lend her an ear.

Part of a customer's thinking is that they don't mind telling you their pain—no matter how personal—because they'll never see you again. I make a point of never giving people advice, just a reference. If I can relate to someone based on an experience I've had, I'll share it with them.

Sometimes it's hard not to get caught up in people's emotions. Once a couple came in and wanted to get matching tattoos. Their baby had just died and they were getting his name tattooed on them as part of their healing process. As they were telling me their story they began to cry. I could barely hold back my own emotions. I had to stop and get a cup of coffee and take a few minutes to get myself together. It was one of the toughest jobs I've ever done.

Moments like these made me realize that through tattooing people and hearing their innermost thoughts you form a temporary bond with them. People connect with you when they're in your chair. As an artist, when you put people in a comfort zone, they are more likely to come back to you if they are working on a big theme. Good people skills make you popular as an artist, and I never forget to treat people the way I'd want to be treated.

No matter how many tales I hear I never get tired of listening. People come in all day long and tell me their stories while I color on them. It's the best job in the world.

JAY

occupation: PRODUCTION MANAGER, HART & HUNTINGTON TATTOO

born and raised: NORCO, CA

artists: BEN CORN; LOKI; JUSTIN BISHOP

first tattoo: JOKER ON RIGHT SHOULDER

number of tattoos: 70 PERCENT COVERED

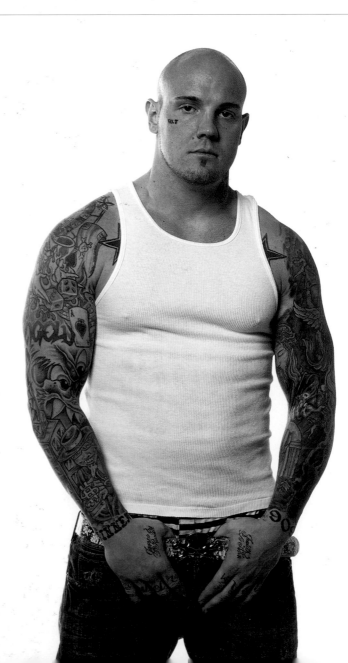

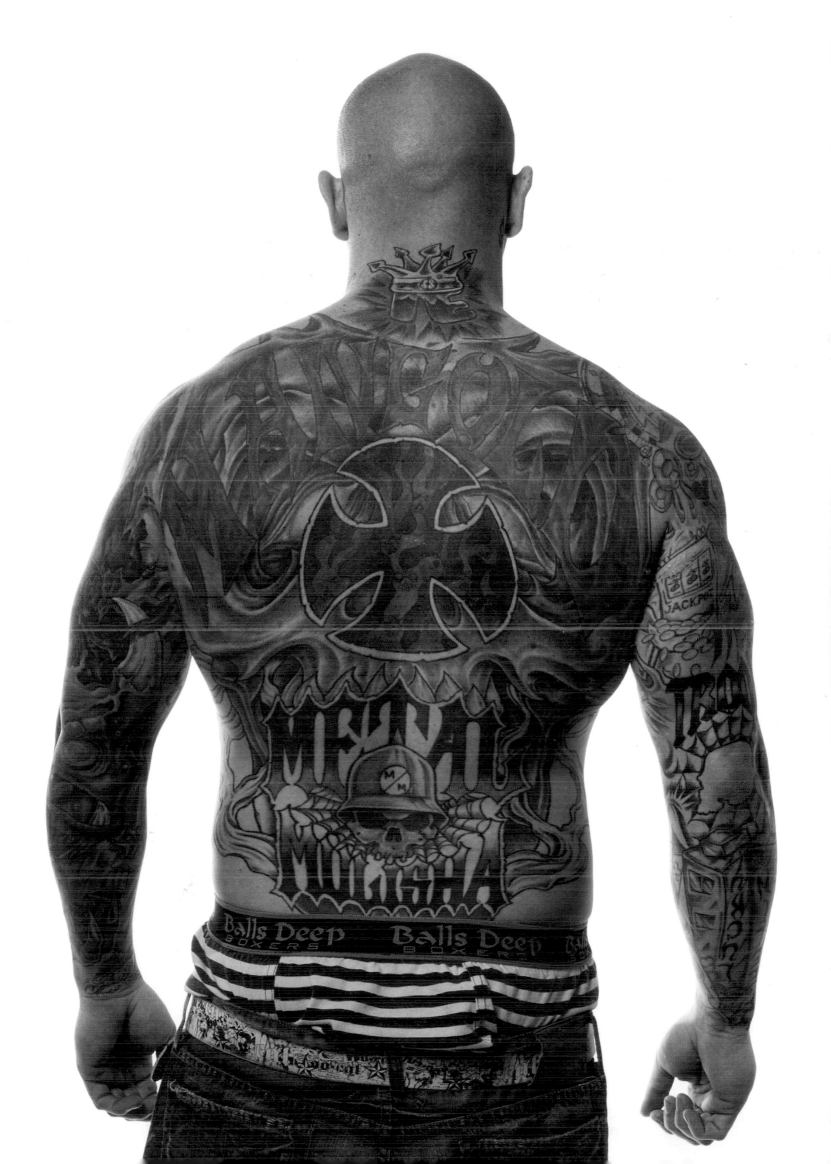

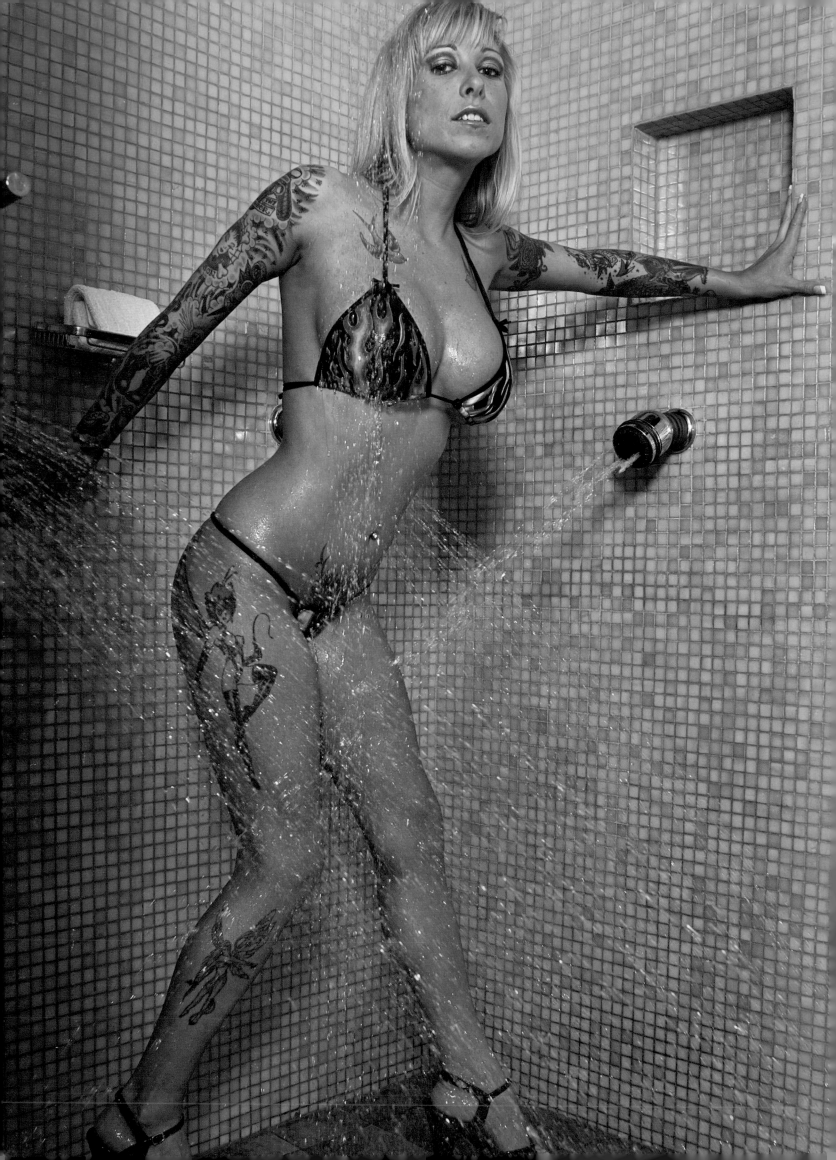

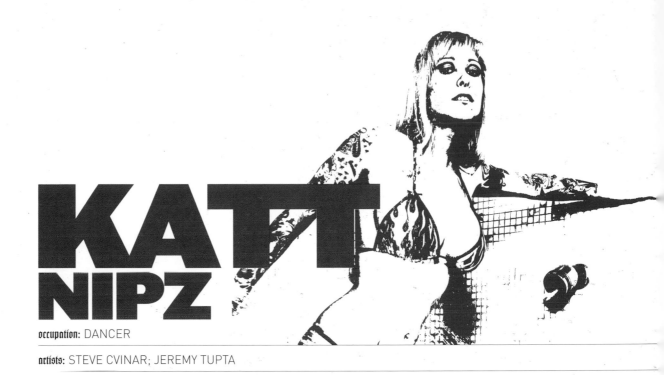

KATT NIPZ

occupation: DANCER

artists: STEVE CVINAR; JEREMY TUPTA

I got my first tattoo to honor my brother who died in a car accident when I was fourteen. I had his name tattooed on my lower abdomen and my father got the same thing. My dad was more like a friend so he was cool with me getting a tattoo before I turned eighteen. I've since gotten it covered because it's hard to date someone when you have a guy's name on your stomach. I replaced it with another memory tattoo on my forearm.

When I moved out west and started dancing I was hanging out with a lot of crazy people who were into the rock scene. One Friday the thirteenth, we were at the Roxy on Sunset, and for reasons I can't remember, I dumped a drink on some guy, which touched off a brawl. We were lucky to make it out of there alive. To commemorate the incident I walked a few blocks to a tattoo shop and got a tattoo of a pair of brass knuckles with the number thirteen over them.

I've got a lot of pride and respect for my country—my grandfather fought in World War II—and it shows in my tattoos. I have some pretty classic old-school designs, like a clipper ship and hearts with daggers. Some of my tattoos have more meaning than others. Along with the names of my mom and stepdad I have swallows on my chest to signify I will always find my way home.

The gypsy girl on my left shoulder reminds me to always travel and never get stuck in one place. I'm from the Midwest and now I live in Vegas but someday I want to travel the world. I plan to get my passport and go see Europe.

I also have an anchor with the word STRENGTH on my left arm to help me keep my head on straight and stay off drugs. I had a problem with drugs and alcohol for a long time, but I've been sober now for more than seven years.

For me the pain hasn't been that bad, with the exception of my elbows and inner biceps. Next I'll probably get the rest of my biceps done and maybe my knuckles, and then I'll be done. Yeah, right.

BIG B

occupation: RAP ARTIST

artists: TRAE HANSEN; MAX KILBOURNE

born and raised: CALIFORNIA AND ARIZONA (AND LAS VEGAS)

first tattoo: CELTIC TRIBAL ARMBAND ON UPPER LEFT ARM

number of tattoos: 80 PERCENT COVERED

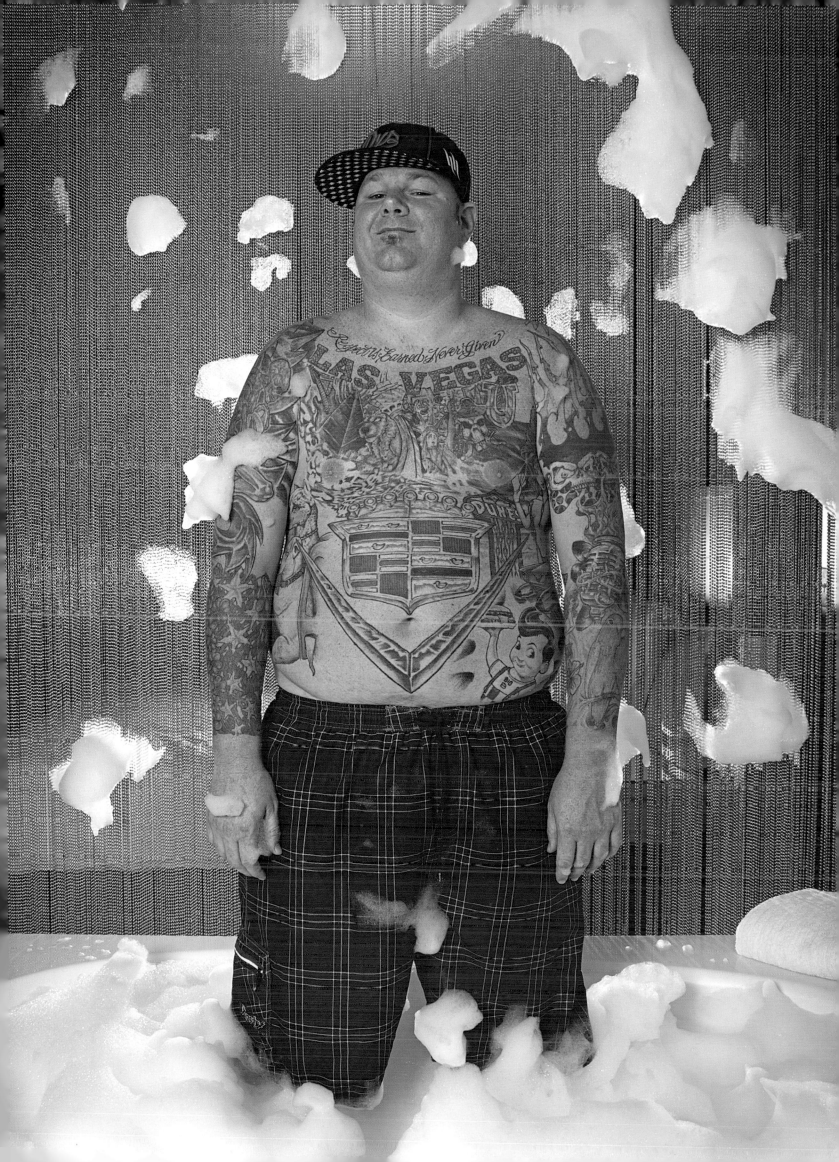

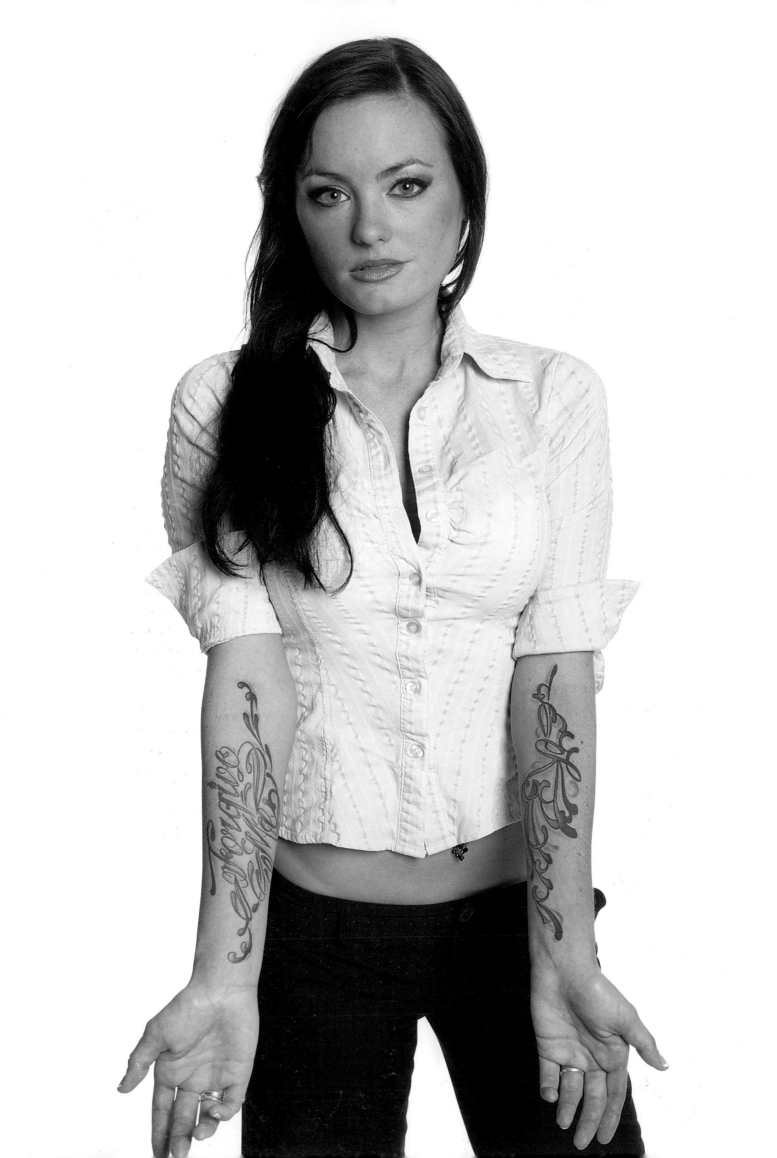

KARLEE MURRAY

occupation: ASSISTANT, TELEVISION INDUSTRY

artist: JESSE SMITH, HART & HUNTINGTON TATTOO

I love my tattoos. They are my favorite accessories because they're black and sexy and match every outfit I have! They go perfect with that little black dress. I'm originally from Boston, and I'm definitely not a J. Crew kind of girl like a lot of people there. I like to stand out and show that I'm not afraid to be an individual. Tattoos can sometimes be a handicap, but I'm too smart to let them stop me.

My most important tattoo is the one with the words FORGIVE ME on the inside of my right forearm. To me it means that you should never leave emotional wounds open for too long. Never get off the phone mad with anyone you love.

I work in television, an industry that promotes creativity and expression, so my tattoos haven't been a problem. I would never interview for a job that would have me cover them up. It's not like I'm managing a hedge fund or working in the finance industry. I'm twenty-eight and have a deep sense of self, so I'm comfortable in my skin.

I lived in Las Vegas for two years and worked in casting on the show *Inked*. For a good Catholic girl from Boston It was a real change of pace. To me Vegas is America's liver, where people go to let it all out. The partying there was nonstop. When I would see normal people living their lives and raising kids and going to work it would surprise me. After a while it was so draining. Now that I'm back on the East Coast I'm definitely thinking about getting more work done. The possibilities are limitless, but whatever I decide on will be positively me.

MICHAEL
POPE

occupation: NORDSTROM'S ASSISTANT DEPARTMENT MANAGER

artist: CLARK NORTH, HART & HUNTINGTON TATTOO

My most recent tattoo is a koi fish with maple leaves and a peony flower with traditional Japanese water bars, waves, and sea foam.

There's no life-altering story behind it, it's just a reminder that I have to work hard to get the best in life. I don't think a tattoo has to have meaning behind it. The aesthetic side means more to me than the story. But at the same time the beauty of your tattoos can tell a story. In the next year or so I plan on finishing a full jacket of traditional Japanese-style artwork that will flow across my back like one big painting. The more work you get done the more your tattoos develop and take on a life of their own. Getting tattoos is very much about the process—watching them evolve and working with an artist on your vision. I look forward to seeing the evolution of my tattoos over my lifetime.

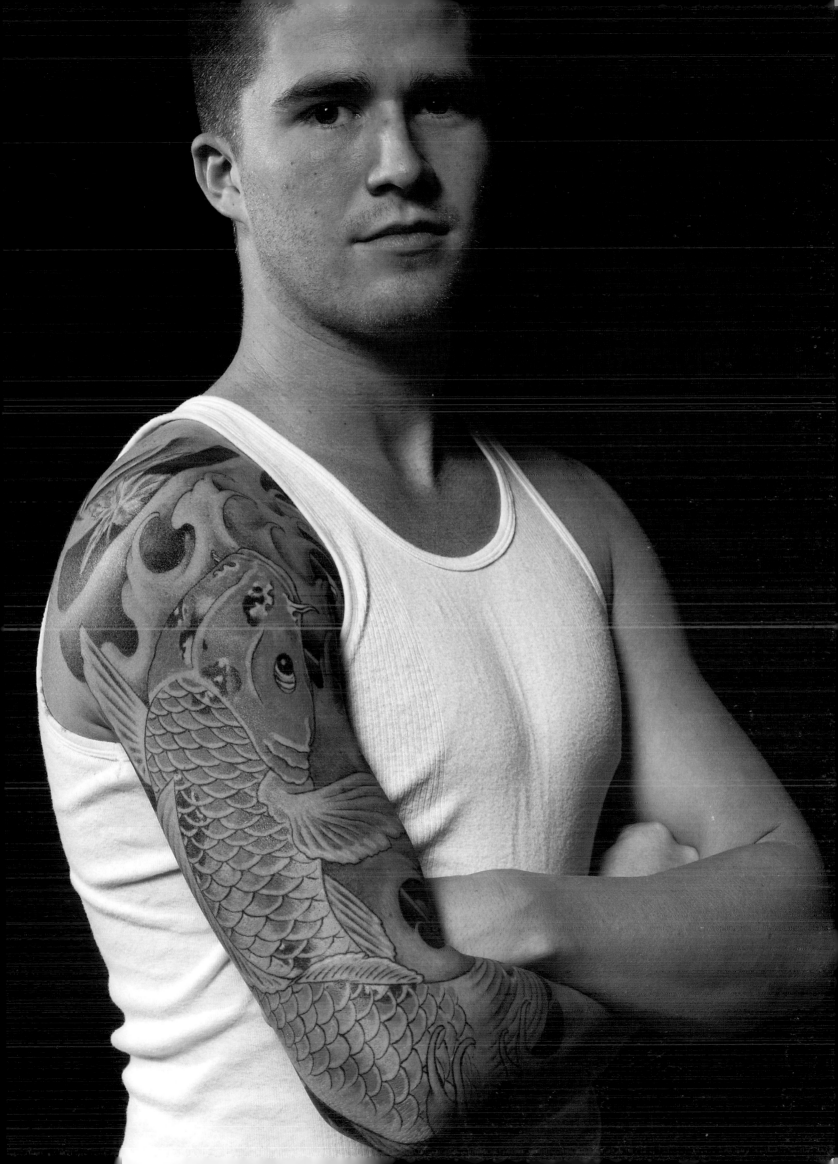

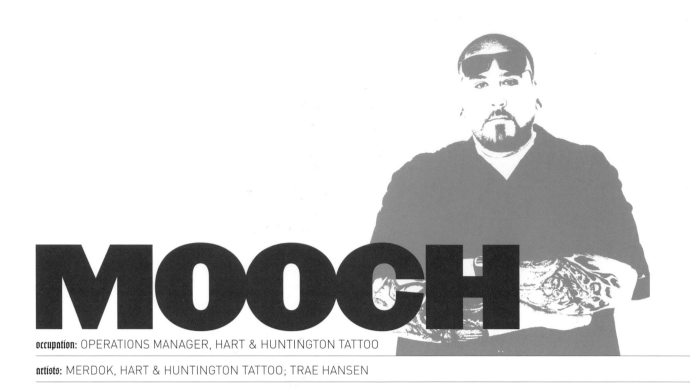

MOOCH

occupation: OPERATIONS MANAGER, HART & HUNTINGTON TATTOO

artists: MERDOK, HART & HUNTINGTON TATTOO; TRAE HANSEN

I got my first tattoo when I was eighteen—my daughter's name in script on my chest. My friend did it with a homemade tattoo machine made out of a Walkman motor and guitar string. After that I was hooked. The second tattoo I got was my last name in Old English across my back. When I had my second daughter, I put both of my daughters' names across my stomach, also in Old English. I have my wife's name on my finger.

When I moved to Vegas from Rialto, California in '97, I was really wanting to get sleeved. Around that time I met Trae Hansen, who owns Pricz Tattoo. I just told him I wanted some demons and skulls, and he went to work on my right arm. There's no substitute for having the right artist for the job. Merdok at Hart & Huntington did my left sleeve. He's a really good black and gray artist and does awesome demons, skulls, and girls.

Overall my tattoos are a mix of meaningful sentiment and the kind of artwork that appeals to me. The lone memorial piece I have is for my brother, David Mendoza.

To me, tattoos show how unique and different you can be, and for those who don't have them, well, hey, they're unique too.

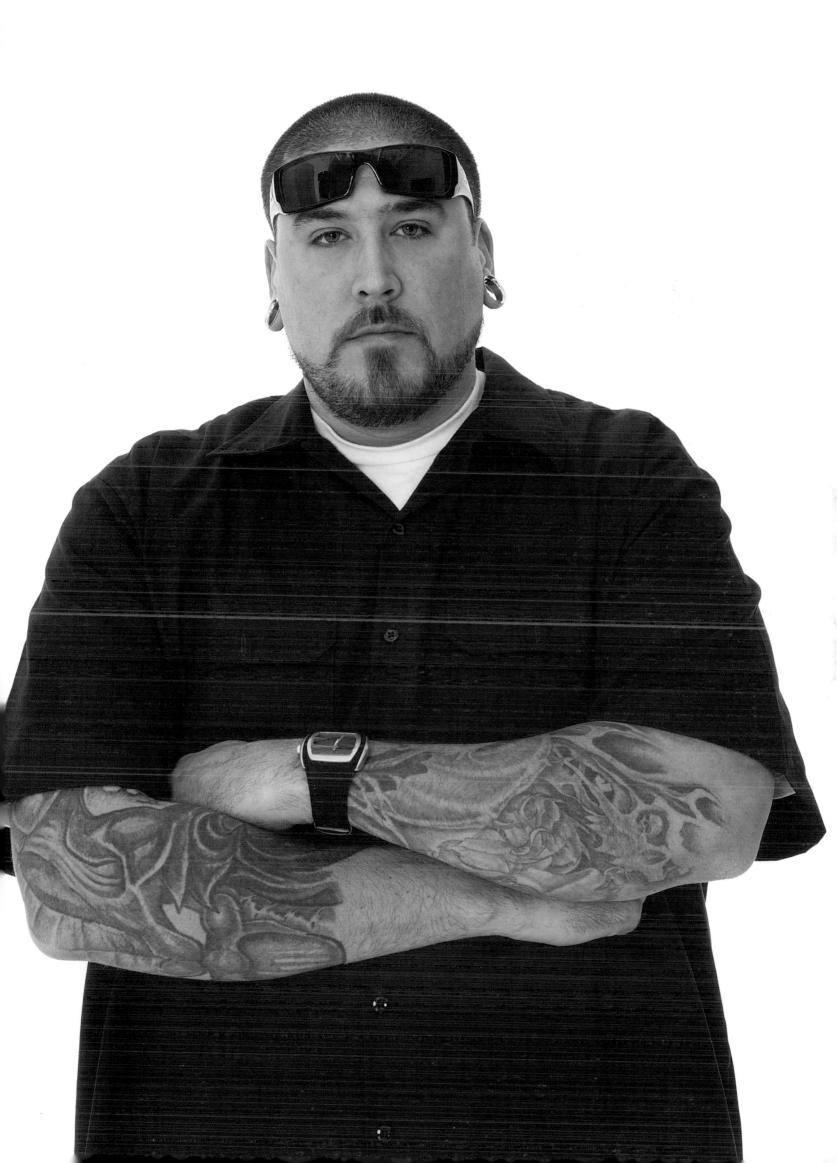

HOW TO CARE FOR A TATTOO

The tattoo artist has just plunged the last drop of ink into your skin. You've endured the pain. Spent your hard-earned cash. Maybe you sat there for thirty-five hours. Maybe just one. Now it's time to take care of that cherished investment. An artist goes to extreme measures to ensure your tattoo was given in a clean, sterile environment. But once you walk out of the shop you're on your own.

SO MUMMY RIGHT NOW!

A tattoo artist isn't simply drawing on you. The needle is puncturing your skin thousands of times over the course of one sitting, essentially wounding your skin. It can be pretty traumatic for the epidermis, so it will need ample time to heal. The tattoo artist will send you home with your new tattoo bandaged up, wrapped in gauze to protect the area from airborne pathogens, dust, germs, and contact with any unclean surfaces. Some artists use Saran Wrap (cellophane), but this doesn't absorb moisture and traps in air and bacteria. Don't remove your bandage for at least four hours.

GET WET

Water is a key component in caring for your tattoo. But don't overdo it. After removing the bandage, wash the area gently with antibacterial soap and water, then pat dry. (Don't use bar soap, it dries the skin out!) For the first cleansing, dab the soap directly on with your finger, as even a soft cloth might be too abrasive. Do not scrub or soak until the tattoo is completely healed. Showers are fine but don't let a strong stream of water hit the tattoo directly. Avoid hot tubs, pools, the Mississippi, and any of the major oceans.

POETRY IN LOTION

Twice daily applications of fragrance-free medicated lotion helps speed up the healing process and combats itchiness. Noxzema Medicated Skin Lotion and A & D ointment, which moms have long used for diaper rash, come highly recommended by more than a few collectors for their soothing properties. Gently blot off any excess. Avoid "soquids" (solids and liquids) like Vaseline (and other petroleum-based products) and thick oils. They shield the skin from contact with air, which facilitates the healing process.

SUN, SUN, SUN

Keep out of it. Sun is your skin's number one enemy during the healing stage. The sun specializes in dulling, distorting, and fading tattoos. (Light colors and pastels are especially susceptible.) That goes double for tanning booths. If you must venture outside be sure to apply sunscreen with a strong enough SPF. But really, who's going to the beach with partially healed tattoos anyway?

DON'T BE PICKY

Your healing tattoo will itch. A lot. No matter how much you're tempted, keep your busy little fingers away from those scabs. Let them peel off naturally, which takes about seven to ten days. The areas of a tattoo that are darkest and have thick lines are where you'll see scabs. Picking a scab can cause that part of the tattoo to heal out, leaving a blank spot and guaranteeing you'll need touch-ups. And touching up that new scar tissue is no fun for the artist. Scratching can damage the skin, lengthen the healing time, and cause unsightly scarring. You've been warned.

ACKNOWLEDGMENTS

I'd like to extend a huge thank you to all of the people and artists who made this project possible. Thank you for opening up and sharing your tattoos and stories.

Bill Thomas who spent months at my house shooting this book. Not bad for a couple of tattooed scumbags! Good thing you had time to shoot photos around your busy nightlife schedule!

My dad, Tom Hart—told you one day these damn tattoos would pay off! I know it didn't make sense when I kept coming home with new tattoos, but everything happens for a reason, I guess! It beats breaking bones!

And to my best friend and love of my life, Alecia. You have made me grow so much as a person. Had this book happened earlier in my life, I would be wearing Dickies and a T-shirt in all the photos. Oh wait, well, you know what I mean! Thank you for always being there for me, and I'm sorry for working a lil' too much. Life is rough but you make it much better.